LETTER PRESS

★★★

NOW

LETTERPRESS
NOW

A DIY GUIDE TO
NEW &
OLD PRINTING METHODS

BY JESSICA C. WHITE

LARK CRAFTS
Asheville

LARK CRAFTS

An Imprint of Sterling Publishing
387 Park Avenue South
New York, NY 10016

If you have questions or comments about
this book, please visit: larkcrafts.com

Library of Congress Cataloging-in-Publication Data

White, Jessica (Jessica C.)
 Letterpress now : a DIY guide to new & old printing methods / Jessica White. -- First edition.
 pages cm
 Includes index.
 ISBN 978-1-4547-0329-7
 1. Letterpress printing. I. Title.
 Z252.5.L48W48 2013
 686.2'312--dc23

 2012003892

10 9 8 7 6 5 4 3 2 1

First Edition

Published by Lark Crafts
An Imprint of Sterling Publishing Co., Inc.
387 Park Avenue South, New York, NY 10016

Text © 2013, Jessica C. White
Photography © 2013, Lark Crafts, an Imprint of Sterling Publishing Co., Inc.,
unless otherwise specified
Illustrations © 2013, Jessica C. White

Distributed in Canada by Sterling Publishing,
c/o Canadian Manda Group, 165 Dufferin Street
Toronto, Ontario, Canada M6K 3H6

Distributed in the United Kingdom by GMC Distribution Services,
Castle Place, 166 High Street, Lewes, East Sussex, England BN7 1XU

Distributed in Australia by Capricorn Link (Australia) Pty Ltd.,
P.O. Box 704, Windsor, NSW 2756 Australia

Manufactured in China

ISBN 13: 978-1-4547-0329-7

For information about custom editions, special sales, and premium and corporate purchases, please
contact Sterling Special Sales Department at 800-805-5489 or specialsales@sterlingpub.com.

For information about desk and examination copies available to college and university professors,
requests must be submitted to academic@larkbooks.com. Our complete policy can be found at
www.larkcrafts.com.

EDITORS:
Kathleen McCafferty
and Thom O'Hearn
ART DIRECTOR: **Kristi Pfeffer**
PHOTOGRAPHER: **Steve Mann**
COVER DESIGNER: **Kristi Pfeffer**

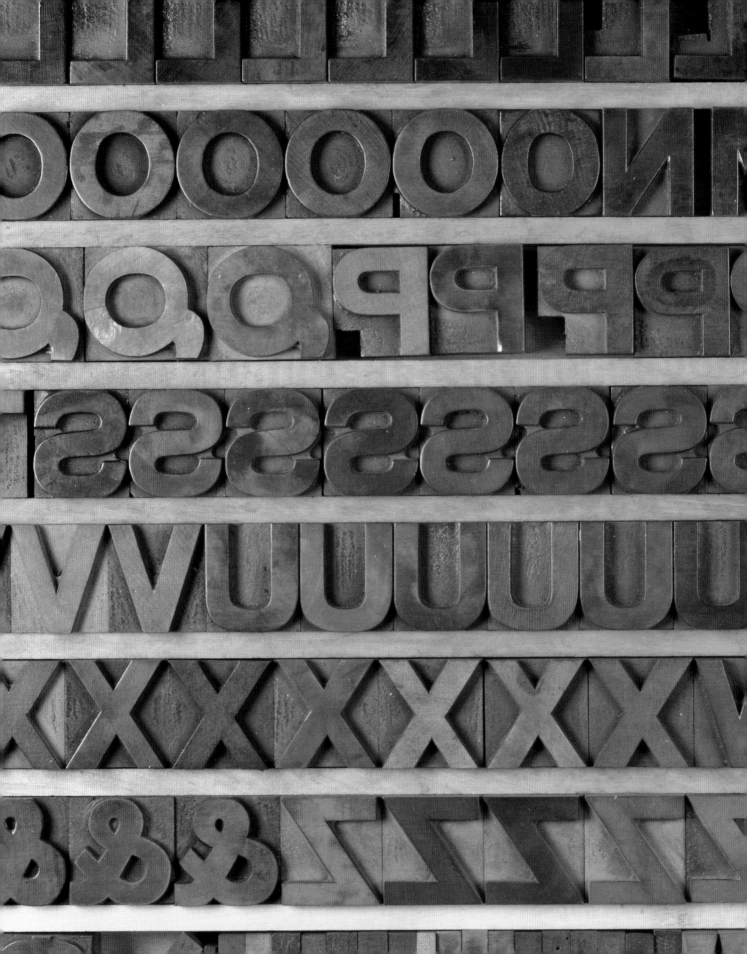

FEATURED ARTISTS

INTRODUCTION

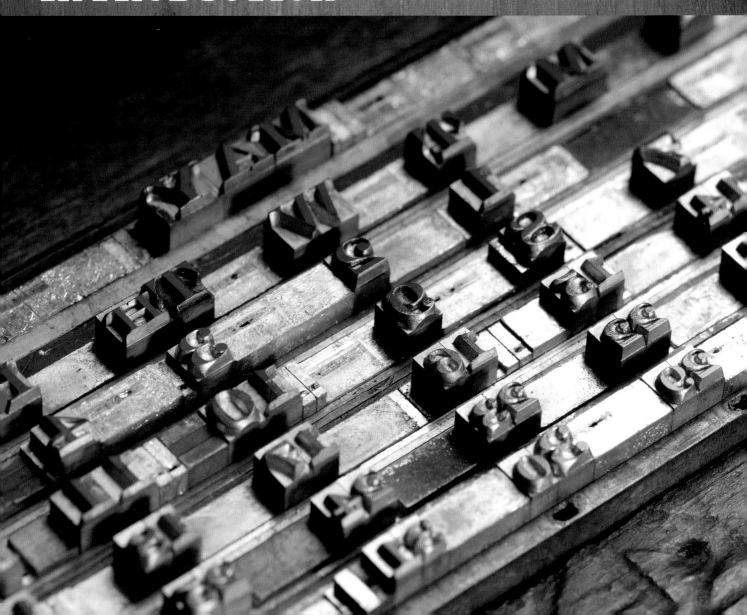

EVERY TIME YOU MAKE SOMETHING BY LETTERPRESS PRINTING, YOU CAN FEEL THE MATERIALS COURSE THROUGH YOUR FINGERS. SETTING TYPE, MIXING INK, PREPARING A PRESS, THE ACT OF PRINTING, AND EVEN FINISHING THE PRINTED SHEETS ARE ALL TACTILE PROCESSES. THE FINISHED PIECE ALSO HAS A PHYSICAL QUALITY UNLIKE ANY OTHER FORM OF PRINTING. WHETHER IT'S A KISS IMPRESSION OR AN EXTREME DEBOSS, IMPRESSIONS FROM A PRESS ARE UNMISTAKABLE.

What creates that impression? Letterpress printing is a type of relief printing that uses type cast from metal or carved from wood and presses made specifically for printing type. It originated in China with the development of movable type around A.D. 1040, when entire pages of text carved out of one wooden block were replaced with carved characters that could be rearranged independently. When Johannes Gutenberg introduced movable type and letterpress printing to the West in the 1450s, it made an enormous impact and changed the way Western civilization regarded printed information. Gutenberg's methods of casting type and printing spread like wildfire. Until the mid-twentieth century, letterpress printing was the primary method for all things printed, including newspapers, books, packaging, and tickets.

During the past century, letterpress printing has been replaced with offset and digital printing as the most common commercial printing methods. Many businesses and schools shoved old printing presses into basements and garages, sold them for scrap metal, or even tossed them out into the woods! Luckily, a few die-hard printers and visionary artists rescued many of them and put them to use. Hobbyists, craftspeople, and even a handful of commercial printers have continued to embrace letterpress and refuse to let this extraordinary craft fade away. Thanks to them, letterpress printing is experiencing a resurgence today, and we still have the tools and equipment necessary to bring about this revival.

As is true for many crafts, there are a variety of ways to approach letterpress printing and learn the skills you need. This book offers a starting point for letterpress and some project ideas for a variety of presses. It's meant to be useful whether you are the lucky new owner of a tabletop platen press, just found a local letterpress studio, or happened upon wood type at a flea market. The large introductory chapter, Getting Started, will answer many of your questions. It will also walk you through letterpress tools and techniques shared across a variety of presses. It even includes a flowchart to help you find the type of press that's right for the project you want to make. The projects themselves are organized along similar lines to the chart: they're grouped by the type of press you plan to use. So flip to whatever interests you, whether it's the smaller tabletop platen press or the giant cylinder presses.

Different projects will also walk you through printing with different materials—from wood type and metal type to linoleum blocks and photopolymer plates. To get even more out of your letterpress printing experience, I encourage you to try a variety of these projects at a local studio if you can— whether you need to use their particular presses or not. There's nothing like spending some time on press making prints and learning directly from another printer.

As you look around the studio, you'll notice that the unique characteristics and the tactile quality of letterpress have attracted a new generation of printers. Impressions on a sheet of paper, which were once regarded as a sign of poor craftsmanship, are now celebrated as a sign of handmade artistry. Letterpress will continue to grow and change as a living craft, and you're invited to become a part of it.

GETTING STARTED

A BRIEF SURVEY OF PRESSES

In order to print a book, Johannes Gutenberg had to be creative and resourceful. An experienced metal worker from Mainz, Germany, he was in his element when he created the perfect alloy for printing type—a combination of lead, tin, and antimony that he formulated in the mid-1400s. Gutenberg is also credited with designing the device for casting type, making it possible for any type foundry to quickly and precisely cast letters from prepunched molds.

Gutenberg must have realized that, although some invention was necessary, he could equip his print shop with tools and materials adapted from other trades. One of his most transformative adaptations was the printing press itself, which was introduced around 1450. A modification of the screw presses commonly used during that time in trades such as winemaking and papermaking, Gutenberg's press design, called the hand press, served as the basis for all printing presses for the next 400 years.

The hand press has three chief components: a flat press bed, a large plate called a platen, and a screw. Type is set, locked up, and inked by hand on the flat surface of the press bed. To produce a print, a piece of paper is placed on top of the bed, which slides on rails underneath the platen. The large screw attached to the top of the platen lowers it towards the bed, exerting sufficient pressure to transfer the ink from the type to the paper. Although press designs have changed since Gutenberg's time, presses today work with the same goal of transferring ink to paper using pressure.

The first major change to Gutenberg's model came about in the 1840s, when American inventor Stephen P. Ruggles developed a design that hinged the platen and the press bed, creating a press that opened and closed like a clamshell. From this design, George P. Gordon created a platen press that set the standard for presses of that variety for the next century. Equipped with rollers that inked the type, these self-inking presses sped up the printing process for the busy commercial printers of the day. They eventually became known as "platen jobbers." These presses run in a vastly different way from hand presses, but the print is still made when two flat platens—one holding the inked type and the other holding the paper—meet evenly under pressure.

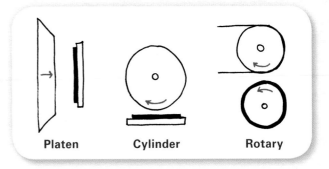

Platen **Cylinder** **Rotary**

Around the same time, R. Hoe & Company, a New York-based printing press manufacturer, developed a way to make a trial print to check for errors in a block of type (also called a form) before sending it to press. This process came to be known as proofing. The printer would place a galley with the set type on the press bed, ink it by hand with a brayer, and place a sheet of paper on top. He would then roll a heavy iron cylinder, which rode on rails, over the paper. This type of machine, known as a flatbed cylinder press, became very popular, and a variety of models were later developed, including motorized versions. The main difference between a flatbed cylinder press and a platen press lies in pressure. With a platen press, pressure is spread out over the entire face of the platen. In a cylinder press, pressure comes only from the thin line where the side of the cylinder meets the paper as it rolls across the form.

A third type of press, the rotary press, also appeared in the mid-1800s. Though this machine is a variation of the cylinder proof press, it did not print from type on a flat press bed. Instead, the type itself was set on a cylinder, then printed onto paper on a corresponding cylinder. This innovation sped up the printing process immensely. Rotary presses could achieve speeds of up to 20,000 sheets per hour. By the 1870s, these presses were made to print from continuously feeding rolls of paper (also called webs) that were later cut into sheets. Rotary presses are so large and print at such high speeds and quantities that they're seldom used these days in letterpress print shops, which tend to produce smaller runs. For this reason, none of the projects in this book require the use of a rotary web-fed press. The focus here is on platen and flatbed cylinder presses.

Now, on to the presses we'll be using to make the projects in this book!

Platen Press

The platen press is often called a "clamshell" press because of the way it opens and closes. This type of press has two flat surfaces: one is the bed, where the form is locked up, and the other is the platen, the smooth surface where the paper is placed. A printed impression is made when the two sides meet. Platen presses have rollers that pick up ink on an inking disc. The rollers transfer the ink to the form as they travel over it on rails.

Tabletop Platen Press

The tabletop platen press was first produced in the early 1800s. It was popular with hobbyists and children in the late 1800s because of its simplicity and portability. Small but powerful, this press is ideal for little jobs such as invitations, business cards, and postcards. It's operated with a lever that cranks the platen and bed together to create an impression. This type of press varies in size, from a small, business card-size model to a larger, heavy-duty version that's capable of professional work. It's the type of press you're most likely to find at a flea market, an antique shop, a printer's fair, or online. Tabletop platen presses are often reasonably priced. Examples: Kelsey, Baltimorean, Excelsior, Chandler & Price Pilot, Craftsmen, Golding Official, Sigwalt, and Hohner.

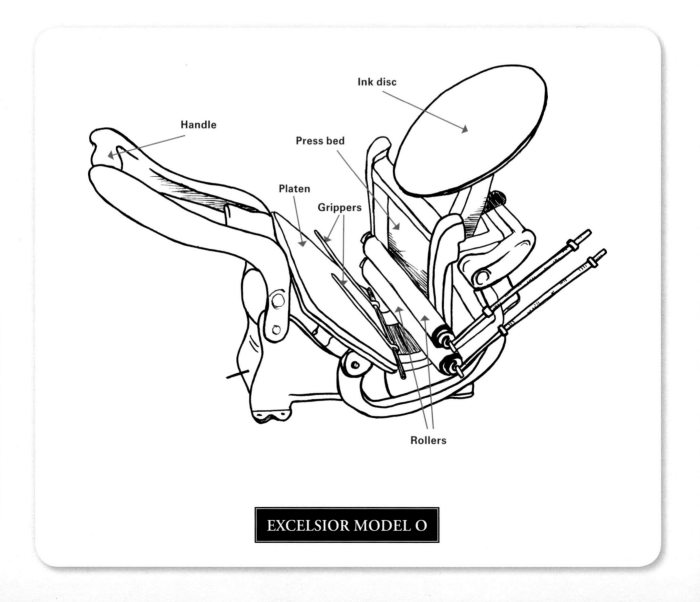

EXCELSIOR MODEL O

Full-Size Platen Press
(Also Called a Job or Jobbing Press)

This large, floor-standing platen model was the mainstay of the printing industry from the mid-1800s onward. It was initially operated by means of a foot-powered treadle instead of a lever, as on the tabletop version. In the early 1900s, the treadle was replaced by powered line shafts, which were eventually motorized. Full-size platen presses were incredibly popular. So many of them were manufactured that even after a rush to scrap and modernize them in the mid- to late 1900s, they still serve as the primary presses for hobbyists and letterpress print shops. Some larger print shops retained them even as they modernized, using them primarily for die cutting, foiling, scoring, and perforating. Schools and community print shops often remove the motors and reattach the treadles for safety reasons. This model continues to be popular with contemporary boutique presses. Examples: Chandler & Price, Golding Jobber, Pearl, and Gordon Franklin.

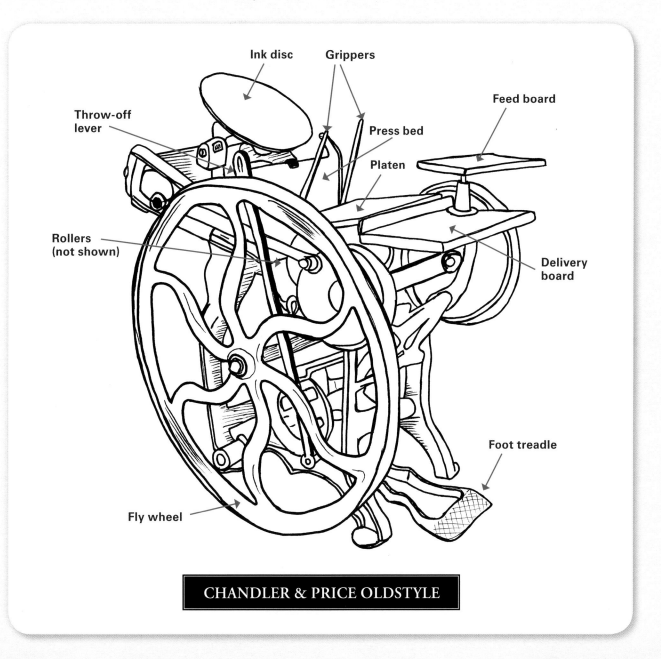

Ink disc

Grippers

Feed board

Throw-off lever

Press bed

Platen

Rollers (not shown)

Delivery board

Fly wheel

Foot treadle

CHANDLER & PRICE OLDSTYLE

Cylinder Press

Also known as a proof press, this model was once used primarily to make proof prints of forms before they went to press on larger, faster machines. Because cylinder presses are simple to set up, safe to operate, and can easily print one sheet at a time, they're ideal for artists, schools, and community print shops.

Tabletop Cylinder Proof Press

The simplest type of letterpress press, a tabletop cylinder proof press has no motor and few mechanical parts. It's essentially a flat bed with a single roller that rides on two tracks. To use this kind of press, you lock up a form on the bed, ink the form with a small handheld roller (called a brayer), then lay a sheet of paper on top. To get an impression, you pull the roller across the form. At one time, tabletop cylinder proof presses could frequently be found in the basements of department stores, where they were used to print sale signs quickly and cheaply. Useful for letterpress printing as well as general relief printing, this type of press is inexpensive, is (fairly) portable, and takes up little space. It's a good starter press. However, I wouldn't recommend it if you're printing delicate type or images, or need precise registration. Examples: Nolan, Triumph, Morgan LinoScribe, SignPress, Sirio, and Atlas.

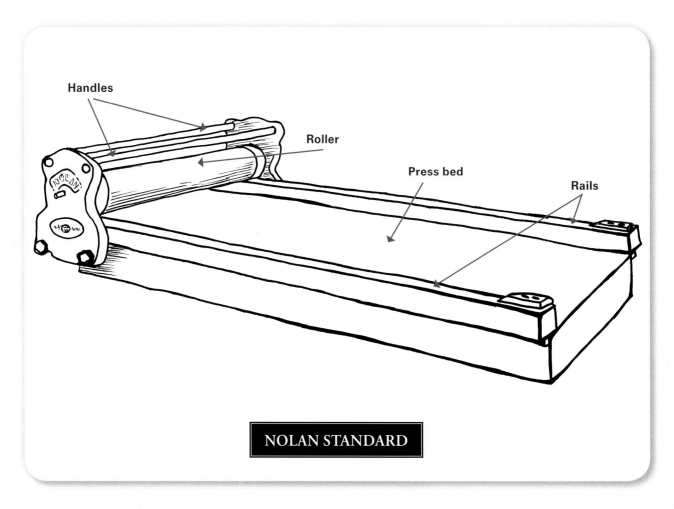

Handles

Roller

Press bed

Rails

NOLAN STANDARD

Precision Cylinder Proof Press

This press is a step up from the tabletop cylinder proof press and is the kind most commonly used in classrooms and community print shops. The precision cylinder proof press often has motorized rollers. Once a form is locked up on the press bed, the motorized rollers apply an even and precise amount of ink to the form. Paper is then passed over it on a rotating cylinder. The pressure from the cylinder can be adjusted with packing, making this a good press for a variety of papers. You can get tight registration, perform fine printing, and easily produce a large edition with a precision cylinder proof press. Because this type of press is considered the gold standard for high-quality, modern letterpress work, it's sought after and used by artists and private presses. Examples: Vandercook, Challenge, Asbern, Reprex, and Canuck.

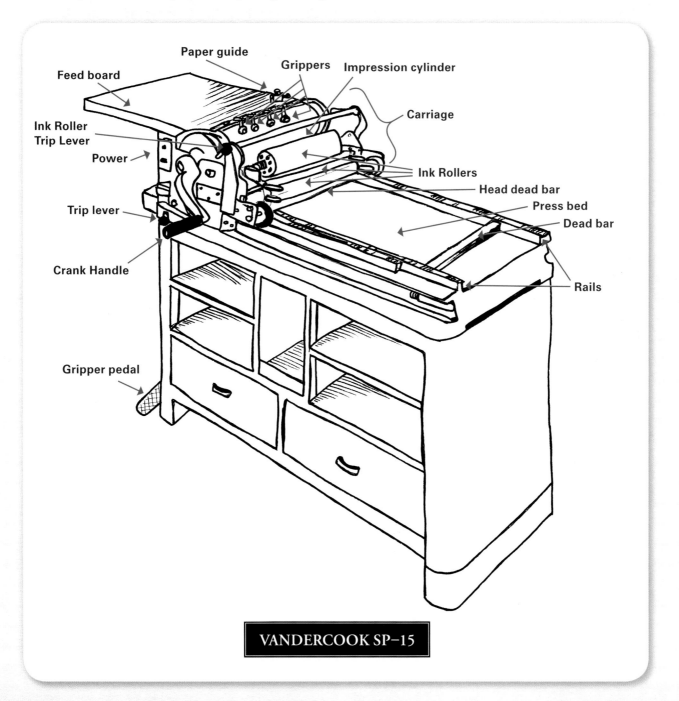

VANDERCOOK SP–15

Labels: Feed board, Paper guide, Grippers, Impression cylinder, Carriage, Ink Roller Trip Lever, Power, Ink Rollers, Trip lever, Head dead bar, Press bed, Dead bar, Crank Handle, Gripper pedal, Rails

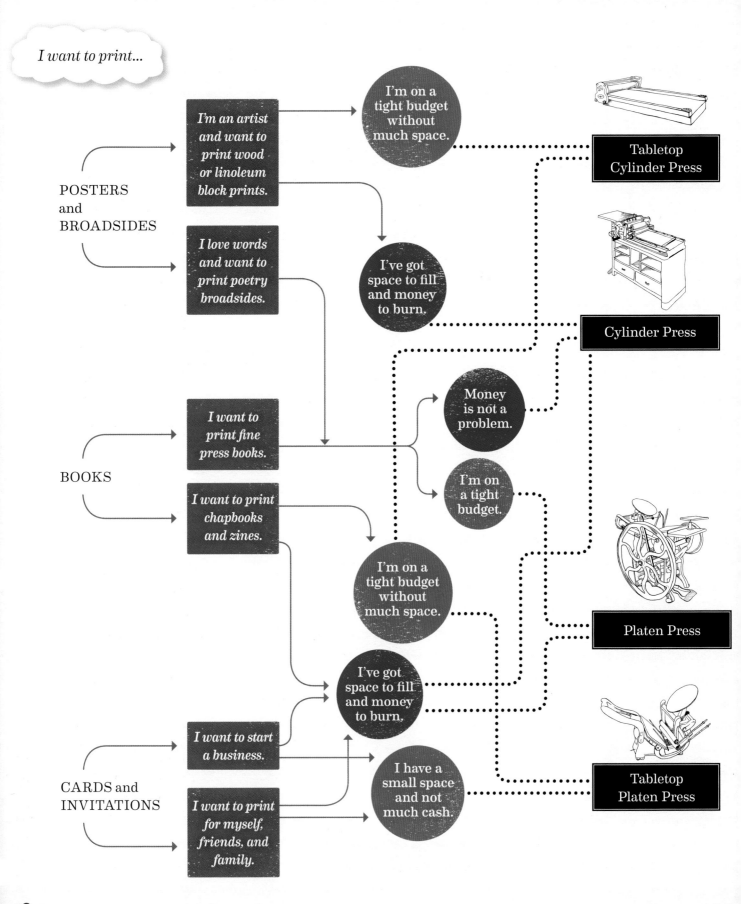

I want to print...

POSTERS and BROADSIDES

I'm an artist and want to print wood or linoleum block prints.

I love words and want to print poetry broadsides.

BOOKS

I want to print fine press books.

I want to print chapbooks and zines.

CARDS and INVITATIONS

I want to start a business.

I want to print for myself, friends, and family.

I'm on a tight budget without much space.

I've got space to fill and money to burn.

Money is not a problem.

I'm on a tight budget.

I'm on a tight budget without much space.

I've got space to fill and money to burn.

I have a small space and not much cash.

Tabletop Cylinder Press

Cylinder Press

Platen Press

Tabletop Platen Press

 ## WHICH PRESS IS RIGHT FOR YOU?

If you plan to print at a commercial studio, chances are they will have a wide variety of presses. However, if you're thinking about buying a press, you should first consider what you want to print. That big concert poster you want to create from wood type just can't be produced on a tabletop platen press! Each type of press is best suited for a specific kind of work. Other factors to consider before purchasing a press include the price, the amount of space you have for the machine, and your own intentions. Will the press be used for hobby purposes only, or do you plan to start a printing business? Here's a handy chart to help guide you through the process of choosing a machine.

Basic Letterpress Printing Tool Kit
(for every project)

★ PROOF PAPER ★

★ DRAWING PAPER ★

★ PENCIL AND ERASER ★

★ INK ★

★ INKING PLATE/INKING TABLE ★

★ PANTONE FORMULA GUIDE (OPTIONAL) ★

★ PALETTE KNIFE ★

★ LINE GAUGE ★

★ GAUGE PINS ★

★ PACKING PAPER ★

★ TYMPAN PAPER ★

★ FURNITURE OR REGLETS ★

★ CHASE (FOR ALL PLATEN PRESSES) ★

★ IMPOSING STONE OR TABLE ★

★ QUOINS ★

★ QUOIN KEY ★

★ CRAFT KNIFE ★

★ PAINTER'S TAPE ★

TOOLS FOR LETTERPRESS

Every letterpress printer needs to be equipped with the right set of tools to get the job done. In addition to the press itself, make sure that your shop is outfitted with the following tools and materials.

Base An aluminum or magnetic block that's precisely engineered for printing with a photopolymer plate. A magnetic base is used with a steel-backed plate, while an aluminum base is used with an adhesive-backed plate.

Brayer A handheld roller that comes in a variety of sizes.

Chase The metal frame used for locking up a form and holding it in place on the press. Chases come in different sizes, based on the size of the press they're used with.

Composing stick (see page 34) A handheld tool that's used for setting metal type. I prefer the composing sticks made by H. B. Rouse and Company. They're easily adjustable and have measurements marked on them.

Craft knife Handy for cutting slits in tympan paper to insert gauge pins. This is also an all-around good tool to have for cutting string, cardstock, etc.

Form string Used to tie up type after it's been set and before it's locked up on a press. Tying up type prevents it from falling over and becoming "pied," or jumbled up in a confused heap.

Furniture Wooden blocks cut to specific sizes that hold a form in place by filling in the spaces around it.

Galley A metal tray that's used for temporarily storing set type. It's not absolutely necessary, but helpful to have on hand.

Gauge pins (see page 30) A variety of small gadgets that hold paper on the tympan during a print run.

Glue stick In this book, I use glue sticks for two purposes: making matrixes for pressure printing, and creating mock-ups (like the collages that I'll refer to as I make my final prints). For mock-ups, I use low-tack glue sticks that allow me to reposition text and imagery until I decide on a final design. For pressure printing, I use permanent glue sticks.

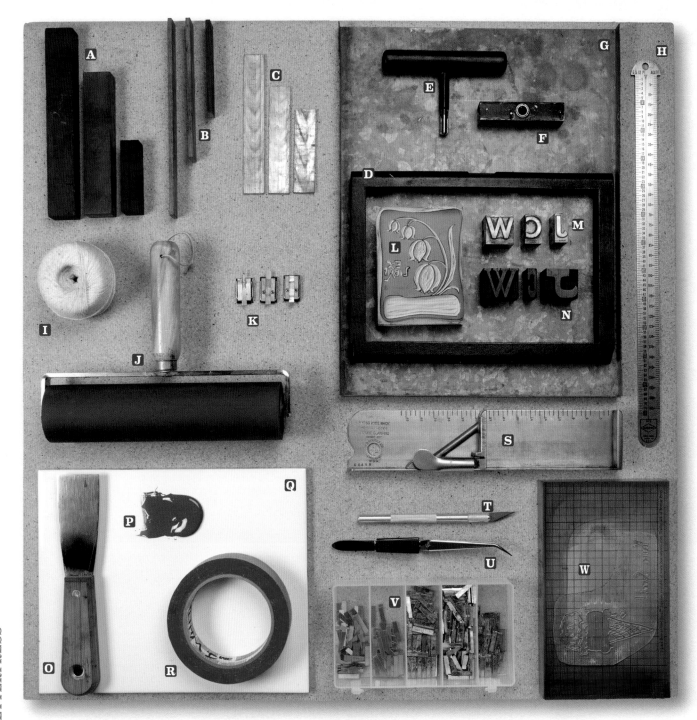

A Furniture

B Reglet

C Leading

D Chase

E Quoin key

F Quoin

G Galley

H Line Gauge

I Form String

J Brayer

K Guage pins

L Linoleum Block

M Metal type

N Wood type

O Palette knife

P Ink

Q Inking plate

R Painter's tape

S Composing stick

T Craft knife

U Tweezers

V Spacers

W Photopolymer plate on a base

Imposing stone A sturdy, smooth surface on which to lock up and plane a form, traditionally made from marble or steel.

Inking plate/inking table A smooth surface on which to work, or warm up, ink before applying it to the press. A piece of glass, firm plastic, or tile works well as an inking plate.

Leads or leading Pronounced "ledding." Strips of metal in varying thicknesses and lengths used as spacing between lines of text when setting metal type.

Line gauge A ruler with measurements in points and picas, the standard units of measurement in letterpress printing. Twelve points equal one pica, and six picas equal approximately 1 inch (2.54 cm).

Packing paper A selection of papers in varying thicknesses that are added to the platen to adjust the amount of impression made during a print run.

Painter's tape Like masking tape but not as sticky. Painter's tape can easily be removed without leaving a gooey residue or tearing paper.

Palette knife A tool used to work ink and apply it to the press.

Photopolymer plate A light-sensitive plastic plate that's used with a base for printing custom designs (I think it's best for images and other digital designs). A steel-backed plate requires a magnetic base, while an unbacked plate is attached to an aluminum base with film adhesive. Premade, press-ready plates can be ordered from a plate-making service (see page 172).

Plane A small block of wood that's used to make sure pieces of type are positioned properly and sitting squarely on their feet.

Quoin Pronounced "coin." A device used to lock a form tightly in place. A quoin can be made to expand or contract by means of a tool called a quoin key.

Red pressboard A dense paper board that's used for hard packing. Red pressboard is usually placed over all the other packing materials, underneath the tympan.

Reglet Used to fill in small spaces around a form. A reglet is similar to a piece of furniture but thinner—generally one pica or six points (½ pica).

Rollers The parts of a printing press that distribute ink evenly and lay a smooth and consistent layer of ink on the form that's being printed. Along with the form rollers that ink the form, cylinder presses also have metal rollers that include the ink reservoir drum, oscillating roller (also called a vibrator roller), and rider rollers. Platen presses typically only have form rollers, but some also have metal rollers that help to evenly distribute or hold ink. Form rollers are usually made from one of these three materials: composite (a mixture of animal-hide glue, syrup, and glycerin), urethane, or rubber. See page 24 for more information on rollers.

Roller-setting gauge Used to determine the height of the rollers from the press bed.

Slug A piece of leading that is six points or thicker.

Spaces Small pieces of metal added while setting type to create space between words, to add white space to the end of a line of text, or to tighten up a line of text.

3-IN-ONE oil A multipurpose oil for lubricating the moving parts of a press. It can be used to clean a press and serves as a safeguard against rust.

Tweezers Very handy for changing out letters while setting type.

Tympan paper Stiff, oiled paper that comes in precise thicknesses and is used as a top sheet over packing paper. Hard tympan paper protects type from wearing down and gives crisp, sharp impressions.

Type The letters used in letterpress printing. Cast in metal or cut from wood, the letters are all manufactured at standard type height—0.918 inch (23.3 mm).

Type case A storage case that's divided into compartments to keep pieces of type organized. A single case holds one font of type. A set of cases is stored in a type cabinet.

Type-high gauge A tool for measuring the height of printing blocks. The gauge can be used to determine whether or not a block is at type height.

CHOOSING INK AND PAPER

When you hold a letterpress print in your hands for the first time, two things are sure to stand out: the lovely texture of the paper and the luscious impression of the ink. Paper and ink are just two small parts of the printing process, but outside of the print shop they're the storytellers of letterpress printing. Here's a little information about each to help you make the right choices when it's time to print.

Ink Types

Printing ink is made up of three main components: pigments, additives, and a vehicle (also called a binder). Pigment gives ink its color. Additives give it unique characteristics, like viscosity (how well an ink flows) and tack (how sticky an ink is). These characteristics differ from ink to ink and depend upon the manufacturer. The vehicle holds everything together. An ink is typically described by its vehicle. For example, "oil-based ink" has pigments and additives that are held together with a vehicle primarily made from oil. Printing inks—letterpress inks included—are typically oil-, rubber-, or acrylic-based.

Oil-based ink has a long history. It has been around for as long as letterpress printing itself. It dries primarily by oxidation—meaning that it dries when exposed to air—which makes it a good ink to use on all types of paper, including coated papers or plastics that don't absorb ink. However, oil-based ink will "skin" (form a thin dry layer across the top) in the container as its surface slowly dries. The skin should be carefully pushed aside or discarded to keep lumps of dried ink off the press. You can avoid skinning altogether through the use of a paper covering that will prevent air from reaching the surface of the ink. Be extra careful not to leave oil-based ink sitting on the press or rollers, where it can dry. It will leave a hard layer that's difficult to clean off! Today most oil-based inks are made with a blend of vegetable oil (like linseed or soy) and petroleum oil, and they dry with a slightly glossy finish.

Some stores now carry soy ink, which is an oil-based ink with a higher percentage of oil made from soybeans. There are claims—as yet unproven—that soy ink is more environmentally friendly than other types of ink. Soy-based ink tends to be runnier than other oil-based kinds. It also requires modifiers (additives that a printer must mix in) to print well.

I prefer rubber-based ink for general letterpress printing. It dries primarily through absorption, so I recommend that you only use it on uncoated papers that absorb ink. Rubber-based ink dries slowly, so it doesn't skin. However, large printed areas will take extra time to dry. You can take your time with a project if you use rubber-based ink. You can even leave it on the press overnight if you're completing a large run. Rubber-based ink will slowly dry in the can, becoming stiff and eventually turning into a solid block. Some printers claim this happens in just a few years, but others say they're still using cans of rubber-based ink they've had for more than a decade. Because it's well suited for general use and doesn't dry on the press, rubber-based ink is a popular choice for schools and community print shops. Unlike oil-based ink, it dries with a matte finish.

Acrylic ink is less commonly used for letterpress printing, but is available through most ink suppliers. This type of ink dries through both absorption and oxidation. It dries much more quickly than oil- or rubber-based ink, making it a good choice for almost all types of paper. It also dries with a slightly glossy finish. It doesn't skin like oil-based ink, but it dries faster in the can than rubber-based ink. It will stiffen and become a hard, solid block within two years. Because of these qualities, it's best to buy acrylic ink in small amounts and use it quickly.

Mixing Ink

Letterpress printing creates layers of thin ink on paper, so you'll get the best results by printing on white or light-colored paper. The color of the paper affects how the ink looks. Because the layer of ink is so thin, you're actually going to see the color of the paper through the ink. That said, a rich black ink will show up beautifully on bright magenta paper. You should play around with colors of paper and inks to find a combination that suits you.

Before mixing inks, I recommend that you get a Pantone Formula Guide **A**. This recipe book for mixing inks will help you achieve the colors that you're looking for. Mixing inks isn't like mixing paint, so even if you're an experienced painter, having a formula guide will help you avoid many hours of frustration.

First flip through the colors and find the one that speaks to you. Next to the color, you'll see two recipes for creating the color with standard ink colors; one describes the amount in parts and the other in percentages. Use the one that makes the most sense to you **B**.

If the color you want to mix has a lot of transparent or black ink in it, I suggest starting with what I call the base color—the color that comes from just the colored inks without added transparent or black ink **C**. Once you have the base color mixed correctly, adjust it. If you want it to be darker, add small amounts of black and test it each time before adding more black. If you want it to be lighter or more transparent, scoop the necessary amount of transparent ink onto the inking plate, then add the base color to it in small amounts. Never add transparency to the base color—you might go through your entire can of transparent ink before you get to the color you want!

To test your mixing skills and make sure that you have the right color before inking up the press, do the "tap-out" test. Using your palette knife, drizzle a tiny amount of ink onto a piece of scrap paper **D**. With a clean fingertip, tap it out, smearing all of the ink into a circular spot on the paper. The color that will print is the not the darkest shade or the lightest, but the shade in the middle. Make adjustments and tap out each time until you reach the right color **E**.

You might have leftover ink that you want to keep and use for your next printing session. Luckily, any ink you've mixed can be stored for future projects. If it's going to be used again in the next couple of days, simply scoop it up into a nice pile on the inking plate and place a small plastic cup over it upside down to protect it from dust. If you want to store it for the long term, a good option is to put it in a lidded plastic cup, or scoop it up onto a piece of tinfoil. Fold the foil neatly into a little package, making sure that no air can reach the ink. Label the package with your tap-out test so that it's easy to see what color is stored inside **F**. It might be tempting to put leftover ink back into the can it came from. However, I do not recommend it. A tiny bit of the wrong ink can contaminate what's already in the can, rendering it useless for precise mixing down the road.

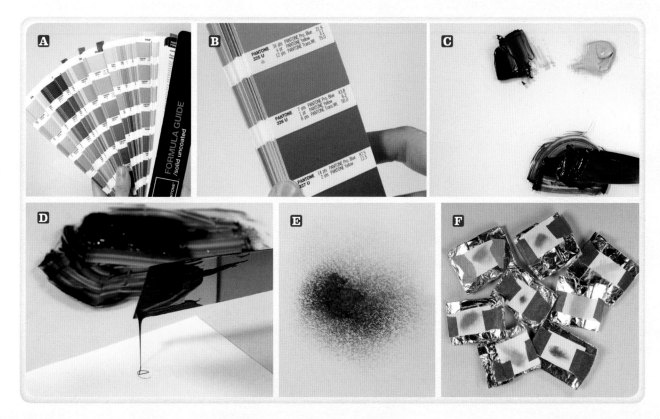

Paper

Paper comes in such a wide variety of weights, materials, and colors that choosing the right kind can be a dizzying task. The type of paper you should use depends on what you're printing and the results you're looking for. If you're printing an invitation and want a deep impression, then you'll need a soft, thick paper that will show heavy debossing. If you want to print pages for a chapbook, then go with a thinner, text-weight paper. Print on it with a light "kiss impression," with little or no debossing, for the best readability.

Paper weights can be confusing because there are two different ways to express this measurement. In the United States, the measurement is often called the basis weight and is measured in pounds. The basis weight of paper is the fixed weight of one ream, or 500 sheets, in that particular paper's basic "uncut" sheet size. However, the "basic sheet size" is not the same for all papers, and sometimes the size is assumed or inferred based on trade practices. In countries that use the metric system, the weight of paper is expressed in terms of grams per square meter (gsm), which is commonly called grammage. This measurement eliminates the need for guessing the sizes of uncut sheets of paper. Please note that these measurements refer only to the weight of paper and not the thickness, or caliper.

Heavier papers tend to be thicker than lighter papers. You should use a micrometer to measure the caliper of a paper if you need an accurate measure of thickness.

Handmade paper is in a class by itself. I love its tactile qualities and use it as much as possible in my projects. When choosing a handmade paper, go with a kind that doesn't have hard inclusions like pieces of plant material, seeds, or plastic bits that could damage your type. I like the light, translucent nature of Japanese paper, which is often referred to as washi. This paper is typically made from one of three types of plant fibers: gampi, mitsumata, or kozo (paper mulberry). Because of their strong, long fibers, these papers can be made very thin and yet very strong. Japanese paper is often erroneously called rice paper, but make no mistake—it's not made from rice.

Choosing the right paper for your project can make all the difference. Take time to consider your paper options. Your selection will affect many of the choices you make down the road, like the amount of packing you'll need, what to use for proofing, and whether or not to dampen. My paper suggestions are listed at right from lightest to heaviest—but I recommend experimenting with many different kinds to find the ones that work for you. Some of my favorite papers and suppliers are also listed.

This little chapbook is printed from handset Gill Sans, on Rives Lightweight paper.

This is copy / of 15 .

Type of Paper	Approx. Weight	Best Uses	Dampen*	Makers/Brands
Japanese paper	A variety of weights, including papers thinner than text or book weight.	Pressure printing, decorative book papers	No	Kitakata Moriki Okawara Sekishu
Text weight or book weight	20–80 lb. 75–125 gsm	Pressure printing, text blocks (pages within a book), stationery	No	French Paper Co. Canson Johannot Mohawk Superfine Rives Lightweight Zerkall Book
Cover weight or cardstock	80–220 lb. 130–600 gsm	Postcards, invitations, greeting cards, paper toys, posters, business cards	Yes or no	Arch ReRag Crane's Lettra French Paper Co. Mohawk Fine Papers Inc. Neenah Paper Inc.
Fine art papers	90–120 lb. 250–320 gsm	Broadsides, invitations, business cards, paper toys	Yes	Arturo Fine Stationery Arches Rives BFK Stonehenge Somerset Velvet Magnani Revere
Handmade papers	A variety of weights are available, depending on the papermaker.	Broadsides, invitations, greeting cards, business cards, stationery, text blocks	Yes or no	Twinrocker Handmade Paper Carriage House Paper Cave Paper Your local papermaker

* I mention dampening paper here only as an option. The "yes" or "no" listed is a suggestion, not a requirement for printing on any of these papers.

GETTING STARTED
CHOOSING INK AND PAPER

Dampening Paper

Printing on dampened paper results in a richer, more vivid transfer of ink. It also produces a deeper impression in the paper without causing damage to metal type, which quickly wears down with constant, heavy pressure on dry paper. If you want to get a deep impression without going to the trouble of dampening the paper first, I recommend printing from photopolymer plates instead.

TOOLS AND MATERIALS ★ TRAY OR TUB OF WATER ★ CLEAN, DRY TOWEL ★ PLASTIC BAG WITH SEAL ★ ROLLING PIN (OPTIONAL) ★ BOARD AND WEIGHT
Note: All items above should be slightly larger than your paper.

➜ **STEP 1** Place half *plus one* of your papers into the tray of water one at a time, making sure that each one is submerged and there are no trapped air bubbles. For example, if you have 40 sheets of paper, place 21 sheets in the water.

➜ **STEP 2** Let the papers soak for at least 30 minutes.

➜ **STEP 3** Open the towel and place it on a table in front of you. Lay the plastic bag flat on the table to the side of the towel, and place the stack of dry paper nearby.

➜ **STEP 4** Pull one sheet of paper from the tray of water, let the excess water run off of one corner, and place the sheet on the towel. Fold the towel over and pat it gently with your hands, or roll over it with the rolling pin.

➜ **STEP 5** Remove the damp sheet from the towel and place it on the plastic bag.

➜ **STEP 6** Place a dry sheet of paper directly on top of the damp sheet.

➜ **STEP 7** Repeat steps 4 through 6, making a stack of alternating wet and dry sheets of paper. When you finish making the stack, the bottom and the top sheets should be dampened papers pulled from the tray of water.

➜ **STEP 8** Pick up the stack and place it inside the plastic bag. Fold the bag over or seal the open end of it, making sure that no air can reach the papers inside.

➜ **STEP 9** Place a board and a light weight (a big book, for example) on top of the stack, and let it sit overnight. The next day, your papers should be uniformly and evenly damp—just right for printing.

➜ **STEP 10** Papers printed damp have a tendency to curl or cockle when they air-dry. If this happens to your prints, wait until the ink has dried, spritz the back of each sheet lightly, and stack them alternately with blotter paper or newsprint. Place them under weights and let them dry for 24 to 48 hours.

PREPARING THE PRESS

Before you print, spend some time preparing your press to make sure it's set the way you want it. You can't make a good print without a good set of rollers! Familiarize yourself with the rollers on your press, or read on for advice on the best kind to buy. There are other pieces to the puzzle, too. Replacing and changing the amount of packing on your press can completely alter the outcome of your prints. Knowing how to place a set of gauge pins can simplify the printing process, and using make-ready (see page 30) will help with small adjustments when you print from vintage type. This may seem like a lot of information, but understanding it will make you a fine printer in no time.

Rollers

On cylinder presses, rollers include metal rollers and form rollers. The large metal roller sitting below the press bed, underneath the carriage, is called the ink reservoir drum. This roller holds extra ink and is run by the motor on a motorized press. On the carriage, a large metal roller called the oscillator or vibrator roller travels from side to side, keeping the ink smooth and evenly distributed. One or two small metal rollers next to the oscillator roller are

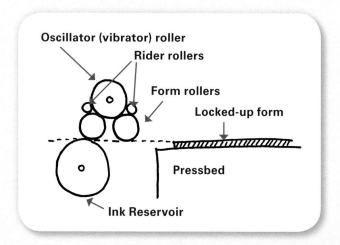

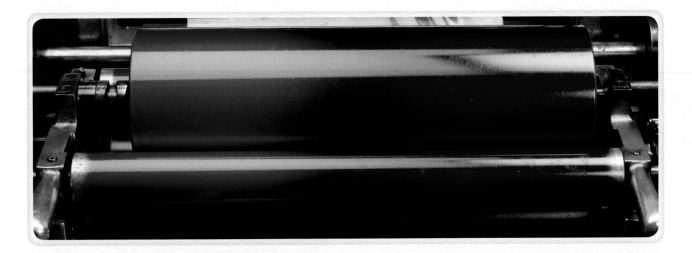

called rider rollers. The rider rollers also help to distribute ink, and the front rider roller is where you add ink to the press. The rollers underneath these metal rollers come in contact with the printing form and are called the form rollers. Platen presses typically only have form rollers, but some also have a metal rider roller that helps to evenly distribute ink.

Form rollers are the rollers that come in contact with the printing form. These rollers come in a variety of sizes and materials, but they all serve two primary purposes: to distribute ink evenly and to lay a smooth and consistent layer of ink on the form that's being printed. Form rollers can be made from a few different materials:

Composite, or composition This material is composed of animal-hide glue (its principal ingredient), syrup, and glycerin. The syrup gives it a tackiness—an ability to hold ink—and the glycerin helps prevent the rollers from drying out and hardening. Other oils or waxes may be added to the mix, depending on the maker. Composite rollers are the best kind in terms of inking qualities, but they swell and shrink depending on temperature and humidity, are tasty to rodents, and are easily damaged by water or high heat.

Urethane This material is typically dark green and made from a chemical compound that has a bad reputation. This compound can "melt" unexpectedly, leaving a sticky, gooey mess that's difficult to clean up. Newer polyurethane rollers are not supposed to have this problem, but if you buy a press that has urethane rollers, the advice you'll receive from most printers is to get rid of them immediately!

Rubber This is the most commonly used material. Compared to composition rollers, rubber rollers are more durable and will usually last longer. They're not as susceptible to changes in heat and humidity or as easily damaged. However, rubber rollers are considered inferior to composition rollers when it comes to inking qualities. They also tend to cost more. Over time, a rubber roller will become "glazed," developing a hard sheen on its surface due to the oxidation of the rubber and the buildup of ink. A glazed roller doesn't hold ink as well, and this can affect the quality of a print. To deglaze your rollers, clean them occasionally with a roller conditioner like Putz Pomade.

Regardless of what your form rollers are made of, they should be kept clean and away from direct sunlight. Rollers should also be raised off of any surface when stored. They should never be stored lying down. Improper storage will leave a permanent flat area on a roller. On cylinder presses, rollers should be stored up and not resting on other rollers. On platen presses, they should be stored all the way down at the bottom of the rails, below the press bed. Another option is removing them from the platen press altogether and storing them with the cores resting on supports.

Form rollers should be replaced when their ends are noticeably flared. Cuts and blemishes in rollers will also negatively affect print quality. When they wear out, rollers can be sent to a roller manufacturer. The manufacturer will remove the old roller material and re-cover the core—the metal rod that runs through the center of the roller—with the material of your choice.

The Roller-Setting Gauge

You may need to adjust the height of your rollers. To determine how much you need to raise or lower them (or if you should adjust them at all), use a roller-setting gauge. This tool is a small metal cylinder that's attached to a long metal rod or handle 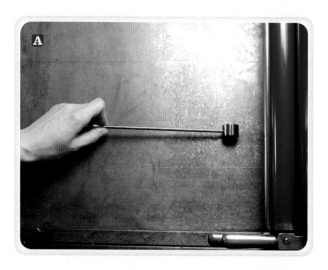. The cylinder has a diameter of 0.918 inch (23.3 mm, or type height) and stands in for the type-high form you want to print.

Here's how to use the roller-setting gauge:

→ **STEP 1** Bring the rollers over the press bed where you'll be printing the form.

→ **STEP 2** Place the gauge flat against the press bed and slide it past one roller.

→ **STEP 3** Flip the gauge on its side and pull it toward you, so that one side of the cylinder rests against the press bed and the other side of the cylinder brushes up against the roller. If you're on a cylinder press, make sure the rollers are down in the printing position when you do this.

→ **STEP 4** The roller should leave a stripe of ink on the gauge where it made contact. The stripe should ideally be $3/32$ inch (2.4 mm) wide—slightly wider than the thickness of a nickel (which I affectionately call the "fat nickel").

→ **STEP 5** A stripe that's thicker than $3/32$ inch (2.4 mm) means you need to raise the rollers to reduce the contact between them and the form. A stripe that's thinner means you need to lower the rollers to increase the contact.

→ **STEP 6** Check both sides and the center of each roller. Adjust them so that they are level to the press bed.

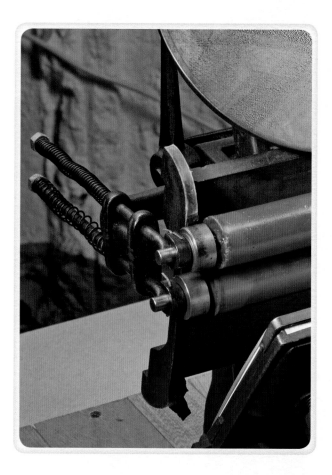

How to Adjust Rollers on a Platen Press

There are two ways to adjust rollers on a platen press: you can change the diameter of the trucks or you can raise or lower the rails that they ride on. The trucks are the cylindrical "wheels" that slide over the roller core on either end and carry the rollers up and down on the rails. They should be the same diameter as the rollers themselves, although some printers prefer rollers that are slightly larger. Get the set of trucks that works best with your rollers, or keep a few sets of trucks with different diameters if you want to change them on a regular basis. Another option is to get expandable trucks that can be adjusted to your needs.

The rails that the trucks ride on wear down over time. To offset the wear, apply strips of rail tape (masking tape and electrical tape can also be used) to the rails until you've built them back up to the right height. Make sure the rails are clean and smooth before taping them.

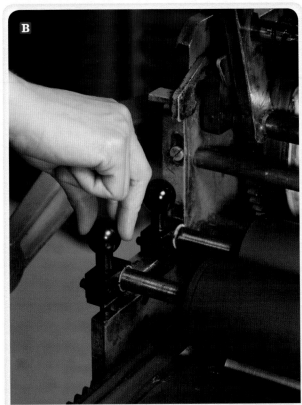

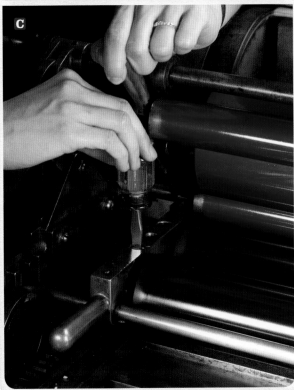

How to Adjust Rollers on a Cylinder Proof Press

Most cylinder presses have a roller assembly made up of an ink reservoir drum, distribution rollers, and form rollers. The ink reservoir drum is a large metal roller that sits below the press bed, is run by a motor, and holds a supply of ink while you print. The distribution rollers are the metal rollers on top that distribute the ink evenly across all rollers. The form rollers are the rubber rollers in between that apply ink to the form; these are the rollers to adjust when you want the form to be properly inked.

The form rollers are supported at both ends by roller cradles. The cradles have screws that control the height of the rollers. Some presses have knobs that can be turned **B**. Others require a screwdriver **C**. These screws are usually held in place with set screws, which are screws that prevent the adjustment screw from loosening due to the vibrations of the press during printing. Depending on the press you have, use a hex key or a screwdriver to first loosen the set screw. Then adjust the rollers by turning the adjustment screw. Remember that you turn it *right* to *raise* the rollers and *left* to *lower* the rollers. It doesn't take much to move a roller. I like to envision a clock face in which I'm turning the screw in 10-minute increments. Keep checking the roller height with the roller-height gauge as you make adjustments. When you find the "fat nickel," tighten up the set screws, and you're ready to print!

How to Adjust Rollers on a Tabletop Cylinder Proof Press

When working with a tabletop cylinder proof press, you'll be applying ink with a brayer, so no roller adjustments are needed. If you find that your form is over-inked, put less ink on the brayer, or apply the ink more gently. If you find that your form is under-inked, add more ink to the brayer, or give the form a few more applications of ink each time with the brayer. The power is all in your hands!

Packing

Packing is a stack of paper and card that's placed on the tympan or cylinder to create supportive padding behind the printing paper. Packing consists of tympan paper, pressboard (on a platen press), and an assortment of papers or Mylar that range in thicknesses. The tympan is an oil-treated paper made specifically to be used as the

uppermost sheet, although some printers prefer to use a sheet of Mylar because of its hard surface (and because it's easier to clean if it gets inked). On a platen press, a sheet of red pressboard is placed underneath the tympan. It has a dense, hard surface that helps produce a clean, crisp print without wearing down the edges of the type. Adjustments take place underneath the pressboard. You should use papers ranging from thin tracing paper to cardstock to find the right thickness for what you're printing. Avoid very soft, spongy paper. Soft packing will cause type to wear down faster. Use paper that will give you the same amount of support throughout the printing of an edition without squishing down as you print. That being said, the tympan and packing will eventually get worn and pockmarked with indentations from printing and should be replaced regularly.

The amount of packing you need will vary according to the size of the form you're printing and the thickness of your paper. In general, large forms require more packing, and small ones less to get a similar amount of impression. Likewise, thinner paper requires more packing, and thicker paper less.

How to Adjust Packing on a Platen Press

On a platen press, the paper and the form should meet parallel to each other. Packing on the platen brings the paper closer to the form, creating more pressure between the two. When adding packing on a platen press, keep in mind that because of the clamshell action of the press too much packing can cause the platen and form to meet unevenly, with more pressure at the bottom than at the top.

➔ **STEP 1** Lower the rollers all the way down. Move the grippers out to the sides and out of the way.

➔ **STEP 2** Cut a new sheet of tympan paper that's the same width as the platen and long enough to catch under both bales (about ½ inch [1.3 cm] on the bottom and at least ½ inch [1.3 cm] or more on top). Score about ½ inch (1.3 cm) in on one side, and fold the paper over. Clip off the corners to help the sheets lie flat.

➔ **STEP 3** Use a flathead screwdriver (or a bale wrench) to pry open the upper and lower tympan bales **A**. Be sure to keep your mind on what you're doing at this point! Tympan bales left on the platen can cause serious

damage if you or someone else walks up and starts operating the press.

➔ **STEP 4** Place the new sheet of tympan on the platen, slide the folded part over the bottom edge, and clamp down the lower bale.

➔ **STEP 5** Place a sheet of red pressboard that's trimmed just a bit smaller than the platen under the tympan. Place a few sheets of packing under the red pressboard. If you're just starting out and aren't sure about how much packing you'll need, start with three sheets of copy paper. Remember that it's always best to start with less and build up **B**.

➔ **STEP 6** Pull the tympan taut and clamp down the upper bale.

➔ **STEP 7** Trim or tear off any excess tympan paper that's extending out from underneath the bale.

➔ **STEP 8** To add or remove packing without changing the tympan, just lift the upper bale and lift the tympan without removing it. Add or remove sheets underneath the red pressboard, then pull the tympan taut and clamp it back down again.

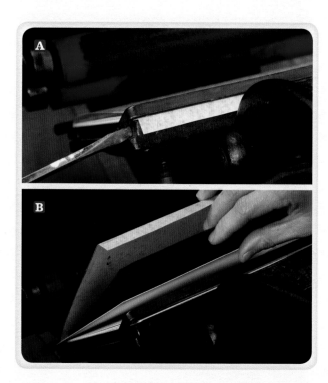

How to Adjust Packing on a
Cylinder Proof Press

The diameter of the cylinder on a cylinder press is smaller than what is necessary for the paper to make contact with the type, so the packing can be adjusted according to the needs of a particular project. On most cylinder presses, you'll find a number stamped into the cylinder on the operator's side of the press, near the cylinder bearing (the raised strips on either side of the cylinder that ride on the rails as you print). This number indicates, in inches, the thickness of the undercut—how much thickness is necessary to bring the paper up to meet a form that's exactly type high. On many presses, the measurement is $\frac{1}{32}$ inch (0.8 mm), but this can vary on different makes and models. You can use this number and a micrometer to measure the thicknesses of your packing and the paper you'll be printing on to get a precise match, but keep in mind that you'll need slightly more packing than a precise type-high match to get a good print or even a kiss impression.

➜ **STEP 1** Clean off the feed board. Move the paper guide all the way back and out of the way.

➜ **STEP 2** Cut the drawsheet—the uppermost sheet that holds the packing in place—out of tympan paper or Mylar. If you have a drawsheet that was cut previously, use it as a template. If not, cut the drawsheet to the width of the cylinder surface, making sure that it's not so wide as to overlap the bearing surface on each side of the cylinder. It should be long enough to be held by the gripper bar on one end and wrap around the reel rod on the other end.

➜ **STEP 3** Score and fold the side of the drawsheet that will be held by the gripper bar, and clip the corners on the other end.

➜ **STEP 4** Place the sheet on the feed board and the cylinder, tuck the folded side under the gripper bar, and clamp it in place.

➜ **STEP 5** Place a few sheets of packing under the drawsheet (remember that it's always best to start with less and build up), sliding it up against the clamped edge. Make sure that all of the sheets are sitting squarely on top of each other, and that none of them are longer than the diameter of the cylinder or overlap the carriage bearings.

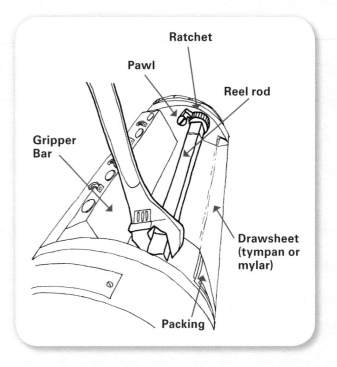

Ratchet

Pawl

Reel rod

Gripper Bar

Drawsheet (tympan or mylar)

Packing

➜ **STEP 6** Hold the packing taut with your left hand against the carriage and walk the carriage halfway down the press bed until the reel rod is exposed.

➜ **STEP 7** Depending on the type of reel rod that's on your press, do one of the following:

a. Clamp the drawsheet in place using the clamp bar (you may need to punch corresponding holes first).

b. Tuck the end of the drawsheet into the slot on the reel rod.

c. Use a piece of masking tape to adhere the drawsheet to the reel rod.

➜ **STEP 8** Turn the rod by hand, making sure the pawl—the little arm that hooks onto the ratchet and prevents the rod from turning the wrong way—is engaged. Tighten the rod with an adjustable wrench or by inserting a lever into the hole of the rod.

➜ **STEP 9** Check for tightness by tapping on the drawsheet next to the rod—it should sound crisp, like a drum. Also, check to make sure the drawsheet is lying flat against the cylinder where it meets the grippers.

→ **STEP 10** To adjust the packing without changing the drawsheet, start by releasing the drawsheet. Using an adjustable wrench or a lever inserted into the hole of the rod, tighten the rod ever so slightly so that you can release the pawl.

→ **STEP 11** Unwrap the drawsheet from the rod and walk the carriage back to the feed board, pulling the drawsheet and packing up so that they lie flat on the feed board.

→ **STEP 12** Add or remove packing as needed, then follow steps 5 through 8 to finish up.

How to Adjust Packing on a Tabletop Cylinder Proof Press

The tabletop cylinder proof press is a simple, easy-to-use machine. Both the ink and the packing are applied by hand. To add packing when printing, simply place sheets of paper or card on top of the printing paper before rolling the roller over the form. Make adjustments by adding or removing sheets. Use proof prints to determine the amount of packing that's needed.

Make-ready

In its broadest sense, make-ready includes everything necessary to prepare a form for printing—literally to "make it ready." More specifically though, make-ready refers to the addition of paper to the form or to the tympan to adjust the pressure of how the inked form meets the paper to get a good print. There are two main ways of adding make-ready: the underlay and the overlay.

An underlay consists of pieces of paper that are placed under the form to bring low areas up to type height. Pieces of type can be lower than type height if they're old and worn down. Sections of plates and parts of wood or linoleum cuts can be lower than type height if the support they're on isn't perfectly even. An underlay should be made with thin paper. If you're proofing on thin paper, you can use the proof itself. Tear off the area that's printing faint (tear, don't cut, so that there's a soft edge), and place it under the form before locking it up again. If you're printing on a platen press, use a glue stick to stick it to the back of the form. You may need to build up a few layers on different parts of the form before it's ready to print.

Before adding an underlay, make sure that the form (or the part that's printing faint) is actually lower than type height; otherwise, you might damage the rollers. Check by looking at the inked form to see whether that area isn't getting inked as much as the rest of the form, or use a type-high gauge to measure the height.

An overlay is made up of pieces of paper that are placed on the tympan, or under the tympan, to lift the paper up to meet the form. Bits of paper torn to the right size and shape can be glued or taped on top of the tympan to correct the problem spot, but make sure that any tape is out of the way of the printing area. On a platen press, tape can be tucked under the tympan so it won't interfere with feeding. Be sure to remove any overlays when you're finished printing to avoid damaging type on the next print run.

Gauge Pins

Gauge pins hold the paper in place on the tympan while you're printing on a platen press. Different types are available. You can buy the metal kind or make your own from cardstock. If you're printing from a large form on a tabletop proof press and aren't concerned about careful registration, simply wedge two spacers against the bottom of the platen using the bottom tympan bale **A**. Place a sheet of proof paper on the spacers and mark the left edge of the sheet on the tympan **B**. Place your paper against this mark when printing. With this method, side-to-side adjustments are easy to make, but you can only move the print up or down by moving the form itself in the chase.

When printing a smaller form on a platen press, or when printing on a larger press, I often use Megill's Patent Spring Tongue Gauge Pins or Kort Adjustable Quad Guides (my favorite). To place a Kort guide, first draw lines on the tympan designating where the edges of the paper will sit; draw two lines for the bottom edge and one for the left edge. Cut a slit in the tympan that's about 1/8 inch (3 mm) behind this line and slightly wider than the guide. Lift the arms on either side of the guide, then slide the front of the guide into the cut, past the drawn line, pushing it up as far as it will go **C**. (The tympan should be between the bottom two plates of the guide.) Cut another slit in the tympan just behind the guide, then slide the back of the

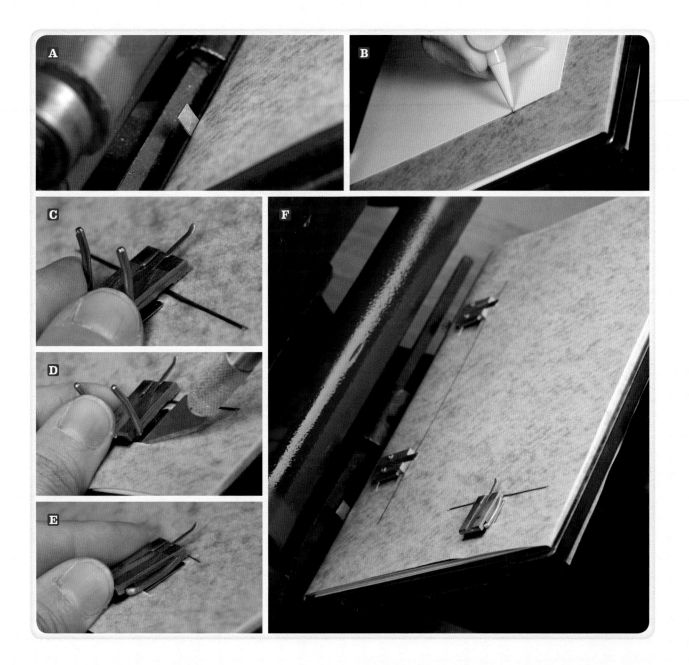

guide into that cut **D**. Place the front edge of the guide against the drawn line and press the arms down, locking it in place **E**. To make slight adjustments, lift the arms and slide the guides around, then lock it in place again.

Other options include gluing homemade guides directly on the tympan. You can use spacers, cardstock, or even photo corners as guides. If you make your own from board or cardstock, cut them into small rectangles and glue a small piece of paper or mylar on top to act as the tongue. *Note:* For good registration, there should always be two gauge pins along the bottom and one on the upper left side of the paper **F**.

SETTING METAL TYPE

As the name suggests, letterpress printing is a form of relief printmaking that's specific to printing letters, which are also known as type. The process developed over hundreds of years in different parts of the world for the purposes of sharing knowledge, spreading literacy, and providing entertainment. Because the equipment we use today developed from a need to print text, I think it's important to know how to print from type. It's a good way to get a true understanding of how the machinery works.

Tool Kit for Setting Type

★ COMPOSING STICK ★

★ LEADING ★

★ SPACING MATERIAL ★

★ GALLEY ★

★ IMPOSING STONE ★

★ CHASE ★

★ CHASE SCREWS OR QUOINS ★

★ TWEEZERS ★

★ FORM STRING ★

★ PLANER ★

★ CASE LAYOUT CHART (OPTIONAL) ★

★ LINE GAUGE ★

Parts of Type

Pick up a piece of metal type and take a look at it (use a piece that's large enough to make viewing easy). The parts of the type are named as follows:

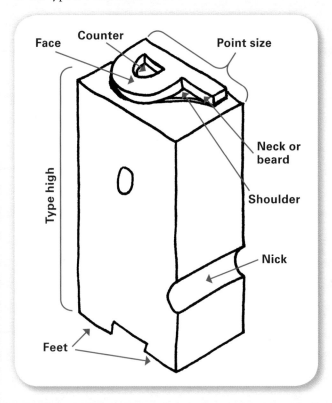

Measurement

In letterpress printing, measurements are made in picas and points. The size of type is measured in points, and the sizes you've seen when typing on the computer correlate with sizes in metal type for letterpress printing.

This is an example of 8-point type.

This is an example of 10-point type.

This is an example of 12-point type.

This is an example of 14-point type.

And so on, up to about 72-point type. Most type that's larger than 72 point is cut from wood (big metal type gets heavy and expensive!).

Twelve points are equivalent to one pica, and six picas add up to almost 1 inch (23.3 mm). In digital design, it's often assumed that six picas equal 1 inch (six picas are actually just a hair short of 1 inch).

Spacing Material

Spaces are pieces of type metal used to create white spaces between words. They're shorter than type, so they don't print when set along with letters. The thickness of a space is based on the em quad, which is based on the typical size and shape of the letter "m." Em quads are the same point size on all four sides, forming a perfect square. Spaces larger than the em quad include the 2-em quad, which is twice the width of the em quad, and the 3-em quad, which is three times the width of the em quad. The space that's one size smaller than the em quad is the en quad, which is half the size of an em quad, based on the typical size and shape of the letter "n."

Following the en quad, there is a series of spaces that get continuously smaller, all based on the em quad: the 3-to-the-em space (one-third the width of one em quad, also called the 3-em space), the 4-to-the-em space (one-fourth the width of one em quad, also called the 4-em space), and the 5-to-the-em space (one-fifth the width of one em quad, also called the 5-em space). After the 5-em space, there are even thinner spaces called hair spaces or thins. Thins include strips of brass and copper (the thinnest), which are simply called brasses and coppers.

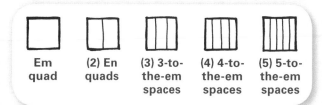

| Em quad | (2) En quads | (3) 3-to-the-em spaces | (4) 4-to-the-em spaces | (5) 5-to-the-em spaces |

While spacing separates words, each line of text is separated by a strip of metal called leading (pronounced "ledding"). Leading is also shorter than the type; just like em quads, leading won't print. Leading is most commonly available at a 2-point thickness but can also be found at 1-point, 3-point, and 4-point thicknesses. Leading that's 6 points or thicker is called a slug.

The Type Case

The type case is a wooden tray divided into compartments that keep type organized. Each case contains one font of a typeface, meaning one size and style of a particular type design. For example, if the typeface is Gill Sans, a type case might hold a font such as Gill Sans 14 pt. Bold. Although they come in a variety of layouts, the California Job Case is one of the most common.

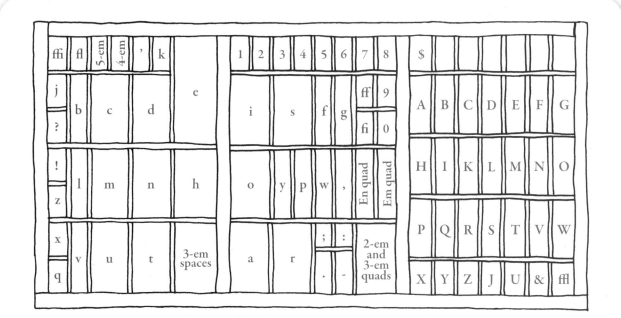

LAYOUT OF THE CALIFORNIA JOB CASE

How to Set Type in a Composing Stick

When you set type, the first thing you need to determine is line length. Line length is based on the length of the longest line you'll set or the size of your page. You don't want to set and print a line that's longer than the width of your paper! There are no hard and fast rules about determining line length; sometimes it just takes trial and error to determine the best line length for your project.

To start, select the type you want to use, find the longest line of your text, and set it on a composing stick to determine its length. A composing stick is a handheld tool that's used for setting metal type. If the line is too long or too short, you may have to change your typeface or type size and set the line again. Once you've determined the best line length for your project, proceed as follows.

→ **STEP 1** Set the composing stick to that length. On the composing stick, lift the clamp to release the knee (the adjustable arm), slide it along the stick to the correct measurement, fit the small row of projections into the corresponding slots, and clamp the knee down into place **A**.

→ **STEP 2** Insert a slug of the same line length in the stick. Always start and end with a slug instead of thinner leading, because a slug's sturdiness will help hold the text block together when you move it from the stick. Place an em quad at both ends of the stick. I always start and end each line with em quads because they don't fall over like smaller spacers do when I'm moving a block of text around **B**.

→ **STEP 3** Hold the composing stick in your left hand as shown in the photo. Set pieces of type one at a time from left to right, upside down, with the face of the type facing out. The nick should show across the top; use your left thumb to feel for the nick and to help slide each piece of type into place.

→ **STEP 4** Use spacing material between each word. I prefer 3-to-the-em or 4-to-the-em.

→ **STEP 5** When you're finished setting the line, use spacing to fill out the rest of the line length. The line will print left justified. To center justify a line, use the same amount of spacing on either side of the line. To fully justify a line, add more spaces between words.

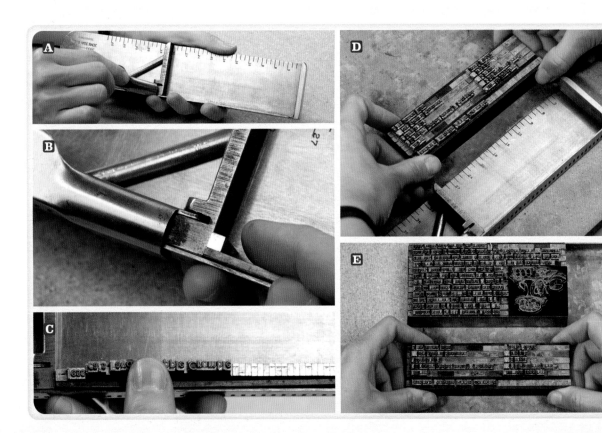

STEP 6 Once you've filled out the extra space and the line is snug, you need to tighten it so that each line locks up and prints correctly. Add as many thins as you can and do the thumb test: push up on the line of type with your thumb. The entire line should start to lift up as one unit. If individual letters lift up, then the line isn't tight enough. Keep adding thins until the line passes the thumb test **C**.

STEP 7 Add leading on top of the line you've just set and continue setting each line. Once you've filled the composing stick halfway up, place a slug on top of the last line and slide the entire block onto a galley. Support the block of type by pressing the top and the bottom with your index fingers and thumbs. Press on the sides with your middle fingers. Pinch the block tight and slide it. Do not lift it **D**!

STEP 8 Slide the block of text to a corner where the walls of the galley will offer some support. Keep the top of the text at the top of the galley and use pieces of furniture on the other two sides to keep the type from falling over. Continue setting type on the composing stick and adding it to the type on the galley that's already set until you've set the entire block of text **E**. Replace slugs with the proper amount of leading between lines, but leave a slug on the top and bottom of the form.

Proofing

Each line of type can be proofed as you set it by using a tabletop proofing press. Proofing each line makes it easier to make changes before completing an entire block of text. In addition to the press, you'll need a piece of carbon paper, a piece of scrap paper, and a strong magnet. Place your composing stick directly on the press bed. Use the magnet or some furniture to hold the type in place. Place the carbon paper on top of the type with the carbon side facing up. Place the scrap paper on top of the carbon paper and run the roller across the press. Voilà! You should have an instant image of how your line will look when printed. If you don't have carbon paper, this step can be done with printing ink and a brayer.

How to Tie Up the Form

After you finish setting the type, you'll want to secure your block of text before moving it to be stored or locked up for printing. To tie up the form, you'll wrap it with a piece of string that should be tied with a small twist. You are (quite literally) tying up the form.

STEP 1 Place the loose end of a piece of string on the upper left corner of the form, leaving about a 4-inch (10.2-cm) "tail."

STEP 2 Wrap the string around the form four times, pulling the string nice and tight as you go around. Try to keep each strand placed flat against the form, directly above the previous strand **F**.

STEP 3 Holding the wrapped string tight with one hand, lift the tail up with the other hand and place it over the four wrapped strands **G**.

STEP 4 Using a brass or piece of leading, tuck the tail under the four wrapped strands and pull out the tail from underneath **H**.

STEP 5 Trim off the excess string and give both ends a slight tug. You should now be able to easily move the form around without worrying about pied type. Remember to slide the form. Don't lift it!

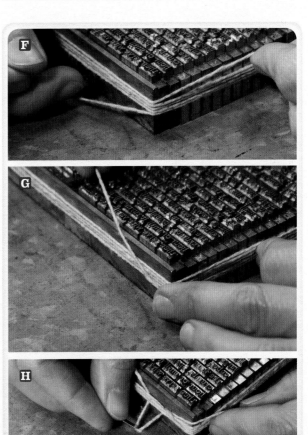

PRESS TROUBLESHOOTING AND ADJUSTMENTS

Ideally, your prints should be crisp and clear, with sharp edges and rich color. If you're having trouble getting a good print, use the chart below.

Issue	Possible Problem	Solution
Print is faint	Not enough ink.	Add ink.
	Not enough packing.	Add packing (see page 28).
	Rollers are too high.	Adjust rollers (see page 26).
Print is fuzzy, or the ink looks like it's bleeding	Too much ink.	Clean ink off the rollers and/or the ink disc, let the remaining ink distribute evenly again, then print.
	Too much packing, or packing is too soft.	Remove or replace packing (see page 28).
	Rollers are too low.	Adjust rollers (see page 26).
One side is printing darker than the other	Rollers are uneven.	Adjust rollers (see page 26).
	Packing is uneven.	Adjust packing (see page 28).
	Ink is not distributed evenly.	Add ink to the faint side, let ink distribute evenly, then print.
	Platen is not meeting the press bed evenly.	Remove some packing or adjust the screws on the back of the platen to level it.
Some letters or parts of letters are not printing	Type is worn.	Add make-ready (see page 30) or replace with good type.
	Type is broken.	Replace with good type.
	Type is not sitting squarely on its feet.	Clean the ink off the type, unlock the quoins, and plane the type. Lock up and print.
	Type is not locked up tightly.	Check for any movement in the form. Unlock and add spaces where necessary.
	Dirt or lint is on the type and/or rollers.	Clean the type with denatured alcohol and a clean rag. Clean rollers and re-ink if necessary.
	Press bed is not clean.	Clean ink off the type, unlock the quoins, and remove everything from the press bed. Wipe down the press bed with a clean rag, then reset and print.

Issue	Possible Problem	Solution
Spaces, furniture, or polymer plate base gets inked or prints	Form is lifted.	Unlock the quoins, let everything settle down, plane the type, then lock up again gently.
	Rollers are too low.	Adjust rollers (see page 26).
Ink/oil/dirt appears on margins or edges of paper	Ink/oil is on the press.	Check and clean places where the paper might hit the press.
	Ink/dirt is on your hands or fingers.	Go wash your hands!
Not printing straight	Gauge pins are uneven (on platen press).	Make sure they haven't moved and that the points are stuck down into the tympan.
	Paper guides are uneven (on flatbed cylinder press).	Make sure the paper guides on the gripper bar are even. Adjust forward and back by turning the round dials on the gripper bar.
	Paper is falling against the form before the cylinder reaches it (on flatbed cylinder press).	Especially small pieces of paper can flop down and print unevenly before the cylinder comes directly over the type. Place a small piece of tape at the end of each sheet of paper, taping it to the tympan as you feed it.
Print shifts	Adjustable lockup bar is not tight.	If your press has lockup pins, use furniture to prop the lockup bar against them. Otherwise, add bits of paper or cardstock to the sides of the lockup bar to tighten the grip.
	Polymer plate is losing stickiness.	Replace the adhesive on the back of the plate. Place a piece of blue painter's tape along the bottom edge of the plate so that you can periodically check it for shifting.
	Steel-backed polymer plate shifts on the magnetic base.	Add adhesive to the back of the plate. Place a piece of blue painter's tape along the bottom edge of the plate so that you can periodically check it for shifting.

CLEANING UP

For a print shop to run smoothly, the tools, the equipment, and the workspace must be kept clean and tidy. If I'm immersed in a large job that's going to take a few days, I might leave ink on the press during that time. Otherwise, I never leave my shop without first cleaning up. It's up to you to decide whether or not to sweep up and put papers in the recycling bin, but you'll definitely want to clean your press at the end of each workday.

Cleaning Tools and Materials

Apron For protecting your clothes and keeping them clean. I only use aprons with pockets so that my essential tools—a clean rag, a pencil, and a permanent marker—are always handy.

Gloves B Always protect your hands when using strong solvents! Make sure that you buy Nitrile gloves that are resistant to these chemicals. Regular dishwashing gloves are not resistant and will disintegrate in a short amount of time.

Oily waste safety container Cleanup after printing involves rags soaked with oily solvents such as mineral spirits. These rags (or anything soaked with solvents) are potentially combustible, and if you toss them in a trashcan you're taking the risk of seeing your studio or home go up in flames. So make sure you store oily rags in safe containers—metal bins or cans with metal lids.

Rags C Clean up using lint-free rags, not paper towels! You don't want to leave little bits of lint or paper behind when you clean. Old washcloths, T-shirts (new ones are linty), and shop rags are all good options for cleaning.

> ## Cleanup Tool Kit
> *(for every project)*
> ★ APRON ★
> ★ GLOVES ★
> ★ OILY WASTE SAFETY CONTAINER ★
> ★ RAGS ★
> ★ RAZOR SCRAPER ★
> ★ SOLVENTS ★

I always start cleaning with a half-dirty rag—one that's been used before but still has a few clean spots on it. Fold the rag up so that it fits nicely in your hand, with no loose edges or bits of thread hanging off the sides. As you clean, when one area of the rag gets too inky (when it's smearing down more ink than it's picking up), unfold it to access its other clean areas. You'll be surprised at how long you can make one rag last.

Once you've removed most of the ink with the half-dirty rag, pull out a nice new rag and do a final cleaning. It's easy to tell when you're done cleaning because you'll reach a point where your rag won't pick up any ink. At this point, find a dry area on the rag and wipe up any remaining solvent residue. Now you have a half-dirty rag ready for the next cleanup!

Razor scraper D This tool with a flat razor is used for scraping ink off the inking plate and ink disc during cleaning.

Solvents E Different people have different opinions about the best solvents to use for cleaning ink off a press and its rollers. Discussions often revolve around the toxicity levels of common solvents. Some printers use kerosene, while others prefer vegetable shortening. My method is simple: I use denatured alcohol to clean ink off type, and odorless mineral spirits to remove ink from everything else. This is what works best for me, but feel free to research and try other types of solvents.

When handling solvents, keep your health in mind. Work with them in a well-ventilated space and wear protective gloves (Nitrile gloves). In most cases, the solvents won't hurt you in small amounts; however prolonged exposure can result in irritation to the skin and the respiratory tract, as well as permanent damage to the brain and the nervous system!

Cleaning the Ink Plate

To clean the ink off the plate, scrape off any excess using a palette knife or glass razor scraper. Smear the ink onto a scrap of paper (I keep an old phonebook handy for this), fold up that paper, and throw it away. Clean off the ink plate, the scraper, and the palette knife with a rag and solvents. Follow up with a dry rag to get rid of any residue.

Cleaning the Press

Before I clean the press, I clean off the type so that I won't forget about it. I leave the type locked up for cleaning because loose type is harder to clean. If the type consists of just a few words set in metal, I'll wipe it off with a clean, dry rag. For a larger amount of type (and, thus, more ink), I'll use a clean rag with a few drops of denatured alcohol, which dries faster than mineral spirits and won't leave as much residue on the type. However, mineral spirits work just as well. If you use mineral spirits, let the type sit out for a while to dry before putting it back into the case.

To clean a platen press, start by cleaning all of the ink off the ink disc with a rag and mineral spirits **A**. If you're cleaning a large press, or if there's a lot of ink on the disc, first scrape off the excess ink with a razor scraper. For smaller presses, including tabletop models, remove the rollers, stand each one on end, and wipe it down with a rag and solvents **B**. For larger presses, you can clean the rollers in the same way or leave them on the press while you clean. Just roll them up toward the ink disc (after you've already cleaned the disc) and wipe them down with solvents as you slowly roll them up. Continue wiping as the rollers reach the top of the ink disc, and keep wiping as you bring them back down again. Give each roller a good finishing wipe when they roll down off the ink disc, and do the same for the ink disc when you've finished cleaning the rollers.

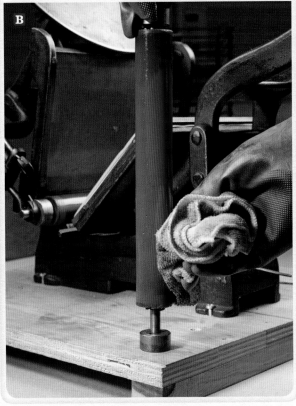

39

To clean a flatbed cylinder proof press, first turn on the motor and activate the rollers by lowering the roller trip lever. Drizzle some solvent on the rollers as they're running, letting the solvent coat each roller **A**. Raise or remove the metal rollers (depending on your press) and wipe each one down, then do the same on the rubber rollers below, adding solvent if necessary **B**. To clean the ink drum, move the carriage forward until it's halfway down the press bed. Turn the motor on and drizzle some solvent on the drum and on your cleaning rag **C**. Then,

with the motor running, press the rag against the right side of the drum and slowly slide it up along the length of the drum **D**. The spinning motion of the drum will help you clean it as it rotates. Find a clean area on your rag and repeat this back down along the length of the drum. Do the entire cleaning process first with a half-dirty rag, then wipe the rollers again for a final cleanup using solvents on a clean rag.

To clean a tabletop proof press…well, there's no ink on this press! No ink means no cleanup!

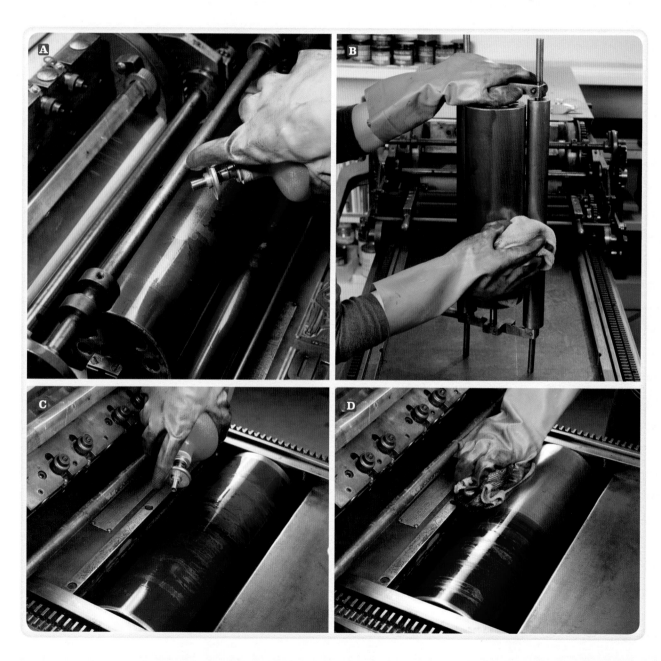

EVERYDAY MAINTENANCE

To keep your press running well for many years to come, you should oil and clean it regularly. Oil it daily, or at least each day that it's used. Wipe it down regularly to remove dust and dirt, and cover it when it's not in use. For maintaining specific types of presses, read on!

Maintenance of a Platen Press

Every moving part of a platen press should be oiled. Each moving part has an oil hole for this purpose. Diagrams that can help you locate the holes are available, but I recommend that you find them by simply watching the press while it runs. A few drops of machine oil (such as

3-IN-ONE oil) in each hole is usually enough—be sure to wipe up any spills or runs. Some holes can only be seen when the press is in a certain position, so move the press as you add oil (but don't do this while the press is running)! Sometimes the oil holes are filled with dirt, which prevents the oil from doing its job. Keep them clean with a small piece of wire or pipe cleaner. Use grease on gears where oil will drip off. Don't neglect the electric motor; add oil to the oil cup every four to six months. Before you leave the shop for the night, make sure the ink has been cleaned off and the rollers are all the way down on the rails or removed. You should also cover the press with a protective cloth or tarp.

Maintenance of a Cylinder Press

Before printing on a cylinder press, use a slightly oiled rag to wipe down the bearers on the bed, the cylinder, and the rails. Wipe down the press bed with a little WD-40 on a rag. Use petroleum jelly to lubricate the worm gear. Keep oil holes clean with a small piece of wire or pipe cleaner. Oil the gripper push rod and the form roller bearings regularly. You should consistently check for and clean off any buildup of grime, dirt, or rust. Before you leave the shop for the night, make sure the ink has been cleaned off and the rollers are lifted up and not resting on any surface or on other rollers. Remember to cover the press with a protective tarp.

What I've covered here are very basic guidelines regarding press care and upkeep. I recommend that you seek out more specific information for your particular press. Make use of online resources, books, and—most importantly—kindred printers. If your press starts to make strange clicking or grinding noises, if you think you need a new part, or if you just want to learn more about press maintenance, check out the Recommended Reading (page 171) and Resources (page 172) sections in this book. You'll find a wealth of information to guide you as you learn more about your press.

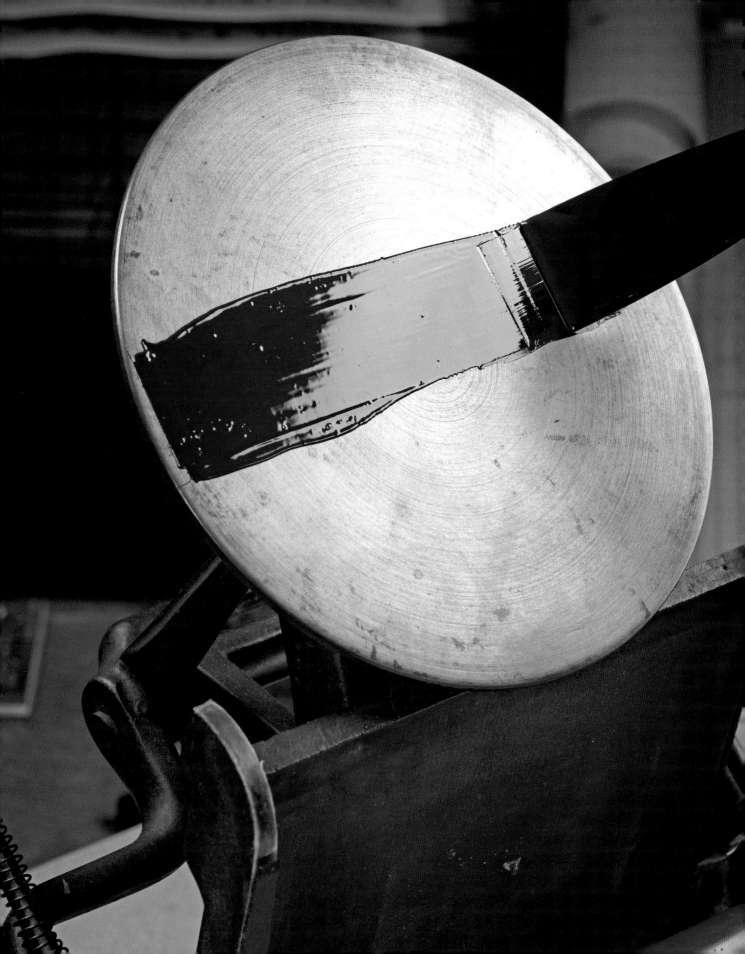

TABLETOP PLATEN PRESS PROJECTS

— ► FEATURING ◄ —

★ CUSTOM BOOK COVERS ★ EX LIBRIS ★

★ POSTCARDS ★ RECIPE CARDS ★

★ BUSINESS CARDS ★ VALENTINE'S DAY CARDS ★

CUSTOM BOOK COVERS

If you're just becoming acquainted with the tabletop press and have only the basic tools and equipment, then printing with a linoleum-block cut (also called a linocut) is a great starter project. This simple type of relief printing can be executed without a press, but doing it this way will allow you to become familiar with your press and have fun while you're at it. For this project, we'll print directly onto blank sketchbooks. What better way to start your journey into letterpress than by printing on a book?

TOOLS AND MATERIALS ★ BASIC LETTERPRESS PRINTING TOOL KIT (PAGE 17) ★
TRACING PAPER (OPTIONAL) ★ LINOLEUM BLOCK MOUNTED ON WOOD, 4 × 6 INCHES (10 × 15 CM) ★
BONE FOLDER (OPTIONAL) ★ PERMANENT MARKER (OPTIONAL) ★ LINOCUTTING TOOLS ★
BENCH HOOK OR NONSLIP RUG PAD (OPTIONAL) ★ BOOKS WITH BLANK COVERS

STEP 1 ➔ Sketch the image.

To get some ideas for cover imagery, think about what you might use your book for. Will it be a travel journal, a dream diary, or a wine diary? Simple lines and shapes are the best way to go for this type of printing, so start by drawing the basic outlines; you can add details and texture as you carve.

STEP 2 ➔ Transfer the image to the linoleum block.

The simplest way to put an image on a linoleum block is to draw directly onto the block. Pencils and erasers both work well on linoleum blocks. However, the image will print as a mirror image of the cut, so you'll have to reverse your image—especially text—as you draw, which can be tricky! This is why many people use tracing paper to transfer their images. To go this route, start by tracing your source image with a soft pencil (2B or softer) to get a nice, dark sketch on the tracing paper. Then turn the tracing paper over onto the linoleum block so that the graphite is in contact with the linoleum. Hold the tracing paper firmly in place with one hand while rubbing over the back of the drawing with the bone folder. The pressure from the bone folder will transfer the graphite onto the linoleum and reverse the image at the same time! Check to make sure that the entire image has been transferred before lifting the drawing, or you might have a hard time putting it back in the correct position **A**.

LINOLEUM

The linoleum on your kitchen floor has gone through many changes and modern developments, but the linoleum we work with as printmakers remains essentially the same as that used by artists like Picasso and Matisse in the early 1900s. It's made from a mixture of solidified linseed oil, pine rosin, and ground cork dust. Usually backed with burlap or canvas, it's also available mounted on wood (the kind we'll use for this project). As opposed to wood, linoleum is softer and cheaper, and it has no grain to interfere with cutting or leave marks when printing. Linoleum occasionally crumbles and gets marred, but its ease of use has helped it remain a popular choice among contemporary artists for making bold, graphic prints.

Before cutting, I like to mark areas that won't be cut away. These areas seem obvious now, but they can be hard to distinguish once you start cutting! Color in your image using a permanent marker. Then, when you move on to the next step, it will be easy to keep things straight—just cut around the black ink!

STEP 3 ➜ Cut the block.

Use the linocutting tools to cut away areas that you don't want printed. I like to outline the image first with a V tool, then cut away excess material with one of the larger gouges. Any linoleum left standing will be inked and will make a printed mark. Anything you cut away will be the white space in your printed image. With this type of printing, you can only print solid areas: they'll either be black or white. However, you can use patterns like dots or lines to create "gray" tones or add interest **B**.

Always cut away from yourself and always place your fingers behind the cutter. To help hold the block steady and to create some pressure while cutting, use a bench hook or place the block on a nonslip rug pad. If you're having a hard time cutting the block, you can make the process easier by warming the linoleum under a desk lamp. If you're still having trouble, you may need a new blade in your cutting tool.

STEP 4 ➜ Lock up the block.

On an imposing stone or table, place the linoleum block in the center of the chase. Add furniture on all four sides of the block until it's snug **C**. Add reglets if necessary to fill in

small spaces. Don't forget to place the chase irons against the chase screws **D**. This will prevent the screws from damaging the wooden furniture. Tighten the screws until the block is held firmly in place **E**. If your chase is missing the chase screws (which is often the case), or isn't equipped with them, use quoins to lock up the block. Place one quoin on the right side of the block and the other at the top, and tighten them with the quoin key. Make sure that when the quoins expand, they expand toward the form.

STEP 5 ➜ Ink the press.

To get the ink out of the can, use the end of your palette knife and gently scrape off the surface as if you were smoothing the icing on a cake. Never gouge the ink out of the can; the surface of ink slowly dries when it's exposed to air, and you don't want dried bits of ink to sink down into the can. Smear the ink onto an inking table or inking plate and warm it by scooping it up, then smearing it down again. Repeat this step a few times, loosening the ink and making sure that all the ingredients are well mixed. This will get the ink ready for the press.

You can add ink to the press in a few different ways, but essentially you want to have a thin layer of ink evenly distributed across the ink disc and the rollers before you start to print. Pick up a roll of ink with the end of your pallet knife and spread a thin, even line of it across the full diameter of the ink disc **F**.

Distribute the ink by pressing down on the handle a few times and letting the rollers spread the ink evenly over the ink disc. The ink disc should spin by a few degrees each time you close the platen **G**. If you have the right amount of ink, the rollers should make a slightly tacky sound as they roll over the ink plate, like a sizzle on a hot griddle. Too much of that sound means you have too much ink on the press. Clean off the disc with a rag and some mineral spirits, and continue to even out the ink that remains on the rollers. Repeat this until you get the right sound.

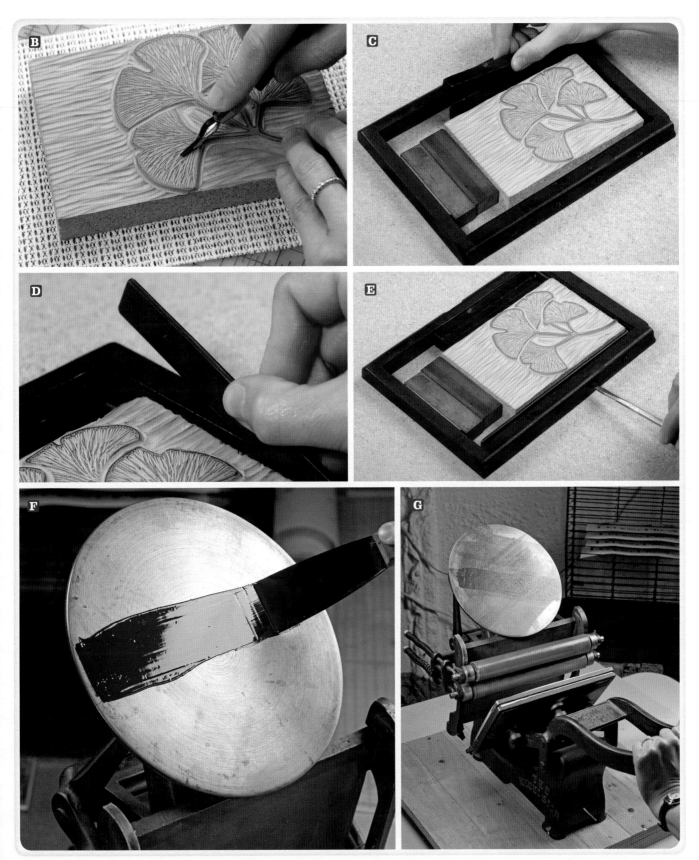

47

STEP 6 → Print.

Once the ink is evenly spread out over the ink disc, place the chase on the press bed and lock it in place **H**. Ink up the block by pressing down on the handle a few times, but don't take it all the way down to where the block engages with the platen.

Before printing the book covers, make a few proof prints on scrap paper that's the same size and thickness as the book cover. Place the paper against the gauge pins (see page 30) and press the handle down, giving it a good, firm squeeze **I**.

Based on the proof, adjust the area where the block prints on the paper; either move the gauge pins or take the chase out and adjust the furniture until the image prints in the right place **J**. (Refer to the troubleshooting section on page 36 if you're having trouble getting good print quality.)

Once you're happy with the proof prints, you're ready to make the final prints! Open the front cover of one of the blank books and place it on the guides. Hold the book in place with one hand and press down on the press handle with the other, giving it a good, firm squeeze when the paper meets the block. Release the handle, remove the book, and admire your new custom-printed book cover!

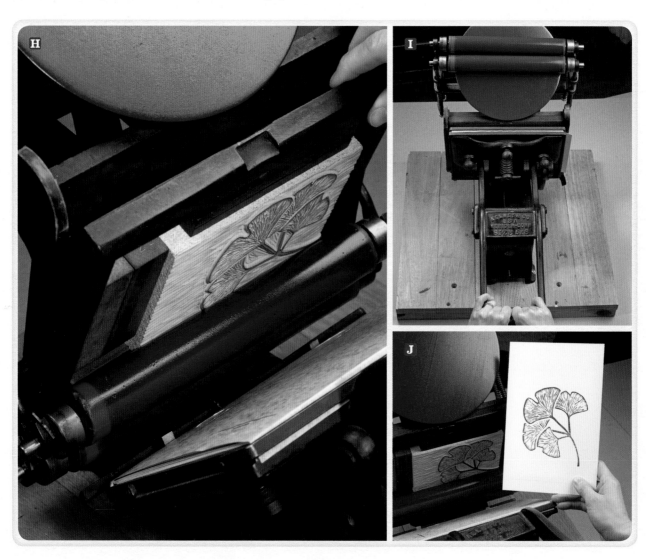

Where does the name of your press/shop come from?

I love the idea of a place where one could slip in to drink whiskey and the thought and pun of speaking easy. A place where you drink illegally is a place where you might think ideas and speak about thoughts you might not elsewhere.

What does letterpress mean to you?

It's literally the "power of the press," where one might express ideas and develop talents.

How did you get your start as a printer?

I studied at the University of Alabama's MFA in the Book Arts Program. I spent a day visiting with a printing class, and I was hooked.

What was your first press?

My first work was on a Vandercook 20 proof press.

What do you use these days?

I have a Challenge 15 hand-crank proof press at home and I also use whatever press is available where I'm teaching.

What do you love most about letterpress?

The rare moment when all parameters in a printing setup come together, and you hear monotype "clicking" against paper. The feeling is indescribable.

What is the biggest misconception about letterpress?

That it's difficult. There is something for everyone with letterpress printing. Find the thing for you, and it's not difficult.

Who/what inspires you in your craft?

I feel inspired from the entire spectrum of book arts, from the heritage of fine letterpress printing to a beautiful artist book, especially when one includes the other. Also, I'm particularly inspired by projects that consider community, such as the Justseeds Artists' Cooperative based in Pittsburgh, or Auburn University's Rural Studio architecture program.

What are your favorite tools or printing methods?

I've been thinking a lot lately about printing in circular form, and I continue my fascination with printing on handmade paper. When your press is set up just right, you can print on just a whisper of fiber.

Do you have a favorite printing trick or tip you can offer?

Tape a T-square to the back of your feed board to keep long paper, or deckled paper, straight as you are printing on it. Yes, you'll be assuming the feed board is parallel with the rest of the press. So far, so good.

Where do you see letterpress in the next 50 years?

Quality work itself is timeless, but I do expect to see more book arts centers and collectives develop as more individuals are educated in, and see the potential in, letterpress printing. And I hope to see a more diverse population of letterpress printers in the future.

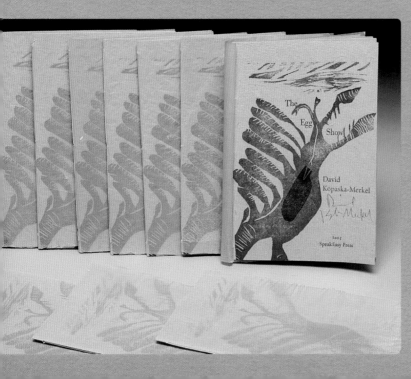

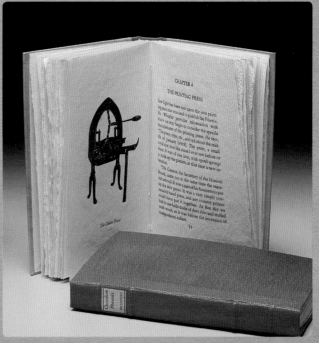

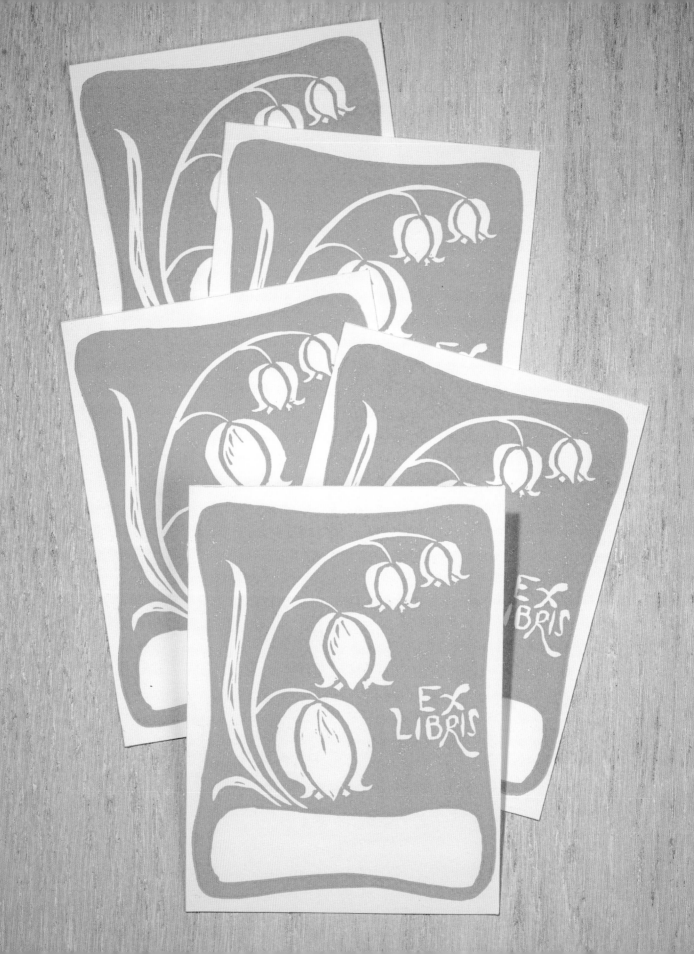

EX LIBRIS

If you have a large library and often loan books out, then this is the project for you! Using a distinctive bookplate—or *ex libris*—can help ensure that your beloved volumes find their way back home. In this project we'll explore unique colors and practice mixing the inks of your choice for your personal bookplate. Many of the core techniques used here are the same as those used in the Custom Book Covers project on page 45. If you're already familiar with that project, this one will be easy. If not, you can refer back to that project as we go.

TOOLS AND MATERIALS ★ BASIC LETTERPRESS PRINTING TOOL KIT (PAGE 17) ★ TEXT-WEIGHT PAPER OR SELF-ADHESIVE LABEL PAPER, 4 × 5 INCHES (10 × 12.5 CM) ★ TRACING PAPER (OPTIONAL) ★ LINOLEUM BLOCK MOUNTED ON WOOD, 3 × 4 INCHES (7.5 × 10 CM) ★ BONE FOLDER (OPTIONAL) ★ PERMANENT MARKER (OPTIONAL) ★ LINOCUTTING TOOLS ★ BENCH HOOK OR NONSLIP RUG PAD (OPTIONAL)

STEP 1 → Sketch or find your image.

Think about the design you want to label your books with. Images related to reading or libraries make good choices, but you can use any design that you like. Remember to leave a space where you can write, type, or print your name **A**.

STEP 2 → Prepare the paper.

For this project, you can use 4 × 5-inch (10 × 12.5-cm) text-weight paper that you'll glue into the book cover, or label paper that's already prepared with adhesive on the back. I'm using label paper. Cut the paper at least ½ inch (1.3 cm) larger than the linoleum block all the way around

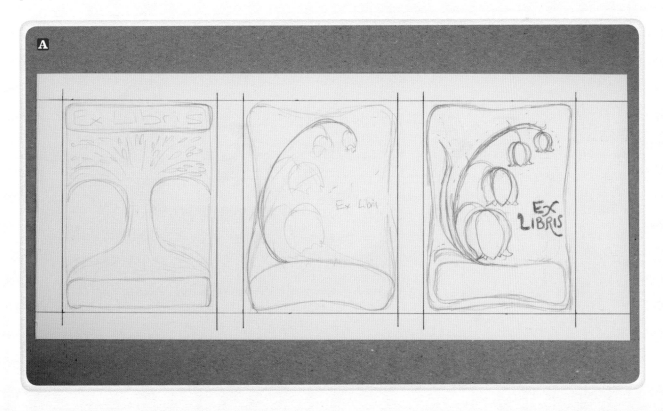

to make room for the gauge pins. You can trim off the excess after printing. Cut as many pieces of paper as you want to print. Be sure to cut at least 10 percent extra for mistakes or accidents, as well as a stack of scrap for proofs. For the proofs, cut to the same size as the printing paper.

STEP 3 ➜ Transfer the image from Step 1 to the linoleum block.

For instructions on how to do this, refer to the Custom Book Covers project on page 45.

STEP 4 ➜ Cut the block. **B**

For instructions on how to do this, refer to the Custom Book Covers project on page 46.

STEP 5 ➜ Lock up the block. **C**

For instructions on how to do this, refer to the Custom Book Covers project on page 46.

STEP 6 ➜ Ink the press.

For instructions on how to do this, refer to the Custom Book Covers project on page 46.

STEP 6 ➜ Print.

Once the ink is evenly spread out over the ink disc, place the chase on the press bed and lock it in place. Ink up the block by pressing down on the handle a few times, but don't take it all the way down to where the block engages with the platen.

Before printing the bookplates, make a few proof prints on your scrap paper. Place the paper against the gauge pins and press the handle down, giving it a good, firm squeeze.

Based on the proof, adjust the area where the block prints on the paper; either move the gauge pins or take the chase out and adjust the furniture until the image prints in the right place. (Refer to the troubleshooting section on page 36 if you're having trouble getting good print quality.)

Once you're happy with the proof prints, you're ready to make the final prints! Place a sheet of the bookplate paper on the guides. Press down on the press handle, giving it a good, firm squeeze when the paper meets the block. Print your stack of bookplates and let them dry overnight. Trim them down to the right size, then get to work labeling your library!

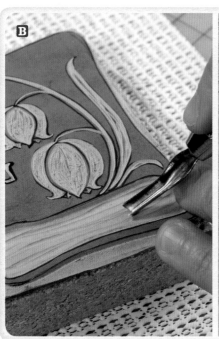

POSTCARDS

One of my favorite ways of spending a day on the press is printing postcards using nothing but wood type. Setting large wood type isn't the same as setting smaller text in metal. You don't need any special tools, and it's a fun way to get acquainted with letterpress printing in general and with setting type. The immediacy of creating words in this way helps me relax and have fun. You shouldn't stress over coming up with beautiful poetry for this project. Just throw down some words (or in some cases, letters), and go with it!

STEP 1 ➤ Prepare the paper.

Cut your cardstock to postcard size, about 5 × 7 inches. Cut the paper at least ½ inch (1.3 cm) larger than the text block all the way around to make room for the gauge pins; you can trim off the excess after printing. Cut as many pieces of cardstock as you want to print. Be sure to cut at least 10 percent extra for mistakes or accidents, as well as a stack of scrap for proofs. For the proofs, cut to the same size as the printing paper.

STEP 2 ➤ Set the type.

This postcard will be set with large wood type, so keep your message short and sweet. Place your chase on an imposing stone or table. Pull the letters you need from the type case, and place them inside the chase. Set the word so that it reads backwards (the letters themselves are already backwards) **A**. Add reglets or leading to kern the letters if necessary.

STEP 3 ➤ Lock up the type.

Make sure your type makes a solid block. If all of your type is the same height, it already makes a block! If your type is of different heights, add furniture or reglets above the shorter type so that it's the same height as the tallest letter. Use leading if the reglets are too thick.

Measure the line length of the text block and fill in the space above and below it with furniture that's the same line length or slightly shorter. Measure the height of the text block, and fill in the two sides with furniture that's the same height or slightly longer. When setting a small form in a large chase, I like to "pyramid" the furniture by using longer pieces of furniture as I move out from the text block. That way, shorter pieces of furniture have extra support from longer pieces. It's okay to have some furniture that's longer than the form you're locking up, but make sure that none of the pieces of furniture will be pushing up against each other when you tighten the form—they should be pushing up against the type. You can do this by sliding the furniture off-center from the type, as shown in the photo **B**.

Don't forget to place the chase irons against the chase screws inside the chase; this prevents the screw from damaging the wooden furniture. Tighten the screws until the block is held firmly in place. If your chase is missing the tightening screws (which is often the case), use quoins to lock up the form. Choose quoins that are about the same length on each side, and always use furniture between the quoin and the form. Place one quoin on the right side of the text block, and the other at the top. Make sure that when the quoins expand, they expand toward the form.

Place one hand on the type. Using the quoin key, tighten up one of the quoins slightly **C**. Do the same for the other quoin, and repeat back and forth until they're both tight. If you feel the type lift up a little, then you've tightened the quoins too much. Release the quoins and tighten them again.

The last step in locking up the type is making sure the type is tightly in place and won't fall out when you place the chase in the press. Lift one corner of the chase and place it on the quoin key. Tap each and every piece of type to make sure it's tightly in place **D**. If any pieces feel loose or drop down, add spacing to that line. Set the chase back down,

loosen the screws or quoins, and add a copper in the line that's loose. Lock up the type again and repeat until all of the type stays tightly in place.

STEP 4 ➜ Ink the press.

For instructions on how to do this, refer to the Custom Book Covers project on page 46.

STEP 5 ➜ Print.

Once the ink is evenly spread out over the ink disc, place the chase on the press bed and lock it down. Ink up the block by pressing down on the handle a few times, but don't push the handle all the way down to where the form engages with the platen.

Before printing the postcards, make a few proof prints on your scrap cardstock. Place the paper against the gauge pins and press the handle down, giving it a good firm squeeze. Based on the proof, adjust the area where the form prints on the paper; either move the gauge pins or take the chase out and adjust the furniture until the text prints in the right place. (Refer to the troubleshooting section on page 36 if you're having trouble getting good print quality.)

Once you're happy with the proof prints, you're ready to make the final prints! Place a sheet of the postcard paper on the platen, slide it against the guides, and press down on the handle, giving it a good firm squeeze when the paper meets the block. Repeat until you have a nice stack of postcards.

STEP 6 ➜ Round the corners.

If you want your postcards to have nicely rounded corners, clip each corner with a corner punch that you can get at most craft stores **E**. Some community print shops also have heavy-duty corner rounders that can cut a stack of paper all at once.

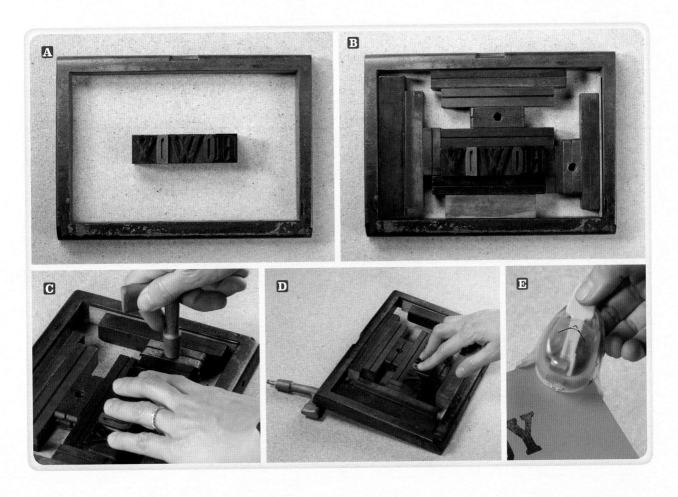

Jessica's Favorite Apple Crumble

Filling:
6 c apples, peeled, cored, & chopped
2 tbsp sugar
1/2 tsp ground cinnamon
2 tsp lemon juice

Crumble topping:
3/4 c all-purpose flour
1/2 c sugar
1/2 tsp salt
1 stick butter

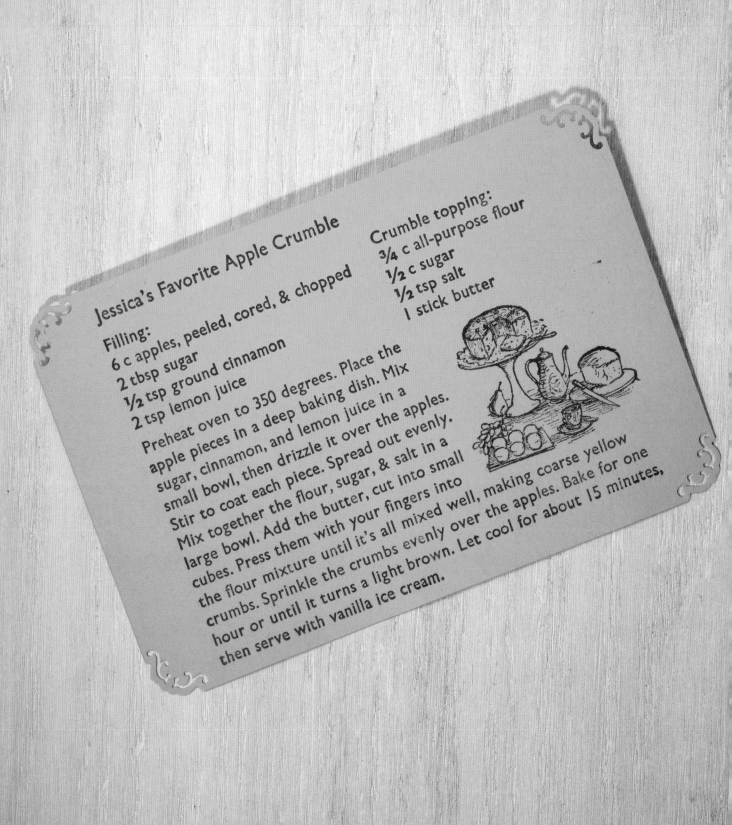

Preheat oven to 350 degrees. Place the apple pieces in a deep baking dish. Mix sugar, cinnamon, and lemon juice in a small bowl, then drizzle it over the apples. Stir to coat each piece. Spread out evenly. Mix together the flour, sugar, & salt in a large bowl. Add the butter, cut into small cubes. Press them with your fingers into the flour mixture until it's all mixed well, making coarse yellow crumbs. Sprinkle the crumbs evenly over the apples. Bake for one hour or until it turns a light brown. Let cool for about 15 minutes, then serve with vanilla ice cream.

RECIPE CARDS

I love receiving recipe cards as gifts from friends. Sometimes they share recipes they created themselves, and sometimes they pass on special family dishes found in grandma's old cookbook. Letterpress printing recipes onto cards turns them into extra-special keepsakes. Find a recipe you'd like to share, and decide how many cards you want to print. Make extras as gifts for friends and family down the road!

TOOLS AND MATERIALS ★ BASIC LETTERPRESS PRINTING TOOL KIT (PAGE 17) ★ CARDSTOCK ★ METAL TYPE ★ A WRITTEN COPY OF A RECIPE ★ TOOL KIT FOR SETTING TYPE (PAGE 32) ★ DECORATIVE CORNER PUNCH (OPTIONAL)

STEP 1 ➤ Prepare the paper.

For this project, you'll need cardstock that's cut to 5 × 7 inches (12.5 × 17.8 cm), to be trimmed down later to 4 × 6 inches (10 × 15 cm). The extra margin will ensure that there's room for the gauge pins when you print. Cut at least 10 percent extra for mistakes or accidents, as well as a stack of scrap for proofs. For the proofs, cut to the same size as the printing paper.

STEP 2 ➤ Set the type.

Choose the typeface and font that you want to use for this project. Keep in mind that you'll be referring to this card when you're cooking, so choose a size and a style that will be easy to read when you're chopping and stirring.

Pull out the type case and set it on a flat surface where you'll be comfortable setting type as you refer to your written recipe. Other handy things to keep nearby when you're setting type include spacing material, tweezers, and a case layout chart (if you haven't yet memorized where all of the letters are stored).

Set your composing stick to a line length that fits the paper you'll be printing on. For a 4 × 6-inch (10 × 15-cm) card printed in landscape format, I recommend setting a line length of no more than 30 picas, or about 5 inches (12.5 cm) **A**. Refer to page 34 for instructions on how to set the rest of the type and tie up the form.

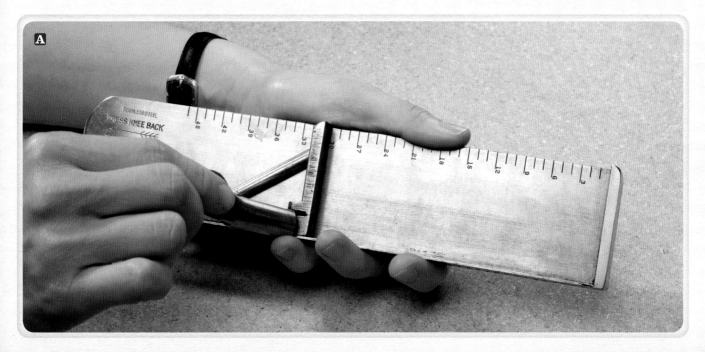

57

STEP 3 → Lock up the form.

Place the galley on the imposing stone and slide the text block onto the stone. Place your index fingers on the top slug, your thumbs on the bottom slug, and your middle fingers on either side of the text block, and squeeze tightly. You should be bending it slightly while you slide it down onto the imposing stone. Move the galley aside and set the chase down, centered over the text block.

Measure the line length of the text block and fill in the space above and below it with furniture that's the same line length or slightly shorter. Measure the height of the text block, and fill in the two sides with furniture that's the same height or slightly longer. Don't forget to place the chase irons against the chase screws inside the chase; this prevents the screws from damaging the wooden furniture. Tighten the screws slightly until the block is held in place **B**.

It's okay to have some furniture that's longer than the form you're locking up, but make sure that none of the pieces of furniture will be pushing up against each other when you tighten the form—they should be pushing up against

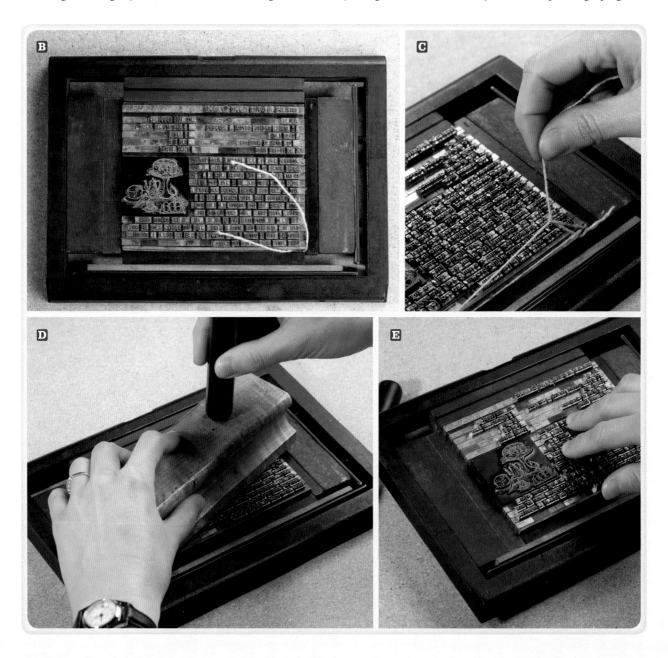

the type. You can do this by sliding them off-center from the type, as shown in the Postcards project on page 55.

If your chase is missing the tightening screws (which is often the case), use quoins to lock up the form. Choose quoins that are about the same length of the form on each side, and always be sure to place one piece of furniture between the form and each quoin. Place one quoin on the right side, and the other at the top.

Once the form is snugly in place, pull up on the trimmed end of the string that you used to tie up the form. It should pull up easily and leave a bit of space all the way around the form. Fill in these spaces with reglets if necessary to snug it up again **C**.

Tighten the chase screws or lock up each quoin slightly. Place a plane on the form and tap it gently with the side of your quoin key to make sure that each piece of type is resting squarely on its feet **D**. Move the plane around on the form and repeat two or three times, then lock it up securely—tight enough so that nothing moves, but not so tight that you feel the form lifting up. If you feel the

type lift up a little, then the form is too tight. Release the quoins and tighten them again.

The last step in locking up the form is making sure the type is tightly in place and won't fall out when you place the chase in the press. Lift one corner of the chase and place it on the quoin key. Tap each and every piece of type to make sure it's tightly in place **E**. If any pieces feel loose or drop down, add spacing to that line. Set the chase back down, loosen the screws or quoins, and add a copper in the line that's loose. Lock the form up again and repeat until all of the type stays tightly in place.

STEP 4 → Ink the press.

For instructions on how to do this, refer to the Custom Book Covers project on page 46.

STEP 5 → Print.

Once the ink is evenly spread out over the ink disc, place the chase on the press bed and lock it down. Ink up the block by pressing down on the handle a few times, but

don't push the handle all the way down to where the form engages with the platen.

Before printing the recipe cards, make a few proof prints on your scrap paper. Place the paper against the gauge pins and press the handle down, giving it a good firm squeeze. Based on the proof, adjust the area where the form prints on the paper; either move the gauge pins or take the chase out and adjust the furniture until the text prints in the right place. (Refer to the troubleshooting section on page 36 if you're having trouble getting good print quality.)

Once you're happy with the proof prints, you're ready to make the final prints! Place a sheet of the recipe card paper on the platen, slide it against the guides, and press down on the handle, giving it a good firm squeeze when the paper meets the block. Repeat until you have a nice stack of recipe cards.

STEP 6 ➜ Decorate the corners.

After printing all of the recipe cards, trim them down to size. If you want your recipe cards to have decorative corners, just clip each corner with a corner punch that you can get at most craft stores **F**.

BUSINESS CARDS

Let's face it: one of the best parts of having letterpress printing skills is being able to print your own handmade, custom-designed business cards. There's just something about a lusciously printed card with a nice deep impression on thick paper that says, "I have arrived." In addition to showing you how to create your own cards, this project gives you the chance to explore your collection of ornaments and dingbats and print with them.

STEP 1 ➜ Plan what you want on your card.

It's easier to set type when you have copy to refer to, so go ahead and write down everything that you want on the card. You'll be putting a lot of information in a small space, so plan your design carefully and simplify it if necessary **A**. While you're thinking about the layout and design of your card, look though your ornaments and pull out a few that will work with your design. Try a flourish, a border, or an image that could serve as a logo.

STEP 2 ➜ Prepare the paper.

For this project, you'll need cardstock that's cut to 3½ × 4 inches (8.9 × 10 cm). You'll be printing two cards on each sheet. Cut as many pieces of cardstock as you want to print. Be sure to cut at least 10 percent extra for mistakes or accidents, as well as a stack of scrap for proofs. For the proofs, cut to the same size as the printing paper.

STEP 3 ➜ Set the type.

Choose the typeface and font that you want to use for this project. Because you'll be putting a lot of information in a small space, stick to small but legible fonts. Pay attention to the information that you really want to stand out, such as your name, and choose larger or bolder type for that text.

Pull out the type case and set it on a flat surface where you'll be comfortable setting type. Other handy things to keep nearby when you're setting type include spacing material, tweezers, and a case layout chart (if you haven't yet memorized where all of the letters are stored).

Set your composing stick to a line length that's the length of the longest line on your card, including any lines with ornaments. Refer to page 34 for instructions on how to set the rest of the type and tie up the form.

Note that it's best to set lines of type that are all the same point size. If you do have a line with two different sizes, such as a line of 12-point type with a 10-point ornament,

fill in the spaces above or below the smaller type within that line with spacing or leading. Keep in mind that you want all of the lines of type to be set as a solid block that can be locked up tight before printing **B**.

STEP 4 ➜ Lock up the form.

Place the galley on the imposing stone and slide the text block onto the stone. Place your index fingers on the top slug, your thumbs on the bottom slug, and your middle fingers on either side of the text block, and squeeze tightly. You should be bending it slightly while you slide it down onto the imposing stone. Move the galley aside and set the chase down, centered over the text block.

Measure the line length of the text block and fill in the spaces above and below it with furniture that's the same line length or slightly shorter. Measure the height of the text block, and fill in the two sides with furniture that's the same height or slightly longer. Don't forget to place the chase irons against the chase screws inside the chase; this prevents the screws from damaging the wooden furniture. Tighten the screws slightly until the block is held in place.

It's okay to have some furniture that's longer than the form you're locking up, but make sure that none of the pieces of furniture will be pushing up against each other when you tighten the form—they should be pushing up against the type. You can do this by sliding them off-center from the type, as shown in the Postcards project on page 55.

If your chase is missing the tightening screws (which is often the case), use quoins to lock up the form. Choose quoins that are about the same length of the form on each side, and always be sure to place one piece of furniture between the form and each quoin. Place one quoin on the right side, and the other below the form **C**.

Once the form is snugly in place, pull up on the trimmed end of the string that you used to tie up the form. It should pull up easily and leave a bit of space all the way around

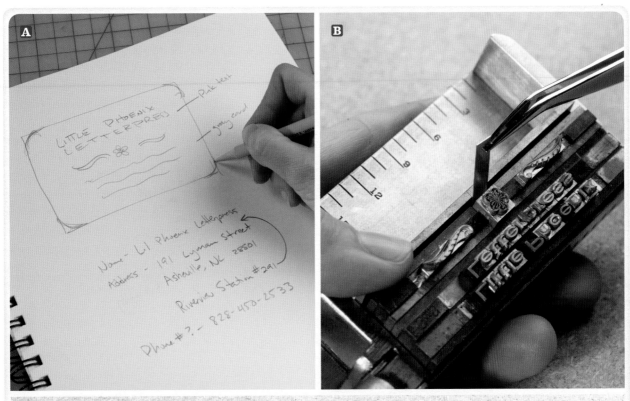

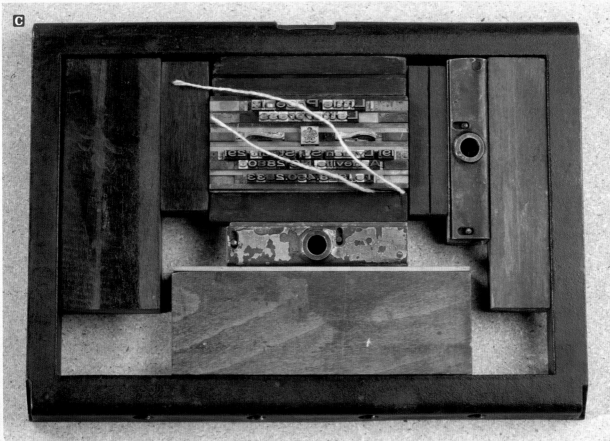

the form. Fill in these spaces with reglets if necessary to snug it up again.

Tighten the chase screws or lock up each quoin slightly. Place a plane on the form and tap it gently with the side of your quoin key to make sure that each piece of type is resting squarely on its feet. Move the plane around on the form and repeat two or three times, then lock it up securely—tight enough so that nothing moves, but not so tight that you feel the form lifting up. If you feel the type lift up a little, then the form is too tight. Release the quoins and tighten them again **D**.

The last step in locking up the form is making sure the type is tightly in place and won't fall out when you place the chase in the press. Lift one corner of the chase and place it on the quoin key. Tap each and every piece of type to make sure it's tightly in place. If any of the pieces feel loose or drop down, you need to add spacing to that line. Set the chase back down, loosen the screws or quoins, and add a copper in the line that's loose. Lock the form up again and repeat until all of the type stays tightly in place.

STEP 5 ➜ Ink the press.

For instructions on how to do this, see the Custom Book Covers project on page 46.

STEP 6 ➜ Register with Mylar and gauge pins.

Once the ink is evenly spread out over the ink disc, place the chase on the press bed and lock it down. Ink up the

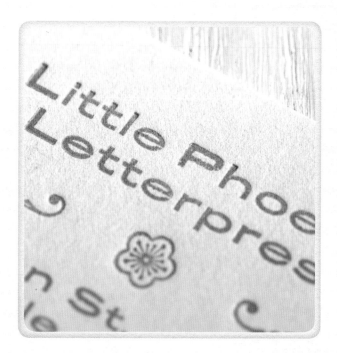

block by pressing down on the handle a few times, but don't push the handle all the way down to where the form engages with the platen.

Cut a piece of Mylar that's a little smaller than the size of the platen and tape it to the top of the platen with blue painter's tape **E**. Print onto the Mylar. Where the print appears on the Mylar is where it will print on a piece of paper on the platen. Place a piece of the proof paper underneath the Mylar and align the text to print on the paper centered on the upper half of the sheet **F**.

Hold the paper in place with one hand while you draw the edges of the paper with the other **G**—this is where you'll place your gauge pins—two on the bottom and one on the upper left side **H**.

STEP 7 ➜ Print.

Before printing the business cards, make a few proof prints on your scrap paper. Place the paper against the gauge pins and press the handle down, giving it a good firm squeeze. Based on the proof, adjust the area where the text block prints on the paper; either move the gauge pins or take the chase out and adjust the furniture until the text prints in the right place. (Refer to the troubleshooting section on page 36 if you're having trouble getting good print quality.)

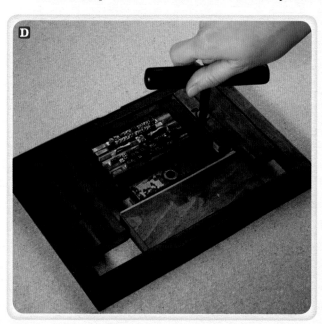

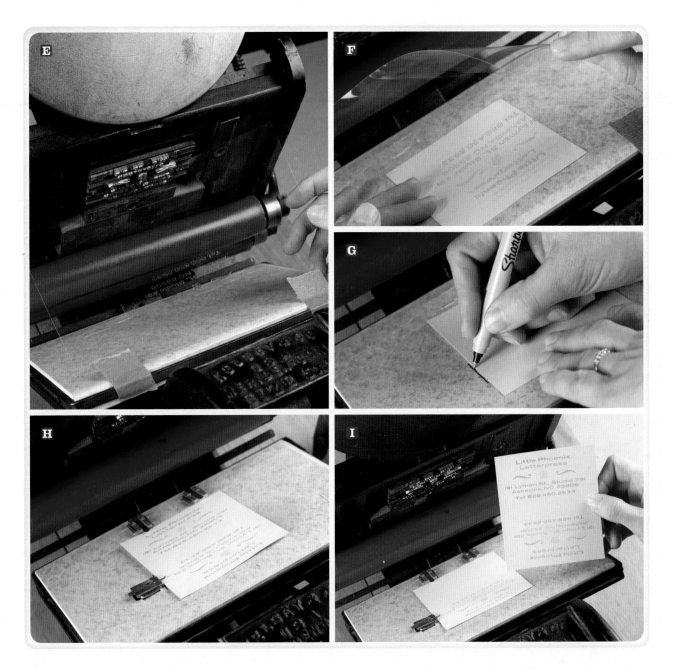

Once you're happy with the proof prints, you're ready to make the final prints! Place a sheet of cardstock on the platen, slide it against the gauge pins, and press down on the handle, giving it a good firm squeeze when the paper meets the block. Spin the card around and repeat on the other side of the sheet. Printing two prints at a time on one sheet using this method is called a "work-and-turn **I**." Repeat until you have a nice stack of business cards, then cut them in half with a paper cutter or craft knife.

STEP 8 → Round the corners.

If you want your business cards to have nicely rounded corners, just clip each corner with a corner punch that you can get at most craft stores. Some community print shops also have heavy-duty corner rounders that can cut a stack of paper all at once. Start handing out your business cards!

Where does the name of your press/shop come from?
The shop was founded in 1879 by two brothers, Charles and Herbert Hatch, who were originally from Wisconsin.

How did you get your start as a printer?
In an effort to "get out of college fast and take whatever courses were easy," I ended up taking a printmaking course at Middle Tennessee State University in 1980.

What does letterpress mean to you?
Here in the shop we have the mantra of "preservation through production." This is what letterpress means to me.

What was your first press?
The shop's first press was a Babcock Optimus 6 built in 1906, and it weighed around 18,000 pounds. Today, we use a Miehle 29 for our production work and then, of course, several Vandercooks.

What do you love most about letterpress?
Having the opportunity to travel every day with the future of this shop.

What is the biggest misconception about letterpress?
That proofing the job for the customer is easy and that changes are effortless.

Who/what inspires you in your craft?
Of course, the four walls of this shop, and a gentleman from the Netherlands named Hendrik Werkman. He was shot dead in 1945.

Describe your creative process.
The two words that best describe what I do would be "color" and "contrast," and I care very little for negative space. Fill up the paper.

Who are your favorite letterpress artists?
The folks I work with every day. Their work is inspirational and amazing and original.

What are your favorite tools or printing methods?

I cut my woodblocks with Flexcut tools, and I brayer ink directly onto the paper quite often.

What are common themes/motifs in your work?

I am constantly reworking the age-old theme of Southern culture as found in some context here at Hatch Show Print in Nashville, Tennessee.

Do you have a favorite printing trick or tip you can offer?

Of the many techniques employed to streamline production, I suppose what helps me most on every job is a simple piece of paper, 2 inches (5 cm) thick and 8 inches (20 cm) long, with pencil marks on it every 1½ inches (3.8 cm). This is basically the "template" I use to space out my checkerboard borders.

Where do you see letterpress in the next 50 years?

The interest will still be there but not near the number of people attempting to pull this off as a business. In the next 10 to 15 years, I won't be surprised to see a flushing out of folks who are presently enamored with letterpress once their romantic ideas of printing begin competing with the reality of a revenue stream.

Anything else?

I look at all the kids in letterpress today and am still surprised at their interest. I have come to the conclusion that we are, as humans, hard-wired for "process," and we are discontent with the work done for us in this screen-saturated society. Letterpress is the new mystery to people born during the mid-1980s and after. I'm glad we can do our part at Hatch Show Print to help keep alive the simple act of "letters pressed into paper with ink in between."

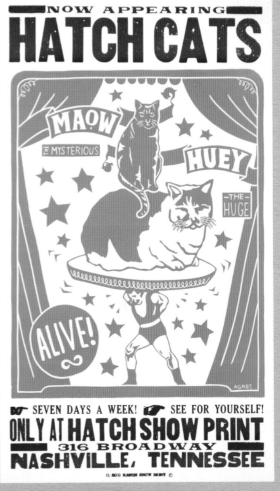

VALENTINE'S DAY CARDS

What's sweeter than a handmade Valentine? Not much! You can easily print up a batch of Cupid-approved cards that will be treasured year-round. To get started, you'll need a photopolymer plate. You can purchase a premade, press-ready plate from a plate-making service (check out the Resources section on page 172 for contact information), or you can make a photopolymer plate yourself. To do this, you'll need an unexposed polymer plate, a UV-exposure unit, photonegatives, and a soft brush for developing the plate. Photopolymer plates are thin, so you'll need to place yours on a base that's designed to bring it up to type height for letterpress printing. In my examples, I use plastic plates with adhesive backing on an aluminum base. However, plates can also be made with steel backing, in which case you'll need a magnetic base. I suggest that you do some research to find out which type of plate is right for you.

STEP 1 ➜ Sketch the image.

Think about what you want to draw for Valentine's Day. To me, there's nothing sweeter than an ice-cream cone! The entire design for this project will come from your drawing, so you can really play with the text—try your hand at calligraphy, or play with a creative font. You can start out by drawing with a pencil, but you should make the finished image with a black ink pen, creating only black-and-white areas without shading or gray tones. Erase any visible pencil marks after inking 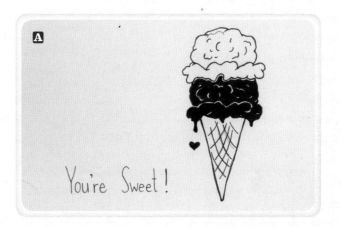.

PHOTOPOLYMER PLATES

Even though letterpress printing has been around for hundreds of years, the craft continues to grow and evolve to meet the needs of contemporary printers. One of the newest ways to print, historically speaking, is from photopolymer plates. The plates we use today are adaptations of printing plates that were first developed in the 1950s. These metal plates had a light-sensitive coating. A photonegative of the image to be printed was placed on the plate, which was then exposed to light and developed in a chemical solvent bath. The resulting etched metal plate was used as the matrix.

Over the years, photopolymer plates have been through various revisions— from the materials used to coat them to the solvents used to develop them— and modified to become the plates we use today. We still use photonegatives to block out the light that the plate is exposed to. Areas of the plate that are

exposed to light harden, and the remaining unhardened areas are developed and washed away. However, the plates we use today can be developed in plain tap water, creating a printable plastic plate rather than an etched metal plate.

7.5-4-5 Boxcar Grid Base™ Supplies available at www.boxcarpress.com. Trademark of

STEP 2 ➤ Make the plate.

Unless you have a UV-exposure unit, you'll need to send your drawing away in order to have a photopolymer plate made of it. For a list of companies that make plates, check out the Resources section on page 172. Most companies offer two options: you can send them the hard copy of your drawing or submit it as a digital file. You should get in touch with the company before sending the file. They'll be able to walk you through the necessary steps and save you a lot of heartache (and money) down the road.

STEP 3 ➤ Prepare the paper.

For your project to match mine, you'll need paper with a deckled edge. Cut the paper to 5½ × 8½ inches (14 × 21.5 cm), leaving the deckle untrimmed along one 5½-inch (14-cm) edge. Cut at least 10 percent extra for mistakes or accidents, as well as a stack of scrap for proofs. For the proofs, cut to the same size as the printing paper. Fold each sheet of the card paper and the proofing paper in half; the deckled edge should be along the fore edge, or the side of the card that opens. Press down the folded edge with the bone folder to give it a good sharp crease.

STEP 4 ➤ Lock up the base.

On an imposing stone or table, place the aluminum base in the upper right corner of the chase. This will leave extra room below and to the left of the chase for the gauge pins to clear without getting smashed. Add furniture below and to the left side of the base until it's snug in the chase. Add reglets if necessary to fill in small spaces. Don't forget to place the chase irons against the chase screws; this prevents the screws from damaging the wooden furniture. Tighten the screws until the block is held firmly in place.

If your chase is missing the chase screws (which is often the case), or isn't equipped with them, use quoins to lock up the block. Place one quoin on the left side and the other at the bottom, and tighten them with the quoin key. Make sure that when the quoins expand, they expand toward the base **B**. Place the chase on the press bed and lock it in place.

STEP 5 ➤ Place the plate on the base.

When the plate arrives, you may need to trim away excess plate material from around the image. Be careful to leave at least ¼ to ½ inch (6 mm to 1.3 cm) of plate material around the image areas.

Roll up a small piece of painter's tape and place it on the face of the polymer plate, then place the plate face down on a sheet of proof paper in the place where you want it to print **C D**.

Place the paper with the plate taped to it against the gauge pins on the tympan, folded side down. Remove the protective backing from the sticky side of the plate **E**.

Close the platen by pressing down on the handle. The plate should stick to the base in the correct position for printing. Remove the paper and any remaining tape, and make sure the plate is adhered well to the base **F**. Remove the chase from the press bed before inking the press.

STEP 6 ➤ Ink the press.

For instructions on how to do this, refer to the Custom Book Covers project on page 46.

STEP 7 ➤ Print.

Once the ink is evenly spread out over the ink disc, place the chase on the press bed and lock it in place. Ink up the plate by pressing down on the handle a few times, but don't push the handle all the way down to where the block engages with the platen.

Before printing the cards, make a few proof prints on your scrap paper. Place the paper folded side down against the gauge pins and press the handle down, giving it a good firm squeeze. Based on the proof, adjust the area where the form prints on the paper; either move the gauge pins or lift the plate and move it on the base. (Refer to the troubleshooting section on page 36 if you're having trouble getting good print quality.)

Once you're happy with the proof prints, you're ready to make the final prints! Place a sheet of the handmade paper on the platen, slide it against the gauge pins, and press down on the handle, giving it a good firm squeeze when the paper meets the block. Repeat until you have a nice stack of Valentine's Day cards, then share the love!

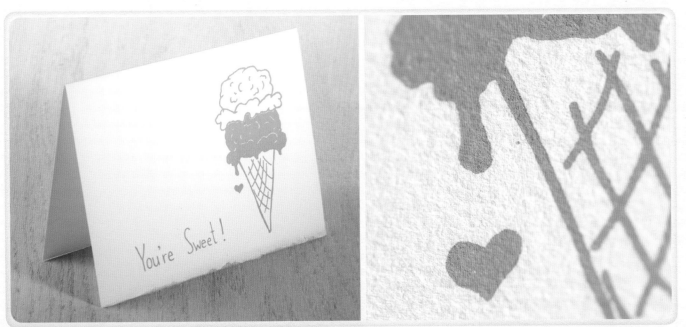

FULL SIZE PLATEN PRESS PROJECTS

FEATURING

★ **PERSONALIZED STATIONERY** ★ **MASQUERADE MASKS** ★

★ **TREE ORNAMENTS** ★ **THAUMATROPE** ★ **INVITATIONS**

WITH RSVPS ★ **GIFT TAGS** ★ **ALL-OCCASION CARDS** ★

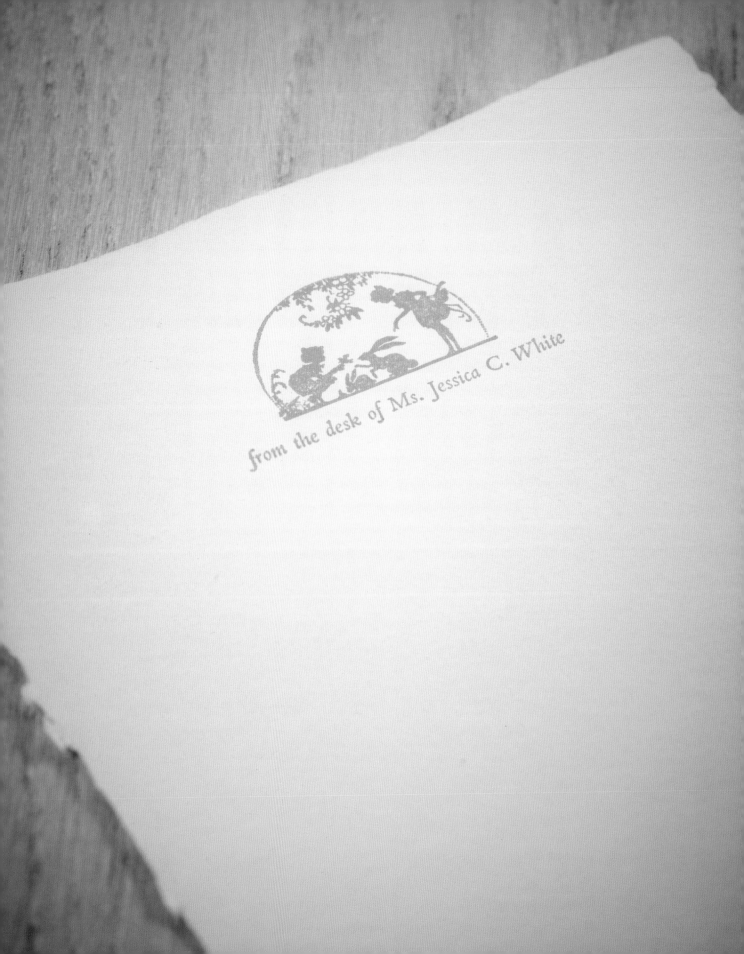

from the desk of Ms. Jessica C. White

PERSONALIZED STATIONERY

If you're like me, every now and then there's something special you want to tell someone—something that's best expressed in a handwritten letter. For that kind of communication, plain paper won't do! With this project, we'll print up a stack of distinctive stationery that will make your heartfelt messages extra memorable. To get started, find the ornaments, dingbats, or cuts—elements that reflect your personality and taste—that you'd like to use on your stationery. If you don't have your own collection to choose from, look for them at antique stores and flea markets, or online at eBay or Etsy.

TOOLS AND MATERIALS ★ BASIC LETTERPRESS PRINTING TOOL KIT (PAGE 17) ★ METAL TYPE, ORNAMENTS, CUTS, AND DINGBATS ★ TOOL KIT FOR SETTING TYPE (PAGE 32) ★ HANDMADE OR OTHER GOOD-QUALITY PAPER, ABOUT 7 × 10 INCHES (17.8 × 25.4 CM) ★ WOOD TYPE (OPTIONAL) ★ MYLAR, SLIGHTLY SMALLER THAN THE PLATEN OF YOUR PRESS

STEP 1 ➜ Plan what you want to print on your stationery.

On a piece of scrap paper, write and sketch everything that you want to put on your stationery. This information could include your name or your initials, the name of your business, or a little phrase like "From the desk of …" Pick out an ornament or two that will work well with your design.

STEP 2 ➜ Prepare the paper.

For this project, you'll need paper that's cut to a good size for letter writing. I prefer a size that's slightly smaller than regular letter-size paper, such as 7 × 10 inches (17.8 × 25.4 cm), to make my stationery more distinctive. Cut (or buy) as many pieces of paper as you want to print. Be sure to cut at least 10 percent extra for mistakes or accidents, as well as a stack of scrap for proofs. For the proofs, cut to the same size as the printing paper.

STEP 3 ➜ Set the type.

Choose the typeface and font that you want to use for this project. Choose one that represents you and your personal sense of style. If you want to make a really bold statement, use larger wood type.

Pull out the type case and set it on a flat surface where you'll be comfortable setting type. Other handy things to keep nearby when you're setting type include spacing material, tweezers, and a case layout chart (if you haven't yet memorized where all of the letters are stored).

Set your composing stick to a line length that's the length of the longest line on your design, including any lines with ornaments. Refer to page 34 for instructions on how to set the rest of the type and tie up the form.

Note that it's best to set lines of type that are all the same point size. If you do have a line with two different sizes, such as a line of 12-point type with a 10-point ornament, fill in the spaces above or below the smaller type within that line with spacing or leading. Keep in mind that you want all of the lines of type to be set as a solid block that can be locked up tight before printing.

STEP 4 ➜ Lock up the form.

Place the galley on the imposing stone and slide the text block onto the stone. Place your index fingers on the top slug, your thumbs on the bottom slug, your middle fingers on either side of the text block, and squeeze tightly. You should be bending it slightly while you slide it down onto the imposing stone. Move the galley aside and set the chase down over the text block **A**.

Measure the line length of the text block and fill in the spaces above and below it with furniture that's the same line length or slightly shorter. Measure the height of the text block, and fill in the two sides with furniture that's the same height or slightly longer. Leave room for quoins, one on the right and one below the form. Place furniture that's about 4 picas wide between the quoins and the form; never place a quoin directly against the form.

When setting a small form in a large chase, I like to "pyramid" the furniture so that shorter pieces of furniture have extra support from longer pieces **B**. Make sure that none of the pieces of furniture will be pushing up against each other when you tighten the form—they should be pushing up against the type.

Once the form is snugly in place, pull up on the trimmed end of the string that you used to tie up the form. It should pull up easily and leave a bit of space all the way around the form. Fill in these spaces with reglets if necessary to snug it up again.

Place one hand on the form and tighten the quoins slightly. Place a plane on the form and tap it gently with the side of your quoin key to make sure that each piece of type is resting squarely on its feet. Move the plane around

on the form and repeat two or three times, then lock it up securely—tight enough so that nothing moves, but not so tight that you feel the form lifting up. If you feel the type lift up a little, then the form is too tight. Release the quoins and tighten them again.

The last step in locking up the form is making sure the type is tightly in place and won't fall out when you place the chase in the press. Lift one corner of the chase and place it on the quoin key. Tap each and every piece of type to make sure it's tightly in place. If any pieces feel loose or drop down, add spacing to that line. Set the chase back down, loosen the quoins, and add a copper in the line that's loose **C**. Tighten the quoins again and repeat until all of the type stays tightly in place.

STEP 5 ➜ Ink the press.

To get the ink out of the can, use the end of your palette knife and gently scrape off the surface as if you were smoothing the icing on a cake. Never gouge the ink out of the can; the surface of ink slowly dries when it's exposed to air, and you don't want dried bits of ink to sink down into the can. Smear the ink onto an inking table or inking plate and warm it by scooping it up, then smearing it down again. Repeat this step a few times, loosening the ink and making sure that all the ingredients are well mixed. This will get the ink ready for the press.

You can add ink to the press in a few different ways, but essentially you want to have a thin layer of ink evenly distributed across the ink disc and the rollers before you start to print. Pick up a roll of ink with the end of your palette knife and spread a thin, even line of it across the full diameter of the ink disc **D**.

Put the press in the trip position by pushing the throw-off lever away from you **E**, and run the press until the ink is spread evenly across the ink disc and rollers. The ink disc should spin by a few degrees each time the platen closes. If you have the right amount of ink, the rollers should make a slightly tacky sound as they roll over the ink plate, like a sizzle on a hot griddle. Too much of that sound means you have too much ink on the press. Clean off the disc with a rag and some mineral spirits, and continue to even out the ink that remains on the rollers. Repeat this until you get the right sound.

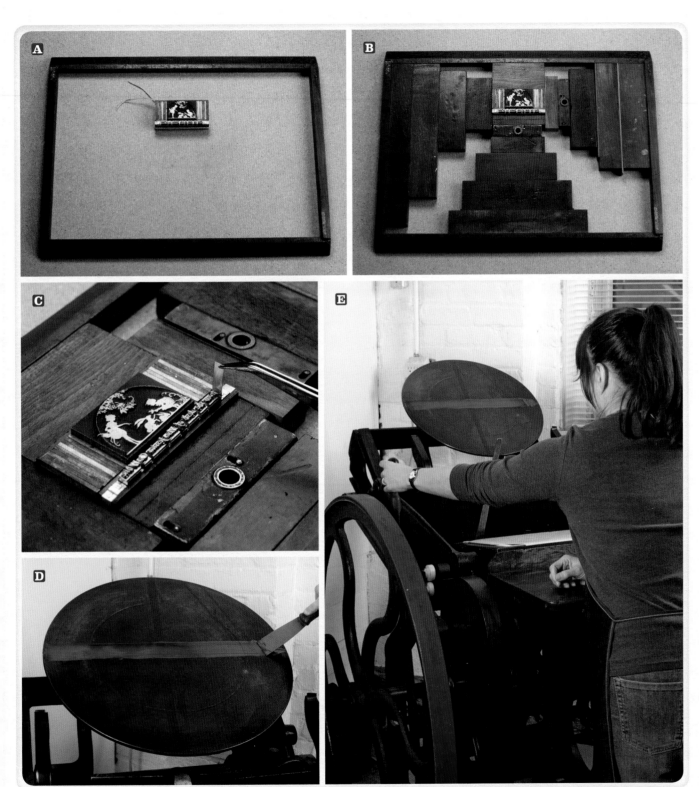

STEP 6 → Register with Mylar and gauge pins.

Once the ink is evenly spread out over the ink disc, pick up the chase by the two upper corners, place it on the press bed, and lock it into place **F**. Then ink the form. Activate the flywheel by spinning it with your hand, or use the foot treadle so that the platen closes and the rollers roll over the form. Do this three times to add three fresh layers of ink on the form.

Cut a piece of Mylar that's a little smaller than the size of the platen and tape it to the top of the platen with painter's tape. Put the press into the print position by pulling the throw-off lever toward you **G**. Activate the flywheel and print onto the Mylar. Where the print appears on the Mylar is where it will print on a piece of paper on the platen. Place a piece of the proof paper underneath the Mylar and align the text to print on the paper centered on the upper half of the sheet.

Hold the paper in place with one hand while you draw the bottom and left edges of the paper with the other—this is where you'll place your gauge pins.

STEP 7 → Print.

Before making final prints, make a few proof prints on your scrap paper. Place a sheet of proof paper on the tympan, then put the press in the print position and activate the flywheel to make a print. Check the proof for print quality. (Refer to the troubleshooting section on page 36 if you're having trouble getting good print quality.) Also, check the proof for where the print falls on the page. Use your line gauge to get precise measurements for any necessary changes and mark these measurements on the proof. To make adjustments, either move the gauge pins or take the chase out and adjust the furniture until the image prints in the right place.

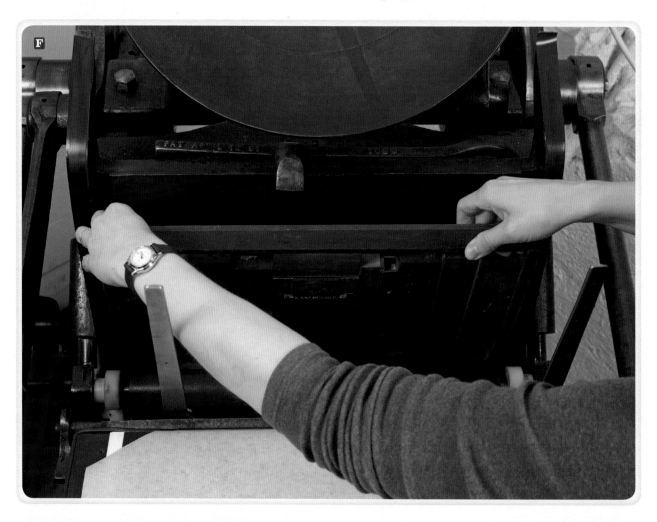

Once you're happy with the proof prints, you're ready to make the final prints! Place your stack of papers on the upper feed board and fan them out ⬛. Make sure the press is in the trip position and start up the press by turning on the motor or by using the foot treadle. While the press is running, put it in the print position by pulling the throw-off lever toward you.

When the platen opens, place a sheet of paper against it, sliding it against the gauge pins. Quickly move your hand out of the way as the platen closes ⬛. When the platen opens again, pull the printed sheet out with your left hand and place it on the delivery board while your right hand places the next sheet in place on the platen ⬛. Repeat for each print. If this is too much activity to handle when you're just starting out, push the throw-off lever back into the trip position between each print and print one sheet at a time. You'll work your way up to a rhythm with the press.

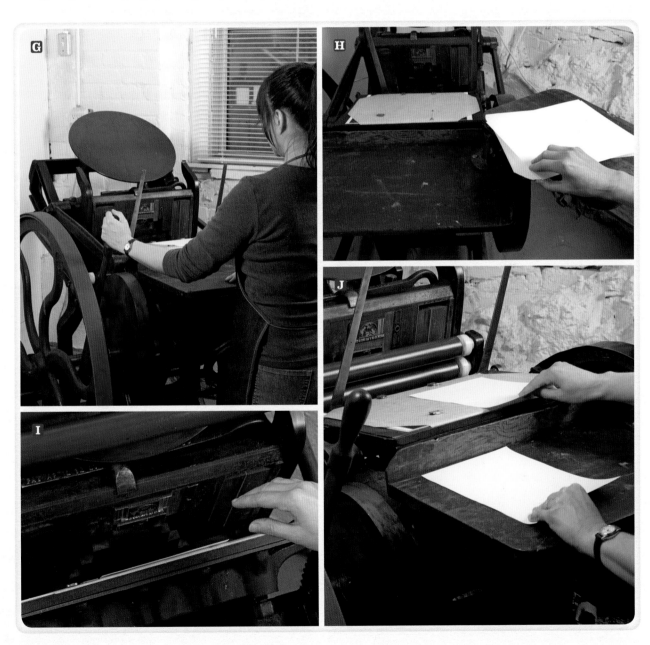

MASQUERADE MASKS

One of my favorite types of parties is a masquerade ball. Nothing's more fun than dressing up in disguise and assuming a new identity for the night. If you're planning an evening of intrigue, be sure to have a stack of masquerade masks on hand. Pass them out as party favors, and they'll add to the magic of the night.

TOOLS AND MATERIALS ★ **BASIC LETTERPRESS PRINTING TOOL KIT (PAGE 17)** ★ **CARDSTOCK** ★ **TRACING PAPER (OPTIONAL)** ★ **LINOLEUM BLOCK MOUNTED ON WOOD, 6 × 8 INCHES (15 × 20 CM)** ★ **BONE FOLDER (OPTIONAL)** ★ **PERMANENT MARKER (OPTIONAL)** ★ **LINOCUTTING TOOLS** ★ **BENCH HOOK OR NONSLIP RUG PAD (OPTIONAL)** ★ **MYLAR, SLIGHTLY SMALLER THAN THE PLATEN OF YOUR PRESS** ★ **COLORED PENCILS, MARKERS, CRAYONS, OR PAINT** ★ **GLUE AND GLUE BRUSH** ★ **GLITTER, LACE, FEATHERS, OR OTHER DECORATIVE ITEMS (OPTIONAL)** ★ **SCISSORS** ★ **LARGE OVAL PAPER PUNCH (OPTIONAL)** ★ **WOODEN POPSICLE OR STIR STICKS** ★ **ROUND PAPER PUNCH (OPTIONAL)** ★ **STRING OR ELASTIC (OPTIONAL)**

STEP 1 ➜ Sketch the mask.

Think about the kind of mask you want to make. Does your party have a theme? If not, then anything goes, from elegant Victorian-style masks to playful masks of cute little animals. Start by sketching out the basic shape of the mask, then fill in the details. Don't forget to indicate where the eyeholes will be cut out **A**!

STEP 2 ➜ Prepare the paper.

Use thick cardstock for this project so the mask will stand up and last through the night. To make room for the gauge pins, cut the paper at least 1 inch (2.5 cm) larger all the way around than the 6 × 8-inch (15 × 20-cm) linoleum block. You can trim off the excess after printing. Cut as many pieces of paper as you want to print. Be sure to cut at least 10 percent extra for mistakes or accidents, as well as a stack of scrap for proofs. For the proofs, cut to the same size as the printing paper.

STEP 3 ➜ Transfer the image to the linoleum block.

The simplest way to put an image on a linoleum block is to draw directly onto the block. Pencils and erasers both work well on linoleum blocks. However, the image will print as a mirror image of the cut so you'll have to reverse your image—especially text—as you draw, which can be tricky! This is why many people use tracing paper to transfer their images. To go this route, start by drawing or tracing your source image with a soft pencil (2B or softer) to get a nice, dark sketch on the tracing paper. Then turn the tracing paper over onto the linoleum block so that the graphite is in contact with the linoleum. Hold it firmly in place with one hand while rubbing over the back of the drawing with the bone folder. The pressure from the bone folder will transfer the graphite onto the linoleum and reverse the image at the same time! Check to make sure the entire image has been transferred before lifting the drawing, or you might have a hard time putting it back in the correct position.

Before cutting, I like to mark the areas that won't be cut away. These areas seem obvious now, but they can be hard to distinguish once you start cutting! Color in your image using a permanent marker. Then, when you move on to the next step, it will be easy to keep things straight—just cut around the black ink!

STEP 4 ➜ Cut the block.

Use the linocutting tools to cut away areas that you don't want printed. I like to outline the image first with a V tool, then cut away excess material with one of the larger gouges. Any linoleum left standing will be inked, and will make a printed mark. Anything you cut away will be the white space in your printed image. With this type of printing, you can only print solid areas: they'll either be "black" or "white." However, you can use patterns like dots or lines to create "gray" tones or add interest.

Always cut away from yourself and always place your fingers behind the cutter. To help hold the block steady and to create some pressure while cutting, use a bench hook or place the block on a nonslip rug pad. If you're having a hard time cutting the block, you can make the process easier by warming the linoleum under a desk lamp. If you're still having trouble, you may need a new blade.

STEP 5 ➜ Lock up the block.

On an imposing stone or table, place the linoleum block in the center of the chase. Measure the width of the block and fill in the space above and below it with furniture that's the same length or slightly shorter. Measure the height of the block, and fill in the two sides with furniture that's the same height or slightly shorter. Leave room for quoins on two sides of the block, making sure the quoins expand toward the block. Place furniture about 4 picas wide between the quoins and the form. Add reglets if necessary to fill in smaller spaces **B**.

Place one hand on the block and use a quoin key to lock up each quoin slightly. Repeat until both are locked securely—tight enough so that nothing moves but not so tight that you feel the block lifting up. If you feel the block lift up a little, then you've tightened the quoins too much. Release the quoins and tighten them again **C**.

STEP 6 ➜ Ink the press.

For instructions on how to do this, refer to the Personalized Stationery project on page 76.

STEP 7 ➜ Register with Mylar and gauge pins.

For instructions on how to do this, refer to the Personalized Stationery project on page 78.

STEP 8 ➜ Print.

Before making final prints, make a few proof prints on your scrap paper. Place a sheet of proof paper on the tympan, then put the press in the print position and activate the flywheel to make a print. Check the proof for print quality. (Refer to the troubleshooting section on page 36 if you're having trouble getting good print quality.) Also, check the proof for where the print falls on the page. Use your line gauge to get precise measurements for any necessary changes and mark these measurements on the proof. To make adjustments, either move the gauge pins or take the chase out and adjust the furniture until the image prints in the right place.

Once you're happy with the proof prints, you're ready to make the final prints! Place your stack of papers on the upper feed board and fan them out **D**. Make sure the press is in the trip position and start up the press by turning on the motor or by using the foot treadle. While the press is running, put it in the print position by pulling the throw-off lever toward you.

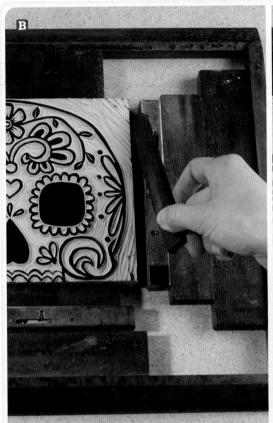

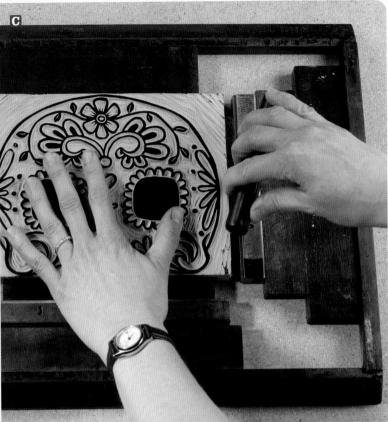

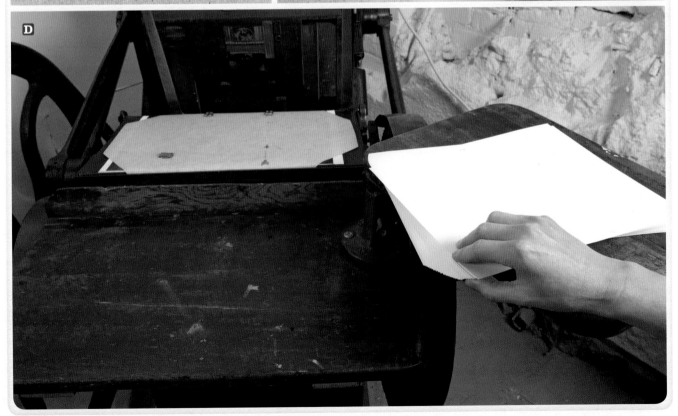

When the platen opens, place a sheet of paper against it, sliding it against the gauge pins. Quickly move your hand out of the way as the platen closes **E**. When the platen opens again, pull the printed sheet out with your left hand and place it on the delivery board while your right hand places the next sheet in place on the platen **F**. Repeat for each print. If this is too much activity to handle when you're just starting out, push the throw-off lever back into the trip position between each print and print one sheet at a time. You'll work your way up to a rhythm with the press.

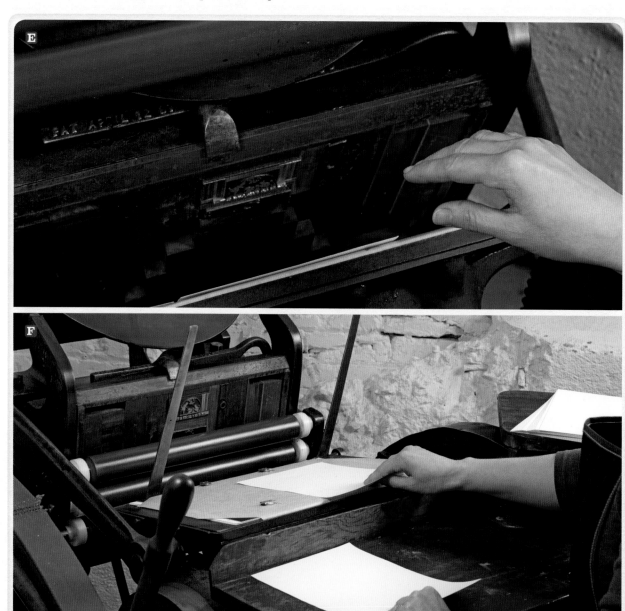

STEP 9 → Finishing.

Color the mask by hand with colored pencils, markers, crayons, or paint. Color each mask with the same colors, or have fun and change colors with every mask **G**. You can also decorate your printed mask by gluing on glitter, lace, or feathers. Let the masks dry overnight if you use paint or glue.

Use the scissors to cut out the masks. To cut out the eyeholes, use scissors, a craft knife, or a large oval paper punch. Glue one of the wooden Popsicle or stir sticks onto the back of each mask. Or, instead of wooden sticks, punch holes on both sides of each mask and tie string or elastic to them. Pass the masks out to your party guests, and let the masquerading begin!

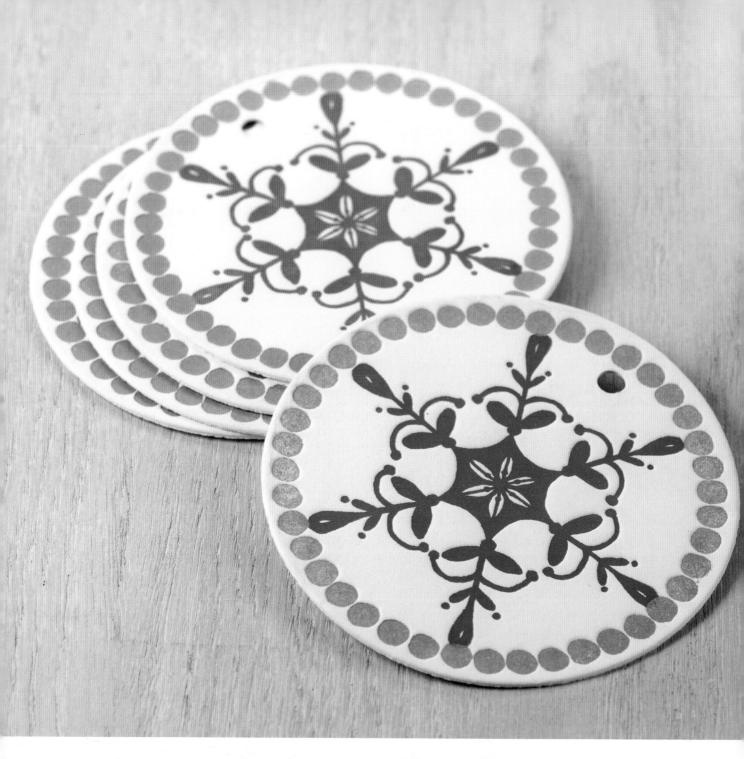

TREE ORNAMENTS

You may have noticed awesome letterpress-printed coasters at your local bar. Fortunately, blank coasters are still being produced for the commercial printing industry—and they're cheap and plentiful! This project puts a spin on the traditional coaster concept, offering an extra way to get creative with the little disks. You can also use the instructions to print your own personalized coasters.

TOOLS AND MATERIALS ★ BASIC LETTERPRESS PRINTING TOOL KIT (PAGE 17) ★ 4-INCH (10-CM) ROUND BLANK COASTERS, USUALLY SOLD IN PACKS OF 50 OR 100 ★ DRAWING PAPER FOR SKETCHING DESIGN ★ FROSTED MYLAR OR DRAFTING VELLUM ★ BLACK PIGMENT PEN ★ PHOTOPOLYMER PLATE OF YOUR DESIGN (SEE STEP 2) ★ CARDSTOCK FOR COASTER FRAME ★ SCISSORS ★ DOUBLE-STICK TAPE ★ ALUMINUM OR MAGNETIC BASE ★ ROUND PAPER PUNCH ★ STRING OR RIBBON

STEP 1 ➤ Sketch the image.

Use a blank coaster as a guide to draw a circle with a 4-inch (10-cm) diameter onto drawing paper. Inside the circle, draw a design that would look nice as a tree ornament, whether it's based on a season or a holiday. You're making this a design with two colors, but draw the entire design, keeping in mind that you won't be able to get a tight registration with this process.

Place a sheet of frosted Mylar or drafting vellum on top of the drawing, and trace over the design for one color using a black pigment pen. Get another sheet of the frosted Mylar or drafting vellum and trace over the design for the second color, also using a black pigment pen. You should now have two separate drawings in black ink, one for each color that will be printed.

STEP 2 ➤ Make the plate.

Unless you have a UV-exposure unit, you'll need to send your drawing away in order to have a photopolymer plate made of it. For a list of companies that make plates, check out the Resources section on page 172. Most companies offer two options: you can send them the hard copy of your drawing or submit it as a digital file. You should get in touch with the company before sending the file. They'll be able to walk you through the necessary steps and save you a lot of heartache (and money) down the road.

STEP 3 ➤ Make a frame for the tympan.

Using a blank coaster as a guide, draw a circle on a piece of cardstock that's about the same thickness as the coasters. Use a craft knife or scissors to cut away along the line so that the coaster fits snugly but doesn't get stuck. Cut away a notch above the opening so that it's easier to place and remove the coasters while you print. Tape it to the platen of the press with double-stick tape, and add small bits of tape around the center opening so that the coasters don't slide underneath the frame while printing **A**.

STEP 4 → Lock up the base.

On an imposing stone or table, place the aluminum base in the upper right corner of the chase. This will give extra room below and to the left of the chase for the gauge pins to clear without getting smashed.

Place one quoin on the left side and another at the bottom of the base, making sure the quoins expand toward the base. Add furniture to fill in the spaces until it's snug in the chase. Add reglets if necessary to fill in small spaces, and tighten each quoin with a quoin key **B**. Lock it securely—tight enough so that nothing moves but not so tight that you feel the base lifting up. If you feel the base lift up a little, then you've tightened the quoins too much. Release the quoins and tighten them again.

STEP 5 → Place the plate on the base.

If your plate was made for you, you may need to trim away excess plate material from around the image. Be sure to leave at least ¼ to ½ inch (6 mm to 1.3 cm) of plate material around the image areas. Cut away the image you'd like to print first.

Pick up the chase by the two upper corners, place it on the press bed, and lock it in place. Roll up a small piece of blue painter's tape and place it on the face of the polymer plate, then place the plate face down on one of the coasters in the place where you want it to print **C D**.

Place the coaster with the plate taped to it in the frame on the tympan. Remove the protective backing from the sticky side of the plate **E**. Put the press into the print position by pulling the throw-off lever toward you, then activate the flywheel to close the platen. The plate should stick to the base in the correct position for printing. Remove the coaster and any remaining tape and make sure the plate is adhered well to the base **F**. Remove the chase before inking the press.

STEP 6 ➜ Ink the press.

For instructions on how to do this, refer to the Personalized Stationery project on page 76.

STEP 7 ➜ Print.

Before making the final prints, make a few proof prints on your scrap paper. First, ink the form. Place the chase back on the press bed and put the press in the trip position by pushing the throw-off lever away from you. Activate the flywheel by spinning it with your hand or use the foot treadle so that the platen closes and the rollers roll over the form. Do this three times to add three fresh layers of ink on the plate before you start to print. Place a coaster

in the tympan frame. Put the press in the print position by pulling the throw-off lever toward you. Activate the flywheel and make a proof print .

Check the proof for print quality. If the print isn't in exactly the right spot on the coaster, make adjustments by moving the frame on the tympan or by moving the plate on the base. (Refer to the troubleshooting section on page 36 if you're having trouble getting good print quality.)

Once you're happy with the proof prints, go ahead and print the whole stack! Place your stack of coasters on the upper feed board. Make sure the press is in the trip

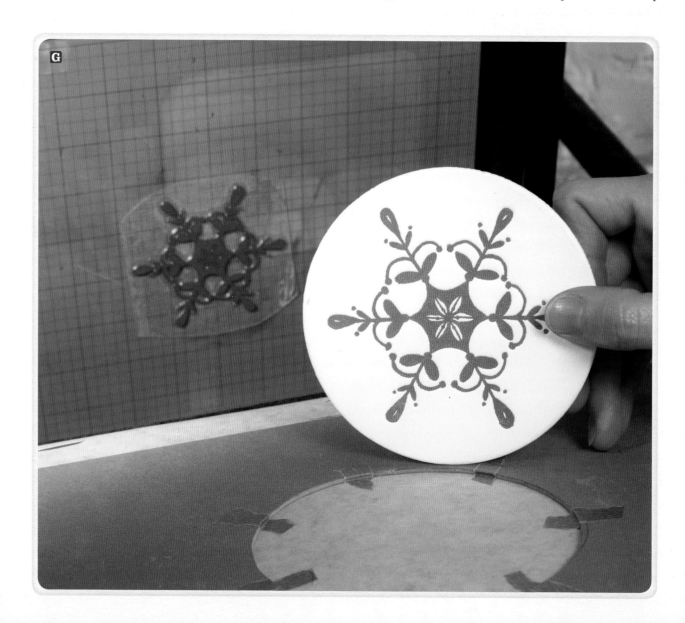

position and start up the press by turning on the motor or by using the foot treadle. While the press is running, put it in the print position by pulling the throw-off lever toward you. When the platen opens, place a coaster in the tympan frame. Quickly move your hand out of the way as the platen closes. When the platen opens again, pull the printed coaster out with your left hand and place it on the delivery board while your right hand places the next coaster in place on the platen. Repeat for each print. If this is too much activity to handle when you're just starting out, push the throw-off lever back into the trip position between each print, and print one disk at a time. You'll work your way up to a rhythm with the press.

STEP 8 → Prepare for the second printing.

After printing the first run on all of the coasters, set them aside and let them dry. If you plan on printing with a different color, clean the press with mineral spirits and let the rollers dry while you prepare the second plate. See page 39 for detailed cleaning instructions.

Take the chase out of the press, and clean the plate with a clean rag and a little bit of mineral spirits. Peel the plate off of the base and replace the plastic backing to protect the sticky layer. It's very important at this point that you don't move the base or the frame on the tympan, so that you print the second round in exactly the same place as the first. Trim the plate for the second run.

STEP 9 → Make the second printing.

Place the chase on the press bed and lock it into place (without the plate adhered to the base just yet). Roll up a small piece of painter's tape and place it on the face of the polymer plate, then place the plate face down on a previously printed coaster, registered in the place where you want it to print.

Place the plate on the base, repeating Step 5. Ink up the press, repeating Step 6. Print the second run on all of the coasters, repeating Step 7.

STEP 10 → Finish your coasters.

Use the round paper punch to punch a hole at the top of each ornament. Tie a piece of the string or ribbon to each ornament. Now you're ready to hang them up!

Where does the name of your press/shop come from?

I wanted a name that would encompass the many types of book-based concepts that I make, from laser-printed and photocopied ephemera to letterpress hand-bound books.

What does letterpress mean to you?

One my favorite quotations is "freedom of the press is guaranteed to those who own one." Letterpress means I have the capacity to print on demand, and that the typography will be exquisite.

How did you get your start as a printer?

When I started making artist books as a young adult, I used computer-based printers (photocopiers, laser printers, ink-jet printers) and was continually frustrated by the non-archival processes and the low-quality reproduction of text. I always wanted to letterpress print, but didn't learn how to do it until 2006, when I was a graduate student in the Book Arts Program at the University of Alabama. The first time I printed my own words on paper that I made by hand, I was hooked for life.

What was your first press?

My first press was loaned to me from Sarah Bryant of Big Jump Press. It is a Vandercook SP-20 in Studio 150 in Gordo, Alabama.

What do you use these days?

I bought a Vandercook SP-15 for $800 in 2009. The press had been in pieces in a friend's basement in New Jersey for 20 years. With the help of many people, I had it shipped to Alabama, and I finished reconstructing it during the summer of 2011. I repainted and reconditioned all the parts. It was an incredible learning experience; Vandercooks are wonderfully complex in their simplicity as machines. I know my press intimately.

What do you love most about letterpress?

The way that type looks when it has been letterpress printed, especially when it has been printed on handmade paper.

What is the biggest misconception about letterpress?

That it is easy to do, and that you can know how to print after one or two print jobs. It is a craft that requires years of printing before you know what you are doing. It is not just about creating a print with the correct impression and inking, but also about knowing how to use the tools (the press, the type, the press setup) expertly.

Who/what inspires you in your craft?

The processes of letterpress printing itself is inspiring to me. I can tell when I haven't printed in a while because I feel tense. I work in an incredible community of artists in Gordo, Alabama. When everyone around you is creating art, it is hard not to feel inspired and pressured to create. I also draw a great deal of inspiration from my peers in the letterpress printing world.

Describe your creative process.

I find a topic I want to publish an artist book about. I create a text-based narrative. To do this, I usually research the topic and compile a set of facts about the narrative. Then, I'll spend some time adapting the research into my own writing.

The topic of the narrative usually informs what kind of paper the artist book will be printed on. I like to use handmade paper, because I can use fibers and techniques that directly refer to the subject matter. For example, in my book *Habitat*, I used inclusions and pulp painting to reference physical effects of Hurricane Katrina on Biloxi, Mississippi.

I usually print books using photopolymer plates. I will create page layouts in InDesign and do most of the graphic design on the computer.

Sometimes, just so I can print, I will set a quotation I have overheard in metal or wood type and print it, in a small edition (for example: "That is what she said."). These are short typographic exercises that provide a good creative contrast to the detailed and long-ranging book projects.

Who are your favorite letterpress artists?

I get inspiration from many divergent sources, people of many different ages and backgrounds, including Glenn House Sr., Steve Miller, Amos Paul Kennedy Jr., Friedrich Kerksieck, Sarah Bryant, Ellen Knudson, Jessica C. White, Bridget Elmer, Emily Tipps, Barbara Tetenbaum, Walter Hamady, Emily Larned, Frank Brannon, and many more.

What are your favorite tools or printing methods?

Metal type, photopolymer plates, and a Vandercook of any type.

What are common themes/motifs in your work?

I try to use the power of typography within artist books to convey my subject matter and narratives. There is something fundamentally powerful about letterpress printing words and paragraphs, in the act of physically pressing the text into the paper. I try to let the aesthetics of the text in combination with the paper I make speak for itself.

Do you have a favorite subject matter?

I like to print artist books. The content of these books is driven by my writing, papermaking, and image making. I like to use my work to bring attention to topics not found in mainstream publishing. Some of my work is about human emotion, some is about shared but underexplored American narratives, such as the history of a race riot in Rochester, New York, or Ma'Cille's Museum of Miscellanea in rural Alabama.

Do you have a favorite printing trick or tip you can offer?

Make sure you print as much as you can. Sometimes your printing won't be good, but try to do it as much as possible. It is the only way to get better.

Where do you see letterpress in the next 50 years?

I hope it will continue to expand in academia through the medium of artist books. I would like to see book arts programs at universities and colleges across the country.

Cause and Effect

Jessica Peterson, 2009

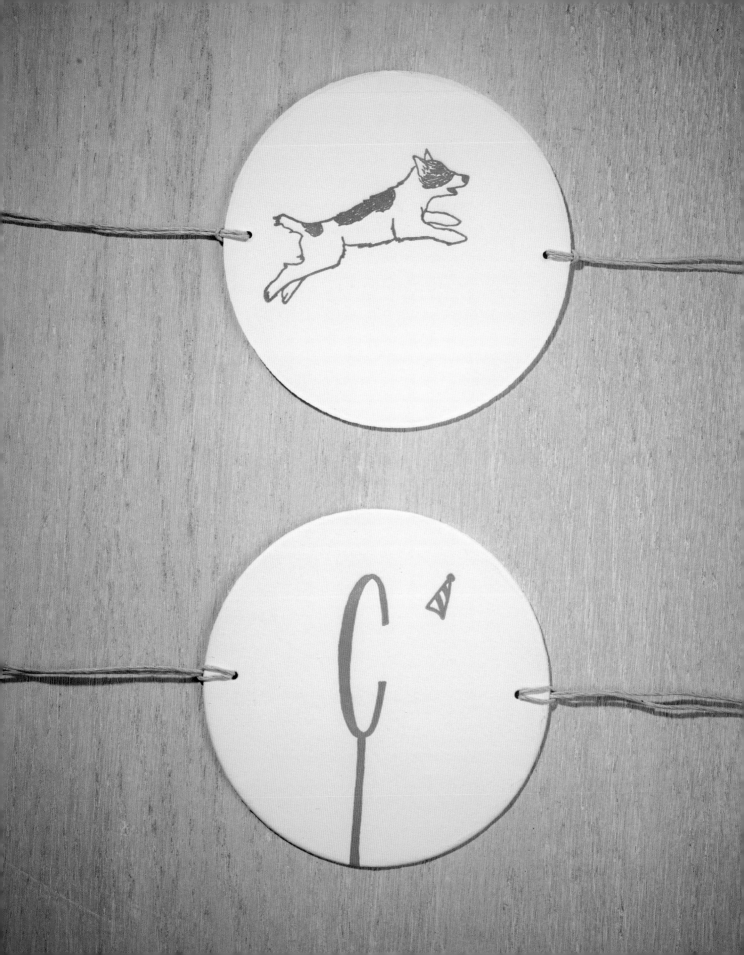

THAUMATROPE

In the early 1800s, scientific experiments on vision led to the discovery of a phenomenon known as the "persistence of vision," whereby our brains continue to "see" an image for a fraction of a second after it's disappeared. The thaumatrope—one of the toys that resulted from the visual research—plays with this extraordinary optic phenomenon. A typical thaumatrope consists of a single card with two separate still images, one on each side of the card. When the card is twirled by strings that are tied to each side, the still images combine to create a single image. Follow the instructions below to make your own thaumatrope. Prepare to be amazed!

TOOLS AND MATERIALS ★ BASIC LETTERPRESS PRINTING TOOL KIT (PAGE 17) ★ 4-INCH (10-CM) ROUND BLANK COASTERS, USUALLY SOLD IN PACKS OF 50 OR 100 ★ DRAWING PAPER FOR SKETCHING DESIGN ★ FROSTED MYLAR OR DRAFTING VELLUM ★ BLACK PIGMENT PEN ★ RULER OR TRIANGLE ★ PHOTOPOLYMER PLATE OF YOUR DESIGN (SEE STEP 3) ★ CARDSTOCK FOR COASTER FRAME ★ ALUMINUM OR MAGNETIC BASE ★ SMALL ROUND PAPER PUNCH OR AWL ★ STRING OR RIBBON

STEP 1 ➤ Sketch the image.

Use a blank coaster as a guide to draw a circle with a 4-inch (10-cm) diameter onto drawing paper. Inside this circle, draw a design you can split into two separate images that will come together again as one. Vintage thaumatropes often featured images of a bird in a cage or a horse and rider—with the horse on one side and the rider on the other. You should draw your entire design, both sides together, on the sheet of drawing paper.

Place a sheet of the frosted Mylar or drafting vellum on top of the drawing, and trace over the design for one side using a black pigment pen. Use another sheet of frosted Mylar or drafting vellum to trace over the design for the second side with the black pigment pen. You should now have two separate drawings in black ink, one for each side that will be printed.

STEP 2 ➤ Prepare the blank coasters.

Stack the coasters, place a ruler or triangle up against the stack, and use a pencil to draw a line along the edge of each coaster **A**. Do this to several smaller stacks if one stack is too high and unwieldy. Repeat on the other side of the coasters so that the marks are directly opposite each other. These lines will be used for registration during printing.

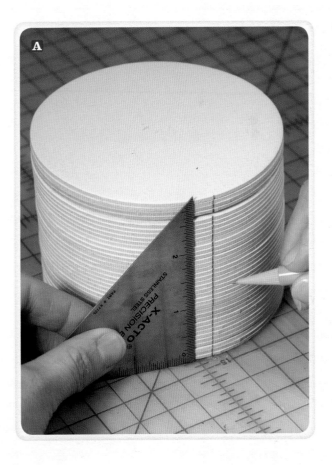

STEP 3 ➔ Make the plate.

For instructions on how to do this, refer to the Tree Ornaments project on page 87.

STEP 4 ➔ Make a frame for the tympan.

For instructions on how to do this, refer to the Tree Ornaments project on page 87. Make sure that the notch cut out in the frame is pointing away from the press on the tympan **B**. Then draw a line on the tympan in the cutout notch of the frame that matches up with the marks on the coasters **C**. This will be the registration line. Match it up with the mark on one side of the coasters every time you print.

STEP 5 ➔ Lock up the base.

For instructions on how to do this, refer to the Tree Ornaments project on page 88.

STEP 6 ➔ Place the plate on the base.

For instructions on how to do this, refer to the Tree Ornaments project on page 88.

STEP 7 ➔ Ink the press.

For instructions on how to do this, refer to the Personalized Stationery project on page 76.

STEP 8 ➔ Print.

Before making the final prints, make a few proof prints on your scrap paper. First, ink the form. Place the chase back on the press bed and put the press in the trip position by pushing the throw-off lever away from you. Activate the flywheel by spinning it with your hand or use the foot treadle so that the platen closes and the rollers roll over the form. Do this three times to add three fresh layers of ink on the plate before you start to print. Place a coaster in the tympan frame, aligned to the registration line. Put the press in the print position by pulling the throw-off lever toward you. Activate the flywheel and make a proof print **D**.

Check the proof for print quality. If the print isn't in exactly the right spot on the coaster, make adjustments by moving the frame on the tympan or by moving the plate on the base. (Refer to the troubleshooting section on page 36 if you're having trouble getting good print quality.)

Once you're happy with the proof prints, go ahead and print the whole stack! Place your stack of coasters on the upper feed board. Make sure the press is in the trip position and start up the press by turning on the motor or by using the foot treadle. While the press is running, put it in the print position by pulling the throw-off lever toward you. When the platen opens, place a coaster in the tympan frame. Quickly move your hand out of the way as the platen closes. When the platen opens again, pull the printed coaster out with your left hand and place it on the delivery board while your right hand places the next coaster in place on the platen. Repeat for each print. If this is too much activity to handle when you're just starting out, push the throw-off lever back into the trip position between each print, and print one disk at a time. You'll work your way up to a rhythm with the press.

STEP 9 ➔ Prepare for the second printing.

After printing the first run on all of the coasters, set them aside and let them dry.

If you plan on printing with a different color, clean the press with mineral spirits and let the rollers dry while you prepare the second plate. See page 38 for detailed cleaning instructions.

Take the chase out of the press, and clean the plate with a clean rag and a little bit of mineral spirits. Peel the plate off of the base and replace the plastic backing to protect the sticky layer. It's very important at this point that you don't move the base or the frame on the tympan, so that you print the second round in exactly the same place as the first. Trim the plate for the second run.

STEP 10 → Make the second printing.

Place the chase on the press bed and lock it into place (without the plate adhered to the base just yet). Roll up a small piece of painter's tape and place it on the face of the polymer plate, then place the plate face down on a previously printed coaster, registered in the place where you want it to print.

Place the plate on the base, repeating Step 6. Ink up the press, repeating Step 7. Turn the coasters over, and print the second run on the backs of the previously printed coasters. This time, register each one to the pencil mark on the opposite side of the coaster so that the second print is upside down in comparison to the first print.

STEP 11 → Finishing.

Use the small round paper punch or the awl to punch a hole on both sides of each disk. Tie a piece of the string or ribbon to each side **E**.

To activate the toy, first hold one string in your hand and rotate the disk to wind the string. Then hold both strings and give them a tug so the disk will spin. The faster the disk spins, the better the illusion.

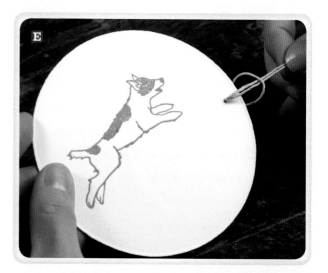

INVITATIONS WITH RSVPS

So many wedding and baby shower invitations are now being letterpress printed that people must be catching on to how special a hand-printed invitation can be. I love to print up my own invitations because it lets me put my personal touch on the event that's taking place, whether it's an elegant sit-down dinner or a come-as-you-are potluck. With this project, you'll knock out two birds with one stone by printing the RSVP card on the same sheet as the invitation. The RSVPs will be perforated so that they can be torn off and mailed back. I put a twist on the traditional reply card by printing raffle tickets rather than conventional RSVPs.

TOOLS AND MATERIALS ★ BASIC LETTERPRESS PRINTING TOOL KIT (PAGE 17) ★ DRAWING PAPER FOR SKETCHING IMAGE ★ FROSTED MYLAR OR DRAFTING VELLUM ★ MARKERS OR COLORED PENCILS ★ BLACK PIGMENT PEN ★ CARDSTOCK, AT LEAST 8 ½ × 11 INCHES (21.5 × 28 CM) ★ PHOTOPOLYMER PLATE OF YOUR DESIGN ★ ALUMINUM OR MAGNETIC BASE ★ PAPER CUTTER ★ PERFORATING RULE ★ CORKING OR EJECTION RUBBER ★ DIE-CUTTING JACKET

STEP 1 ➤ Sketch the image.

Make some sketches for your invitation that are specific to the event. Is the occasion a holiday party or a birthday party? Are kids or adults invited? Include all the pertinent information (date, time, etc.), as well as a section for RSVP-ing. Make the invitation personal, and let it reflect your unique style. You'll be printing two invitations per sheet of paper. The finished invitation should be able to fit in a letter-size envelope, so make your design no larger than 4 × 9 ½ inches (10 × 24 cm).

Your design should have three colors. Draw the entire design on a regular sheet of drawing paper, then place a sheet of the frosted Mylar or drafting vellum on top of it. Trace over the design using the markers or colored pencils to come up with a color scheme. Using this method, you can try a few different combinations of colors and see how well they work together without having to redraw the whole design each time **A**.

One you've decided which color each part of the design will be, place a clean sheet of frosted Mylar or drafting vellum on top of the original drawing, and trace over the design for one color using a black pigment pen. Get another sheet of frosted Mylar or drafting vellum and trace over the design for the second color, also using the pigment pen. Repeat for the third color. You should now have three separate drawings in black ink, one for each color that will be printed **B**.

STEP 2 ➤ Prepare the paper.

For this project, you'll need cardstock that's 8 ½ × 11 inches (21.5 × 28 cm). Cut (or buy) as many pieces as you want to print. Be sure to cut at least 40 percent extra for mistakes or accidents (in this project, there are four runs, including perforation, and you want 10 percent extra per

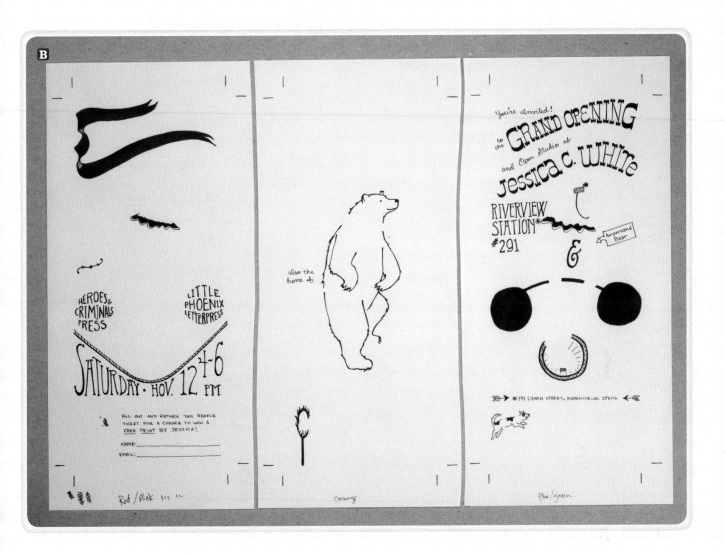

run), as well as a stack of scrap for proofs. For the proofs, cut to the same size as the printing paper. Because you'll be printing two invitations on each sheet, don't forget to divide this number in half for the number of sheets of printing paper that you need to prepare.

STEP 3 ➜ Make the plate.

For instructions on how to do this, refer to the Tree Ornaments project on page 87.

STEP 4 ➜ Lock up the base.

For instructions on how to do this, refer to the Tree Ornaments project on page 87.

STEP 5 ➜ Ink the press.

For instructions on how to do this, refer to the Personalized Stationery project on page 76.

STEP 6 ➜ Register with Mylar and gauge pins.

If your plate was made for you, you may need to trim away excess plate material from around the image. Be sure to leave at least ¼ to ½ inch (6 mm to 1.3 cm) of plate material around the image areas. Cut away the image you'd like to print first.

Peel the protective backing away from the sticky side of the plate, then place the plate on the base in a rolling motion, making sure that no air bubbles are trapped underneath. Place the plate near the top of the base. Gently rub over

the plate with a clean rag or clean hands to make sure it's securely adhered. Pick up the chase by the two upper corners, place it on the press bed, and lock it into place. Then ink the form. Activate the flywheel by spinning it with your hand or use the foot treadle so that the platen closes and the rollers roll over the form. Do this three times to add three fresh layers of ink on the form.

Cut a piece of Mylar that's a little smaller than the size of the platen and tape it to the top of the platen with painter's tape. Put the press into the print position by pulling the throw-off lever toward you. Activate the flywheel and print onto the Mylar. Where the print appears on the Mylar is where it will print on a piece of paper on the platen. Place a piece of the proof paper underneath the Mylar and align the text to print on the paper centered on the upper half of the sheet.

Hold the paper in place with one hand while you draw the bottom and left edges of the paper with the other—this is where you'll place your gauge pins **C**. Make sure the gauge pins are well out of the way of the base so that they don't get damaged when the platen closes.

STEP 7 ➤ Print.

Before making final prints, make a few proof prints on your scrap paper. Place a sheet of proof paper on the tympan, then put the press in the print position and activate the flywheel to make a print. Check the proof for print quality. (Refer to the troubleshooting section on page 36 if you're having trouble getting good print quality.) Also, check the proof for where the print falls on the page. Use your line gauge to get precise measurements for any necessary changes and mark these measurements on the proof. To make adjustments, either move the gauge pins or move the plate on the base until the image prints in the right place.

Once you're happy with the proof prints, you're ready to make the final prints! Place your stack of papers on the upper feed board and fan them out. Make sure the press is in the trip position and start up the press by turning on the motor or by using the foot treadle. While the press is running, put it in the print position by pulling the throw-off lever toward you.

When the platen opens, place a sheet of paper against it, sliding it against the gauge pins. Quickly move your hand out of the way as the platen closes. When the platen opens again, pull the printed sheet out with your left hand and place it on the delivery board while your right hand places the next sheet in place on the platen. Repeat for each print. If this is too much activity to handle when you're just starting out, push the throw-off lever back into the trip position between each print, and print one sheet at a time. You'll work your way up to a rhythm with the press.

Spin each sheet of paper around and print the same image again on the other side. You can do this as you print each sheet, or finish the whole stack, then print the other side **D**. Printing two prints at a time on one sheet using this method is called a "work-and-turn."

STEP 8 ➤ Prepare for the second printing.

After printing the first run on all of the invitations, set them aside and let them dry. Clean the press with mineral spirits and let the rollers dry while you prepare the second plate. See page 38 for detailed cleaning instructions.

Take the chase out of the press, and clean the plate with a clean rag and a little bit of mineral spirits. Peel the plate off of the base and replace the plastic backing to protect the sticky layer. It's very important at this point that you don't move the base or the gauge pins on the tympan, so that you print the second round in exactly the same place as the first. Trim the plate for the second run.

STEP 9 ➤ Print the second and third runs.

Place the chase on the press bed, and lock it into place (without the plate adhered to the base just yet). Roll up a small piece of painter's tape and place it on the face of the polymer plate, then place the plate face down on a previously printed invitation, registered in the place where you want it to print **E**.

Remove the protective backing from the sticky side of the plate, then place the print with the plate taped to it in position on the tympan **F**. Put the press into the print position, then activate the flywheel to close the platen. The plate should stick to the base in the correct position for printing. Remove the print and any remaining tape and make sure the plate is adhered well to the base. Remove the chase before inking the press.

Ink the press, repeating Step 5. Place the chase back on the press and print the second run on all of the invitations, repeating Step 7 **G**. Repeat Step 8 and this step for the third run.

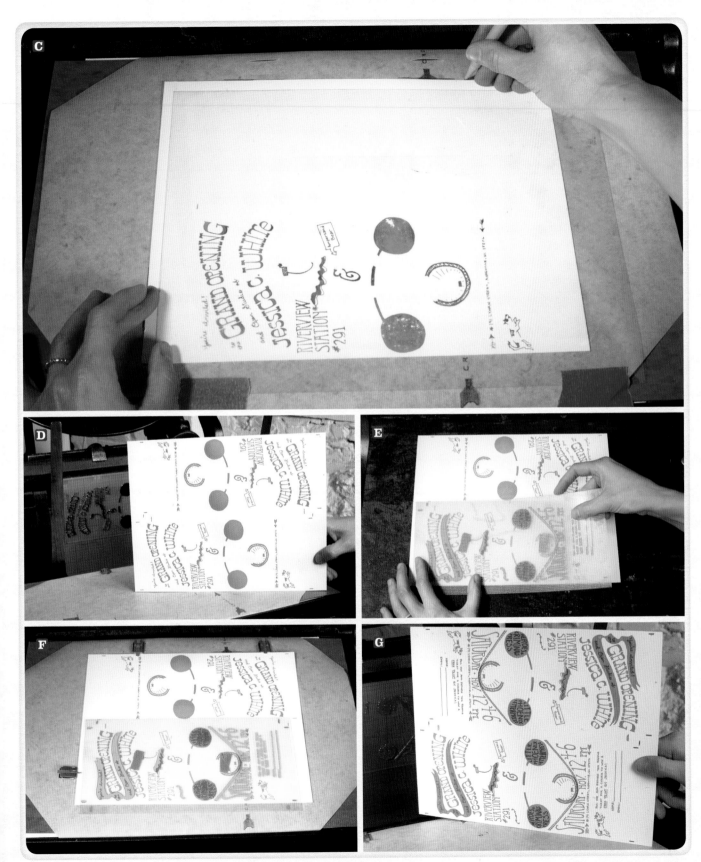

STEP 10 → Perforate the paper.

Because of the work-and-turn method of printing, the raffle ticket is now printed on both sides of each sheet, and you'll need to perforate them separately. Use a paper cutter to cut each sheet down the middle and separate the invitations.

Lock up the perforating rule. On an imposing stone or table, place the perforating rule between two pieces of furniture of the same length or slightly longer in your chase. Fill in the space above and below it with furniture that's the same length. Fill in the space on both sides of the perforating rule with furniture that's slightly shorter. Leave room for quoins, one on the right and one above the form. Place furniture about 4 picas wide between the quoins and the form. Never place a quoin directly against the form **H**.

Add reglets if necessary to fill in small spaces, and tighten each quoin with a quoin key. Lock it securely—tight enough so that nothing moves but not so tight that you feel the form lifting up. If you feel the form lift up a little, then you've tightened the quoins too much. Release the quoins and tighten them again.

Glue strips of corking or ejection rubber on the furniture on both sides of the rule. This will prevent the sheets of paper from getting stuck on the rule with every cut. Weather-stripping rubber with an adhesive back that's about ½ inch (1.3 cm) thick works well for this purpose **I**.

Lift the upper tympan bale and slide a thin metal plate underneath the packing and against the platen. Tape it to the platen **J**. This is called the die-cutting jacket (or die-cutting plate), and it protects the platen from the sharp edges of the perforating rule. Remove most of the packing for now, and add more as you test the perforating rule, building it up slowly until you have the right amount of packing to get a good cut. Don't forget to remove the rollers from your press—this will prevent the perforating rule from damaging them!

Tape a scrap sheet of card to the tympan. Put the press in the print position and close the platen to test where the perforating rule cuts. Register a printed invitation to that line, mark the paper edges on the tympan, and put gauge pins in place. If necessary, add packing to get a good clean cut all the way through the invitation. Run each invitation through the press like you do when you're printing **K**.

STEP 11 → Finishing.

Trim each invitation down to the correct size. Mail each one, and then prepare for your big party!

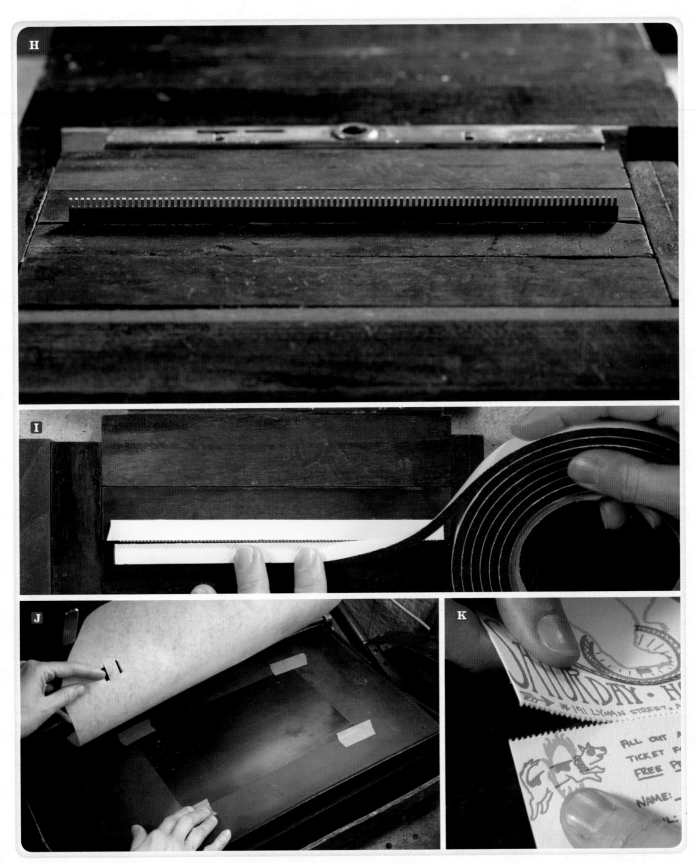

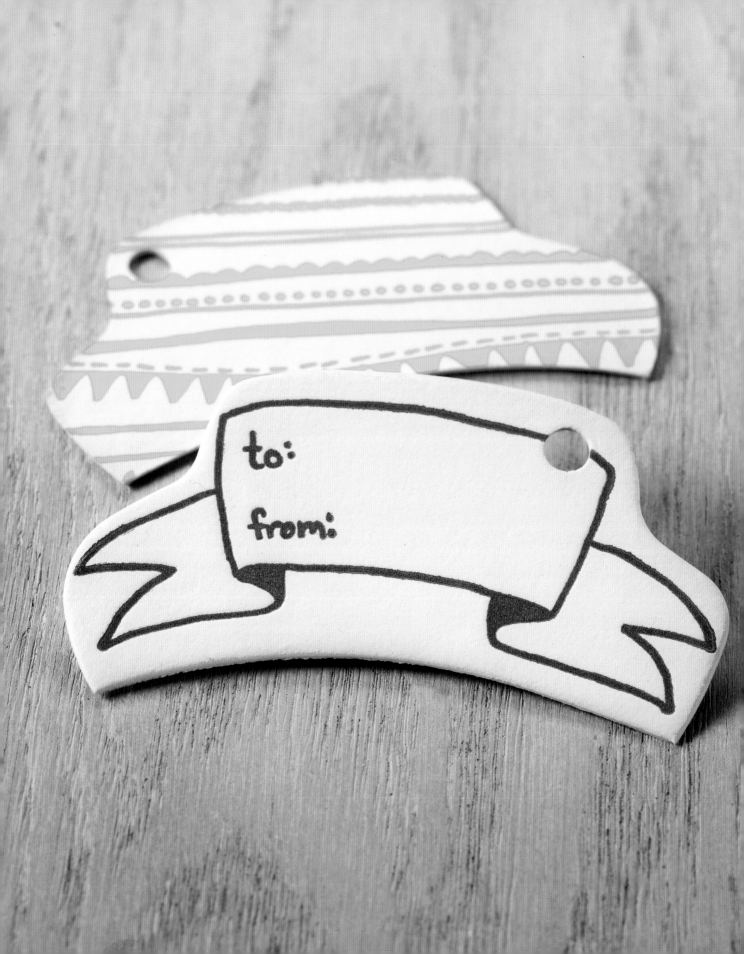

GIFT TAGS

When it comes to gift giving, presentation is everything. From ribbons to wrapping paper, small details make all the difference! Gift tags don't have to be an afterthought. You can easily print beautiful, customized tags that will add pizzazz to any present.

TOOLS AND MATERIALS ★ BASIC LETTERPRESS PRINTING TOOL KIT (PAGE 17) ★ DRAWING PAPER FOR SKETCHING DESIGN ★ GLUE STICK (OPTIONAL) ★ FROSTED MYLAR OR DRAFTING VELLUM ★ BLACK PIGMENT PEN ★ CARDSTOCK, 8½ × 11 INCHES (21.5 × 28 CM) ★ PHOTOPOLYMER PLATE OF YOUR DESIGN (SEE STEP 3) ★ STEEL RULE DIE (SEE STEP 3) ★ ALUMINUM OR MAGNETIC BASE ★ DIE-CUTTING JACKET ★ ROUND PAPER PUNCH ★ RIBBON

STEP 1 ➜ Sketch the image.

For this project, you'll need to sketch three designs: one for the front of the tag, another that will serve as an allover pattern for the back of the tag, and a third that will be the cutout shape of the tag. The die that will be used to cut out the shapes is made from bent strips of metal, so try to keep your designs fairly simple.

You'll be printing eight tags per sheet of paper (each one is about 2 × 4 inches [5 × 10 cm]), but you'll only print four tags at a time. That means your plate design will only be for four tags and it should fit into an 8½-inch-wide × 5½-inch-tall (21.5 × 14 cm) sheet of paper.

Start by dividing up your page into four even spaces. Draw your design so that it fits inside one of the four the grids with plenty of margin all around. On that drawing, you can also add anything you want printed on the tag, either a design or text. Draw the same design in the three other spaces of the grid, or make copies of the drawing, cut them out, and stick them to the grid using the glue stick **A**. Once you have all four spaces filled in, place a sheet of the frosted Mylar or drafting vellum on top of the grid and trace over the design for the die using a black pigment pen. Don't move the Mylar as you make these drawings—they should fit the grid in the same way that the original drawings do **B**.

For the allover pattern that will be printed on the back of the tags, get another sheet of drawing paper that's the same size as the front of your design (8 ½ inches wide × 5 ½ inches tall [21.5 × 14 cm]) and draw a pattern that covers the entire page **C**. You now should have three separate drawings in black ink—two that will be printed and another for the die.

STEP 2 ➜ Prepare the paper.

For this project, you'll need cardstock that's 8 ½ × 11 inches (21.5 × 28 cm). Cut (or buy) as many pieces as you want to print. Be sure to cut at least 30 percent extra for mistakes or accidents (in this project, there are three runs, including die cutting, and you want 10 percent extra per run), as well as a stack of scrap for proofs. For the proofs, cut to the same size as the printing paper. Because you'll be printing eight tags on each sheet of paper, don't forget to divide this number by 8 for the number of sheets of printing paper that you need to have prepared.

STEP 3 ➜ Order the plate and die.

For instructions on ordering the plate, refer to the Tree Ornaments project on page 87. You may be able to find a local die manufacturer through a search on the Internet. If not, refer to the Resources section on page 172, or ask another printer for suggestions. Once you find a manufacturer, let them know that you're interested in having a die made at type height (0.918 inch [23.3 mm]) for die cutting on a letterpress press. Most companies offer the same two options as plate makers for receiving original designs.

STEP 4 ➜ Lock up the base.

For instructions on how to do this, refer to the Tree Ornaments project on page 88.

STEP 5 ➜ Ink the press.

For instructions on how to do this, refer to the Personalized Stationery project on page 76.

STEP 6 ➜ Register with Mylar and gauge pins.

If your plate was made for you, you may need to trim away excess plate material from around the image. Be sure to leave at least ¼ to ½ inch (6 mm to 1.3 cm) of plate material around the image areas. Cut away the image you'd like to print first.

Peel the protective backing away from the sticky side of the plate, then place the plate on the base in a rolling motion, making sure that no air bubbles are trapped underneath. Place the plate near the top of the base. Gently rub over the plate with a clean rag or clean hands to make sure it's adhered securely. Pick up the chase by the two upper corners, place it on the press bed, and lock it into place. Then ink the form. Activate the flywheel by spinning it with your hand or use the foot treadle so that the platen closes and the rollers roll over the form. Do this three times to add three fresh layers of ink on the form.

Cut a piece of Mylar that's a little smaller than the size of the platen and tape it to the top of the platen with painter's tape. Put the press into the print position by pulling the throw-off lever toward you. Activate the flywheel and print onto the Mylar. Where the print appears on the Mylar is where it will print on a piece of paper on the platen. Place a piece of the proof paper underneath the Mylar and align the text to print on the paper centered on the upper half of the sheet.

Hold the paper in place with one hand while you draw the bottom and left edges of the paper with the other—this is where you'll place your gauge pins (as seen on page 111). Make sure the gauge pins are well out of the way of the base so that they don't get damaged when the platen closes.

STEP 7 → Print.

Before making final prints, make a few proof prints on your scrap paper. Place a sheet of proof paper on the tympan, then put the press in the print position and activate the flywheel to make a print. Check the proof for print quality.

(Refer to the troubleshooting section on page 36 if you're having trouble getting good print quality.) Also, check the proof for where the print falls on the page. Use your line gauge to get precise measurements for any necessary changes and mark these measurements on the proof. To make adjustments, either move the gauge pins or move the plate on the base until the image prints in the right place.

Once you're happy with the proof prints, you're ready to make the final prints! Place your stack of papers on the upper feed board and fan them out. Make sure the press is in the trip position and start up the press by turning on the motor or by using the foot treadle. While the press is running, put it in the print position by pulling the throw-off lever toward you.

When the platen opens, place a sheet of paper against it, sliding it against the gauge pins. Quickly move your hand out of the way as the platen closes. When the platen opens again, pull the printed sheet out with your left hand and place it on the delivery board while your right hand places the next sheet in place on the platen. Repeat for each print. If this is too much activity to handle when you're just starting out, push the throw-off lever back into the trip position between each print, and print one sheet at a time. You'll work your way up to a rhythm with the press.

Spin each sheet of paper around and print the same image again on the other side **D**. You can do this as you print each sheet, or finish the whole stack, then print the other side. Printing two prints at a time on one sheet using this method is called a "work-and-turn."

STEP 8 ➜ Prepare for the second printing.

After printing the first run on all of the tags, set them aside and let them dry. Clean the press with mineral spirits and let the rollers dry while you prepare the second plate. See page 38 for detailed cleaning instructions.

Take the chase out of the press, and clean the plate with a clean rag and a little bit of mineral spirits. Peel the plate off of the base and replace the plastic backing to protect the sticky layer. It's very important at this point that you don't move the base or the gauge pins on the tympan, so that you print the second round in exactly the same place as the first. Trim the plate for the second run.

STEP 9 ➜ Print the second run.

Place the chase on the press bed, and lock it into place (without the plate adhered to the base just yet). Roll up a small piece of painter's tape and place it on the face of the polymer plate, then place the plate face down on a previously printed piece of paper, registered in the place where you want it to print.

Remove the protective backing from the sticky side of the plate, then place the print with the plate taped to it in position on the tympan. Put the press into the print position, then activate the flywheel to close the platen. The plate should stick to the base in the correct position for printing. Remove the print and any remaining tape and make sure the plate is adhered well to the base. Remove the chase before inking the press.

Ink the press, repeating Step 5. Place the chase back on the press and print the second run on the other side of the prints, repeating Step 7 **E**.

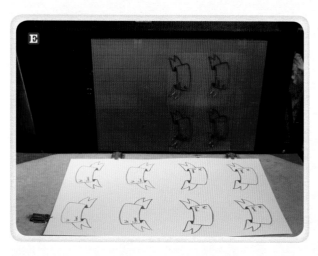

STEP 10 ➜ Die cutting.

Lock up the die in your chase. On an imposing stone or table, place the die in the chase. Fill in the spaces above and below it with furniture that's the same length or slightly shorter. Fill in the space on both sides of the die with furniture that's the same length or slightly shorter. Leave room for quoins, one on the right and one above the form. Add reglets if necessary to fill in small spaces, and tighten each quoin with a quoin key **F**. Lock it securely—tight enough so that nothing moves but not so tight that you feel the die lifting up. If you feel the die lift up a little, then you've tightened the quoins too much. Release the quoins and tighten them again.

Lift the upper tympan bale and slide a thin metal plate underneath the packing and against the platen. Tape it to the platen **G**. This is called the die-cutting jacket (or die-cutting plate), and it protects the platen from the sharp edges of the die. Remove most of the packing for now, and add more as you test the die, building it up slowly until you have the right amount of packing to get a good cut. Don't forget to remove the rollers from your press! This will keep the die from damaging them.

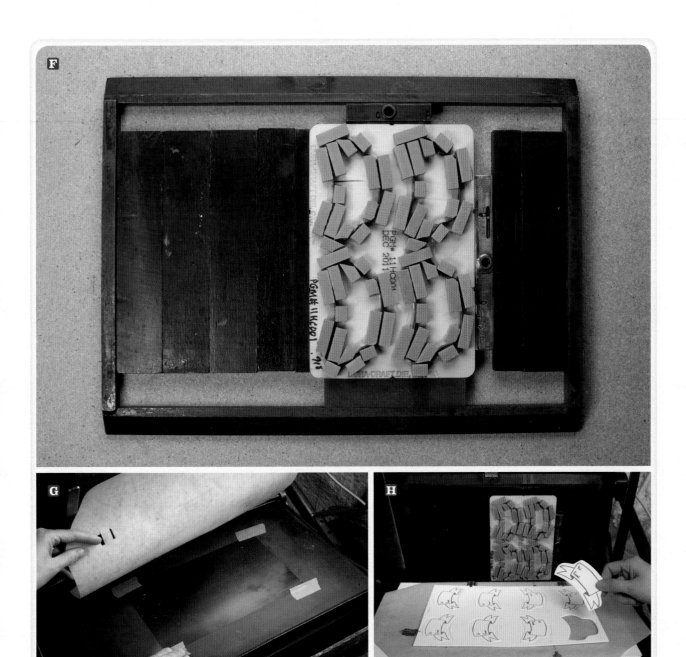

Tape a scrap sheet of cardstock to the tympan. Put the press in the print position and close the platen to test where the die cuts. Place one of your printed tag sheets underneath the cut scrap, and align your designs in the cutout spaces. Mark the paper edges on the tympan and put gauge pins in place. If necessary, add packing to get a good clean cut all the way through the prints. Run each tag sheet through the press like you do when you're printing **H**.

STEP 11 ➔ Finishing.

Use the round paper punch to make a hole in the side of one of the tags. Thread a piece of the ribbon through the hole, and you've got the perfect finishing touch for that special gift!

ALL-OCCASION CARDS

Don't get caught without the right card for that special occasion! With these customizable greetings, you'll be covered for any event, from birthdays to baby showers. Just spin the dial on the front of the card until the appropriate message shows in the window, add a personal note, and send it off to that special someone.

TOOLS AND MATERIALS ★ BASIC LETTERPRESS PRINTING TOOL KIT (PAGE 17) ★ DRAWING PAPER FOR SKETCHING IMAGE ★ COMPASS (FOR DRAWING CIRCLES) ★ PROTRACTOR ★ COMPUTER AND SCANNER (OPTIONAL) ★ TRACING PAPER (OPTIONAL) ★ FROSTED MYLAR OR DRAFTING VELLUM ★ BLACK PIGMENT PEN ★ CARDSTOCK, 8 1/2 × 5 1/2 INCHES (21.5 × 28 CM) ★ PHOTOPOLYMER PLATE OF YOUR DESIGN (SEE STEP 3) ★ STEEL RULE DIE (SEE STEP 3) ★ ALUMINUM OR MAGNETIC BASE ★ DIE-CUTTING JACKET ★ AWL OR SMALL ROUND PAPER PUNCH ★ SMALL DECORATIVE BRADS

STEP 1 ➜ Sketch the image.

For this project, you'll need to create two designs: one for the card in front that spins, and another for the background card. The die that cuts out the cards can be made into almost any shape, but for this project you'll make a simple circular spin card.

Use the compass to draw two circles with 4-inch (10-cm) diameters. Using the protractor, divide one of the 4-inch (10-cm) circles into six even slices. In each slice, write a different greeting. You can also use your computer to compose the greetings. Just print the text, cut it out, and tape it into place. The other circle will be the top card that spins. In this circle, sketch a design that includes a cutout window where the greeting will show from the card that's underneath. Draw in a space for a personal note or some decorative elements, like a border 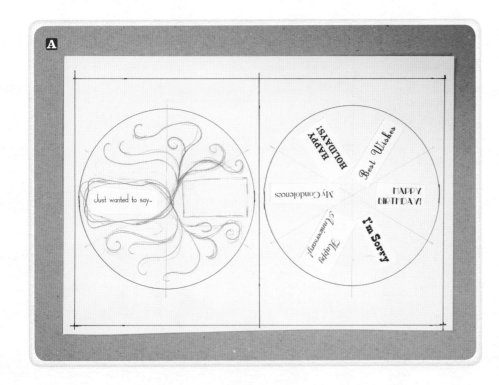.

To make sure that your greetings will show through the window, draw the design for the upper card on a piece of tracing paper or frosted Mylar, and hold it over the background card. Make adjustments to the size of the text or the size of the window before making the final

drawings in pen. Place a sheet of the frosted Mylar or drafting vellum on top of the drawing and refine the design that will be printed using a black pigment pen. This drawing will be used to make the printing plates **B**.

Place another sheet of frosted Mylar or drafting vellum on top of the drawing and use the black pigment pen to trace over the circles and the cutout shape only. This drawing will be used to make the die **C**. You should now have four separate drawings in black ink: two for the printing plates and two for the dies.

STEP 2 → Prepare the paper.

For this project, you'll need cardstock that's 8½ × 5½ inches (21.5 × 28 cm). Cut (or buy) as many pieces of paper as you want to print. Be sure to cut at least 20 percent extra for mistakes or accidents (in this project, there are two runs, including die cutting, and you want 10 percent extra per run), as well as a stack of scrap for proofs. For the proofs, cut to the same size as the printing paper.

STEP 3 → Order the plate and die.

For instructions on ordering the plate, refer to the Tree Ornaments project on page 87. You may be able to find a local die manufacturer through a search on the Internet. If not, refer to the Resources section on page 172 or ask another printer for suggestions. Once you find a manufacturer, let them know that you're interested in having a die made at type height (0.918 inch [23.3 mm]) for die cutting on a letterpress press. Most companies offer the same two options as plate makers for receiving original designs.

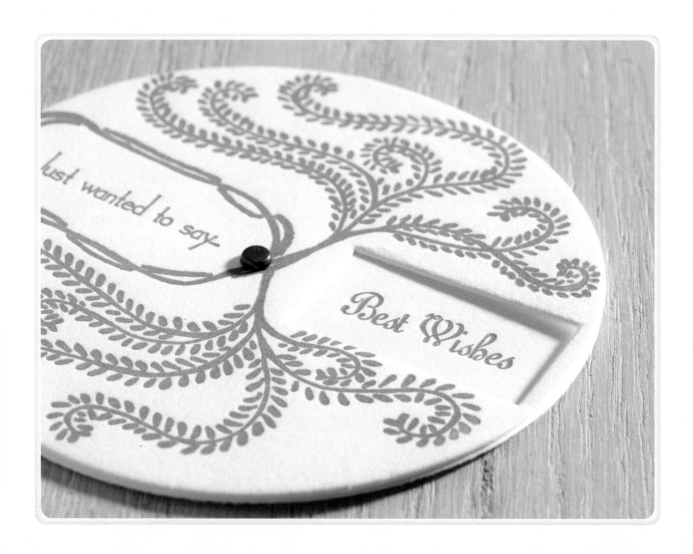

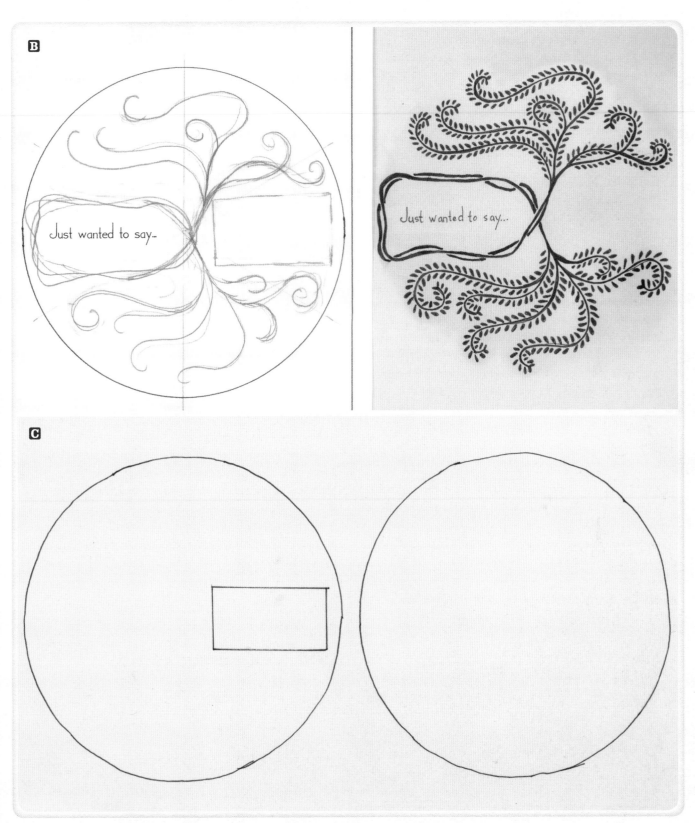

B

Just wanted to say...

Just wanted to say...

C

STEP 4 ➜ Lock up the base.

For instructions on how to do this, refer to the Tree Ornaments project on page 88.

STEP 5 ➜ Ink the press.

For instructions on how to do this, refer to the Personalized Stationery project on page 76.

STEP 6 ➜ Register with Mylar and gauge pins.

If your plate was made for you, you may need to trim away excess plate material from around the image. Be sure to leave at least ¼ to ½ inch (6 mm to 1.3 cm) of plate material around the image areas. Cut away the image you'd like to print first.

Peel the protective backing away from the sticky side of the plate, then place the plate on the base in a rolling motion, making sure that no air bubbles are trapped underneath. Place the plate near the top of the base. Gently rub over the plate with a clean rag or clean hands to make sure it's adhered securely. Pick up the chase by the two upper corners, place it on the press bed, and lock it into place. Then ink the form. Activate the flywheel by spinning it with your hand or use the foot treadle so that the platen closes and the rollers roll over the form. Do this three times to add three fresh layers of ink on the form.

Cut a piece of Mylar that's a little smaller than the size of the platen and tape it to the top of the platen with painter's tape. Put the press into the print position by pulling the throw-off lever toward you. Activate the flywheel and print onto the Mylar. Where the print appears on the Mylar is where it will print on a piece of paper on the platen. Place a piece of the proof paper underneath the Mylar and align the text to print on the paper centered on the upper half of the sheet.

Hold the paper in place with one hand while you draw the bottom and left edges of the paper with the other—this is where you'll place your gauge pins. Make sure the gauge pins are well out of the way of the base so that they don't get damaged when the platen closes.

STEP 7 ➜ Print.

Before making final prints, make a few proof prints on your scrap paper. Place a sheet of proof paper on the tympan, then put the press in the print position and activate the flywheel to make a print. Check the proof for print quality. (Refer to the troubleshooting section on page 36 if you're having trouble getting good print quality.) Also, check the proof for where the print falls on the page. Use your line gauge to get precise measurements for any necessary changes and mark these measurements on the proof. To make adjustments, either move the gauge pins or move the plate on the base until the image prints in the right place **D**.

Once you're happy with the proof prints, you're ready to make the final prints! Place your stack of papers on the upper feed board and fan them out. Make sure the press is in the trip position and start up the press by turning on the motor or by using the foot treadle. While the press is running, put it in the print position by pulling the throw-off lever toward you.

When the platen opens, place a sheet of paper against it, sliding it against the gauge pins. Quickly move your hand out of the way as the platen closes. When the platen opens again, pull the printed sheet out with your left hand and place it on the delivery board while your right hand places the next sheet in place on the platen. Repeat for each print. If this is too much activity to handle when you're just starting out, push the throw-off lever back into the trip position between each print, and print one sheet at a time. You'll work your way up to a rhythm with the press.

Clean the press and repeat Steps 5 through 7 to print the second card **E**.

STEP 8 ➜ Die cutting.

For instructions on how to do this, refer to the Gift Tags project on page 110 **F**.

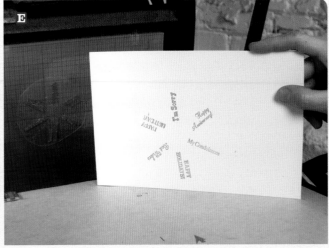

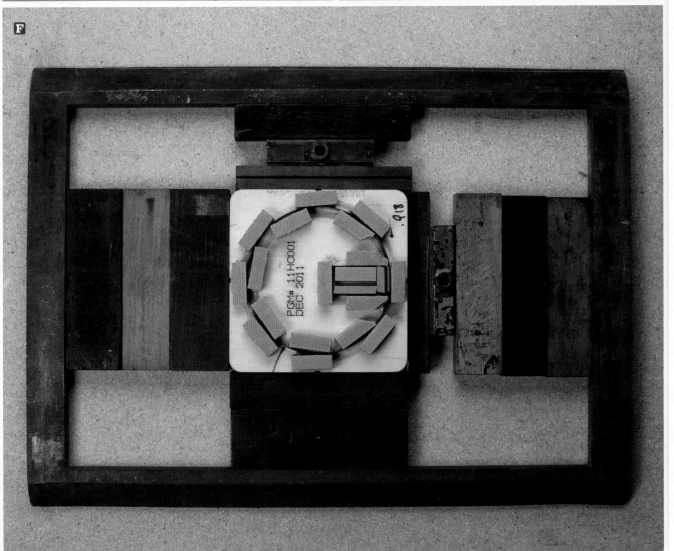

STEP 9 → Finishing.

Align the top card with the cutout window and the bottom card with the text. Using an awl or a small round paper punch, punch a hole through the center of both cards **G**. Insert a decorative brad **H**. Give the card a whirl, and pop it in the mail!

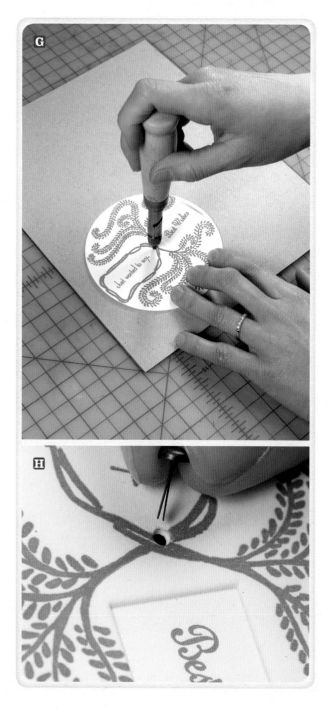

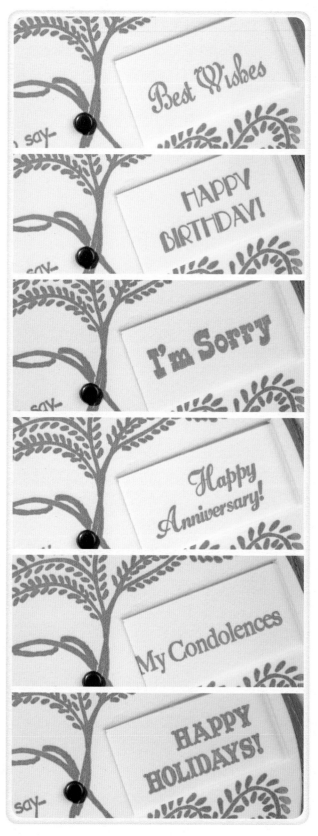

Where does the name of your press/shop come from?

Thomas is my last name, but, further back, my great-grandpa founded a business called Thomas Florists. He was a German immigrant and started that business from scratch, so I like the echo of his entrepreneurial spirit in my own small business undertaking.

What was your first press?

My first press was a Chandler & Price New Series 12x18 from about 1920. I still have it and use it for larger format pieces.

What do you use these days?

My workhorse today is a Chandler & Price Press New Series 10x15. It's a great size (very manageable for me—I'm 5 foot 1 inch tall) and reportedly had only one owner, so it is in great condition. I also have a treadle-operated Chandler & Price 8x12, which I use mostly when the power goes out.

Who are your favorite letterpress artists?

I admire the work of Chandler O'Leary of Anagram Press and Jessica Spring of Springtide Press so much, especially their *Dead Feminist* broadside series. Their work is meticulous, delicate, beautiful, and technically perfect. Kathryn Hunter of Blackbird Letterpress is great and triumphantly local (she's in Baton Rouge, Louisiana), and Jen Farrell of Starshaped Press shows a love of typography and the craft of letterpress that's almost unmatched.

What are your favorite tools or printing methods?

I have a little ruler with a pocket clip that I use as a depth gauge to see in an instant whether a line is printing straight on the page or not. It's a really simple but efficient tool that I use dozens of times a day and it really is indispensable now.

Do you have a favorite printing trick or tip you can offer?

Never be afraid to go slower than you'd like in order to achieve the quality you want. And if you're ever stumped with a particularly pesky problem on press, there's a large community of printers out there who have probably had the same issue and can help you solve it.

Where do you see letterpress in the next 50 years?

I hope it's still going strong, and is practiced by hundreds of people as a craft among many other thriving, vibrant arts and crafts. My worst fear is that letterpress-printed things, and paper things in general, will become too fetishized in our digital world to be sent and used every day. I don't want printed goods to become artifacts; I want them to stay a part of what makes everyday life beautiful!

CYLINDER PRESS PROJECTS

FEATURING

★ T-SHIRT ★ WOODCUT POSTER ★ ARTIST TRADING CARDS ★

★ EVENT POSTER FROM TYPE ★ PRESSURE-PRINTED

BROADSIDES ★ CALENDAR WITH COLLAGRAPH ★ CHAPBOOK ★

T-SHIRT

Printing on fabric isn't a typical letterpress project. The nice debossed impression that letterpress printing produces on a thick sheet of paper doesn't show up on cloth. But if you already have the type, the press, and the ink, why not try something new? This project proves that screen-printing isn't the only way to create a cool T-shirt.

STEP 1 ➔ Set the type.

Start by figuring out what you want the shirt to say. I decided to go with something that I really love! Pull the letters you need from the type case and put them directly on the press bed. Set the letters on the bed right side up but reading backwards (the letters themselves are already backwards) **A**.

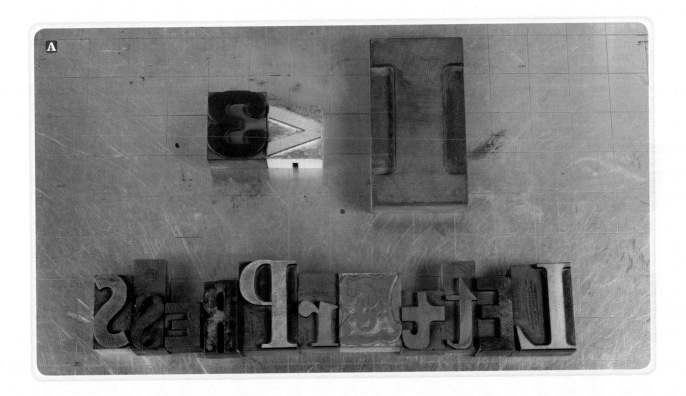

STEP 2 → Set up the form.

Make sure your type makes a solid block. If all of your type is the same height, it already makes a block. If your type is of different heights, add furniture or reglets above the shorter type so that it's the same height as the tallest letter. Use leading if the reglets are too thick **B**. In my example, the letters in the word "letterpress" are of different heights, but I didn't add furniture or reglets because big blocks often stay nice and tight when locked up (in Step 3). If some of your letters are loose after they've been locked up, then fill in the spaces.

Add leading or thin reglets between uppercase letters to give them some space and visual balance. This technique is called kerning **C**.

STEP 3 → Lock up the form.

Carefully slide the text block to where you want to print it on the press bed—I suggest centered and near the top (head) of the press. Add furniture above the text block that's the same line length as the text block or slightly shorter until you reach the head of the press bed.

Place furniture that's the same length or slightly longer than the block on the right side of the block, filling in all the space between the block and the rail opposite the operator's side (the side farthest from you). These pieces of furniture should sit parallel to the rails. Place a piece of furniture that's about 4 picas wide and the same length as or slightly longer than the block on the operator's side of the block (the side closest to you). Place a quoin that's about the same length against it, then use furniture to fill in

the rest of the space between the quoin and the operator's side rail. Again, these pieces of furniture should sit parallel to the rail. Make sure that when the quoins expand, they expand toward the form. If you only have small quoins, use two.

Place a piece of furniture that's 4 picas wide and the same line length as the text block, or slightly shorter, against the bottom of the block. Place a quoin that's about the same length against it, and then place furniture on the other side of the quoin until you fill up the rest of the space on the press bed with furniture and the block is snug.

The form should now be near the head of the press bed, held in place by furniture on each side **D**. If necessary, add reglets to fill in small spaces. Place one hand on the type and use a quoin key to slightly tighten one of the quoins. Do the same for the other quoin, and repeat back and forth until they're both tight **E**. The form should be firmly in place. Make sure it doesn't lift up slightly while you tighten the quoins. If this happens, then you've tightened it too much. Release the quoins and tighten them again.

Push every letter, making sure that none of them are loose. If a letter is loose, then there's extra space in the form, and you need to add more furniture, reglets, or leading to fill in that space. Make sure the pieces of furniture are pressing against the form, not against each other.

STEP 4 → Ink the form.

You should use water-based block-printing ink so that the ink will set properly on the fabric. Squeeze a line of the ink out of the tube and smear it evenly in a line across the top of the inking plate. Roll a brayer slightly into the ink and back and forth on the plate, touching a bit of the ink each time you roll it forward **F**. Spread the ink out evenly in a square on the plate, rolling it back and forth and side to side **G**. Lift up the roller with each pass as you do this, and let it spin a bit each time. This helps spread the ink evenly over the roller.

If you have the right amount of ink, the roller will make a slightly tacky sound as it rolls, like a sizzle on a hot griddle. Too much of a "sticky" or gooey sound means you have too much ink on the plate. Scrape excess ink off the square and continue to even out the ink that remains on the roller. Repeat this until you get the right sound.

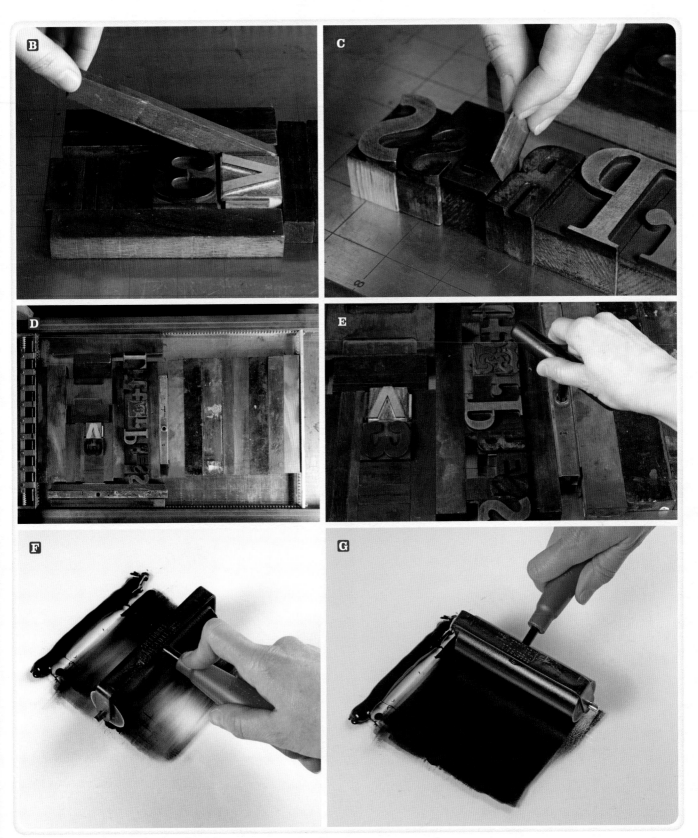

Roll over the type with the inked brayer, laying down a thin, even layer of ink 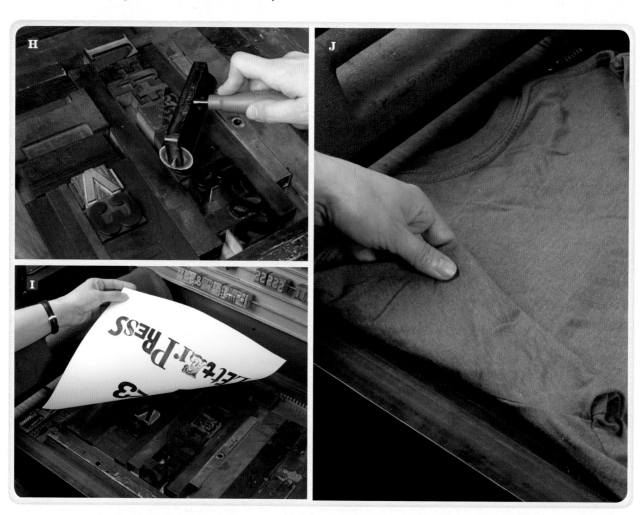. Do this a few times, adding ink to the brayer if necessary, until you have the right amount of ink on the type. If you're not sure how much is enough, make a few test prints on scrap paper or scrap cloth before printing on the shirt **I**. You might need to add a board or a few sheets of scrap paper on top of the proof paper to get enough pressure from the press roller.

STEP 5 ➜ Print.

Carefully place the shirt on the form without shifting it or sliding it around. Give it a slight pat with your fingers to make sure it stays put. Fold the sleeves and any other extra fabric in so that nothing rests on the rails **J**. Place a board or a few sheets of paper on top to add more pressure if necessary, then slide the roller across the press. Carefully pull the shirt up, and check it out.

Before you wash (or wear) the shirt, you'll need to set the ink. To do this, hang the shirt up and let it air-dry for 24 hours, then toss it in a dryer for 20 minutes. Once the ink is set, your shirt is ready to wear!

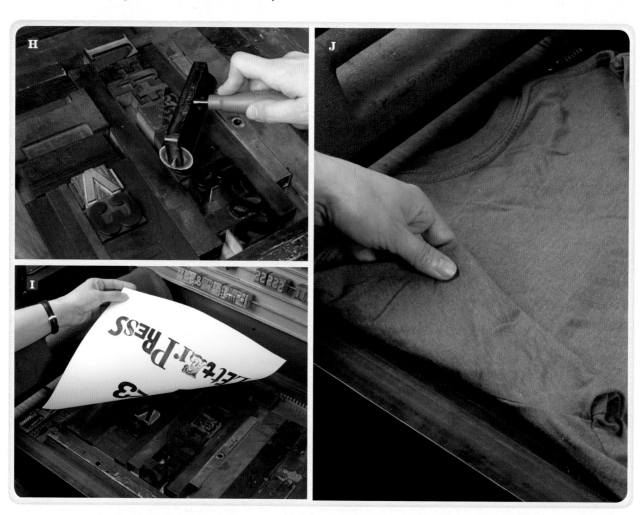

Where does the name of your press/shop come from?

The name came from the technique of letterpress printing called kissing the paper, in which you lightly leave an impression. So, with respect to the earlier process, I use Inky Lips Press—"kissing the paper with inky lips."

What does letterpress mean to you?

To be present in the history of typography and the experimentation of type and image. To apply the skills as a designer using an antique method of printing is very satisfying. Mixing color, setting type, and carving images from linoleum is a very unique process that still continues to excite me.

How did you get your start as a printer?

I was a creative director at Fossil, and we collaborated with Jim Sherraden at Hatch Show Print on an annual report and tin designs in 1994, and the fever started. I was laid off from another job in 2001 and bought a small tabletop press on eBay, and quickly found out it was too small and that I wanted to print posters. I sought out a Vandercook proof press and found a total of three in Texas during a 10-year period. From Georgetown to San Angelo and Athens, Texas, I built my shop with 11 cabinets of type, a cutter, a photopolymer plate maker, saws, and other accoutrements that help with the printing process.

What was your first press?

A Kelsey 3x5 tabletop press.

What do you use these days?

A Vandercook Universal III PAB, a Vandercook Universal I AB, and a Heidelberg Windmill 10x15.

Who/what inspires you in your craft?

Jim Sherraden at Hatch Show Print always has been an inspiration for me. Also, the new techniques printers use to get objects type high (besides metal or wood type on the press) and printing from it—like the guy who printed using Legos.

Who are your favorite letterpress artists?

Jim Sherraden, Amos Paul Kennedy Jr., Dirk Fowler, Studio on Fire, and Studio 204.

What are your favorite tools or printing methods?

Flexcut wood-carving tools for linoleum, split-fountain inking, layering of colors to create other colors, and seeing inconspicuous visuals form in the layering process.

Do you have a favorite subject matter?

My Texas roots continue to influence my work; however, I'm still on the lookout for inspiration. I own about 600 old matchbooks, a few thousand matchbox labels, hundreds of razorblade packages, a dozen ray guns, bowling trophies, and gumball machine toys, so I surround my office and studio with items that excite and inspire me.

Where do you see letterpress in the next 50 years?

In my studio and shop! I'm hopeful it will continue; however, these printing presses aren't being made anymore. For the craft to survive, we need to continue bringing the methods into workshops and educating other people, and as my friend Jim Sherraden at Hatch Show Print would say, "preservation through production."

a PARLIAMENT of owls

WOODCUT POSTER

This project will teach you how to make a woodcut poster using a printing technique called a reduction cut. With a reduction cut, you'll be able to print in multiple colors while getting maximum use out of a single wood or linoleum block. Here's the process in a nutshell: You cut part of an image on a block, print it, cut away more of the image, and print it again in a different color, right on top of the first print. The first color prints as a background, and the second color adds detail. A third color can be added on top for finer details or an outline. For this project, we'll make a reduction cut with three colors on a wood block. You can use a linoleum block instead of wood if you prefer.

TOOLS AND MATERIALS ★ BASIC LETTERPRESS PRINTING TOOL KIT (PAGE 17) ★ CARDSTOCK, 12 1/2 × 19 INCHES (31.8 × 48.3 CM) ★ DRAWING PAPER, 12 1/2 × 19 INCHES (31.8 × 48.3 CM) ★ TRACING PAPER ★ WOOD BLOCK OR LINOLEUM BLOCK MOUNTED ON WOOD, 12 × 16 INCHES (30.5 × 40.6 CM) ★ BONE FOLDER ★ PERMANENT MARKER ★ WOOD-CUTTING TOOLS (OR LINOCUTTING TOOLS IF YOU'RE USING LINOLEUM) ★ BENCH HOOK OR NONSLIP RUG PAD (OPTIONAL) ★ WOOD TYPE (OPTIONAL) ★ BOOKBINDER'S BOARD OR OTHER DENSE BOARD, CUT TO SAME SIZE AS WOOD BLOCK ★ BRAYER

STEP 1 ➜ Prepare the paper.

For this project, you'll need cardstock that's 12 1/2 × 19 inches (31.8 × 48.3 cm). Cut (or buy) as many pieces as you want to print. Be sure to cut at least 30 percent extra for mistakes or accidents (in this project, there are three runs, and you always want 10 percent extra per run), as well as a stack of scrap for proofs. For the proofs, cut to the same size as the printing paper.

STEP 2 ➜ Transfer the image to the wood block.

Sketch out the image that you want to print on a piece of drawing paper, keeping in mind that the image will be printed in three colors. The first color that will be printed is the lightest. It will provide an overall basic shape for the background. The second color will be a medium tone and will designate more specific shapes as well as details or patterns in the image. The third color will be the darkest. It will serve as an outline for the image and any other details or patterns.

Place a sheet of tracing paper over the drawing and trace your drawing with a pencil. Use a soft pencil (2B or softer) to get a nice, dark transfer. Then turn the tracing paper

over onto the wood block, so that the graphite is in contact with the wood. Hold it firmly in place with one hand or tape it down along one edge, then rub over the back of the tracing paper with your bone folder. The pressure from the bone folder will transfer the graphite onto the wood. Check to make sure the entire image has been transferred

before lifting the tracing paper. With this method, the transfer reverses your image for you, so you don't have to draw anything backwards **A**.

Before cutting, mark the areas that won't be cut away. These areas seem obvious now, but they can be hard to distinguish once you start cutting! One way to do this is to color in your image using a permanent marker so that when you move on to the next step, you can easily keep things straight. You'll just cut around the black ink. Another option is to draw "x" marks in the areas to cut away.

STEP 3 → Cut the block.

Use the wood-cutting tools to cut away areas that you don't want printed. Outline the image with a V tool first, then cut away excess material with one of the larger gouges. Any wood left standing will be inked and make a printed mark. Anything you cut away will be the white space in your printed image. With this type of printing, you can only print solid areas—either black or white. However, you can use patterns like dots or lines to create "gray" tones or add interest **B**.

PICKING OUT A BLOCK OF WOOD

The blocks of wood sold at your local hardware store or lumberyard are not usually cut to type-high (0.918 inch [23.3 mm]) thickness. They come in thicknesses of ¼, ½, and ¾ inch (6 mm, 1.3 cm, and 2 cm). I buy ¾-inch (2-cm) sheets, which are close to type height, and use boards to lift the sheets up before printing. You'll learn how to do this later on.

When choosing a type of wood, think about what you want the end results to be and how you like to work. Softer woods such as pine, fir, pear, and sycamore are typically easier to work with but tend to hold less intricate, detailed lines. Hard woods such as poplar, birch, beech, elm, and maple are better for getting fine details, but they can be harder to cut. Plywoods also work fine and can save you some money. One of my personal favorites is ⅜-inch (1-cm) Shina plywood, which is available through McClain's Printmaking Supplies (www.imcclains.com).

Always cut away from yourself and always place your fingers behind the cutter. To help hold the block steady and to create some pressure while cutting, use a bench hook or place the block on a nonslip rug pad. Be aware of the grain of the wood while you cut. When you cut with the grain, the wood tends to splinter and peel up where you don't want to cut away. Use a knife tool to cut these splinters before you lose parts of your image. When you cut against the grain, a dull cutting tool can leave rough and uneven edges.

STEP 4 → Lift the block to type height.

Before you can print the block on a press, you'll need to lift the block up to type height (0.918 inch [23.3 mm]). You can use a type-height gauge **C** or a piece of wood type as a measuring tool. The best letters to use have long, straight edges that you can place along the side of the block. Try "H" or "N." Place the type against the block, and take a look at the difference in height.

Cut down a few pieces of dense board to lift the block up to the same height as the wood type **D**. I use bookbinder's board because of its density and because it comes in a variety of thicknesses. Make sure the board and/or sheets of paper are cut a hair smaller on each side of the wood block so that when you lock it up, the furniture is pressing against the block and not the supports underneath.

STEP 5 → Lock up the form.

Once you've cut down enough board or paper to bring the block up to type height, place those supports down against the top (head) of the press bed and center them. Place the block on top of the supports.

Place furniture that's the same length as or slightly longer than the block on the right side of the block, filling in all the space between the block and the rail opposite the operator's side (the side farthest from you). These pieces of furniture should sit parallel to the rails. Place a piece of furniture that's about 4 picas wide and the same length as or slightly longer than the block on the operator's side of the block (the side closest to you). Place a quoin that's about the same length against it, then use furniture to fill in the rest of the space between the quoin and the rail on the operator's side. Again, these pieces of furniture should

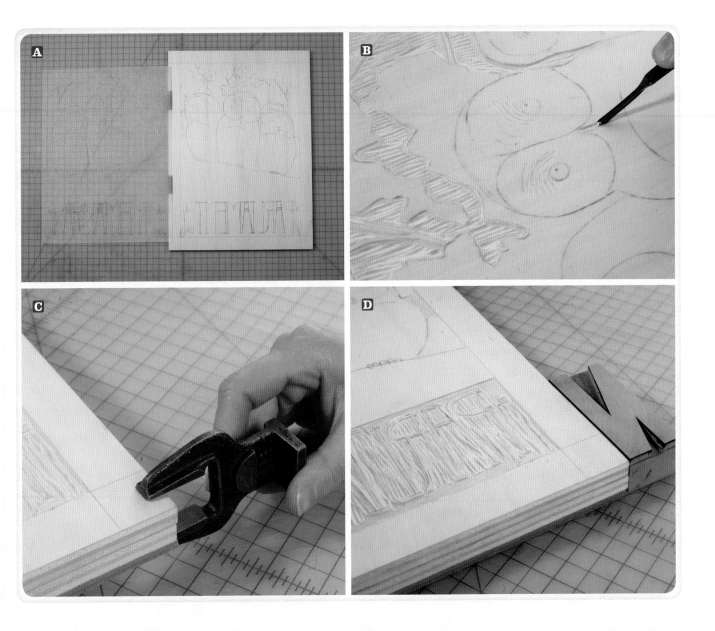

sit parallel to the rail. Make sure that when the quoins expand, they expand toward the form. If you only have small quoins, use two.

Place a piece of furniture that's 4 picas wide and the same line length as or slightly shorter than the text block against the bottom of the block. Place a quoin that's about the same length against it, and then place furniture on the other side of the quoin until you fill up the rest of the space on the press bed with furniture and the block is snug.

The block should now be at the head of the press bed, centered, with furniture holding it in place **E**. If necessary, add reglets to fill in small spaces. Place one hand on the block and use a quoin key to slightly tighten one of the quoins. Do the same for the other quoin, and repeat back and forth until they're both tight. The block should be firmly in place, but be careful that it doesn't lift up slightly while you tighten the quoins. If this happens, then the quoins are too tight. Release them and tighten them again.

STEP 6 ➤ Ink the block.

To get the ink out of the can, use the end of your palette knife and gently scrape off the surface as if you were smoothing the icing on a cake. Never gouge the ink out of the can; the surface of ink slowly dries when it's exposed to air, and you don't want dried bits of ink to sink down into the can. Smear the ink onto an inking table or inking plate and warm it by scooping it up, then smearing it down again. Repeat this step a few times, loosening the ink and making sure that all the ingredients are well mixed. This will get the ink ready for the press.

Use the palette knife to smear an even line of ink across the top of the inking plate. Roll a brayer slightly into the ink and back and forth on the plate, touching a bit of the ink each time you roll it forward. Spread the ink out evenly in a square on the plate, rolling over it back and forth and side to side. Lift up the roller with each pass as you do this, and let it spin a bit each time. This helps spread the ink evenly over the roller.

If you have the right amount of ink, the roller should make a slightly tacky sound as it rolls, like a sizzle on a hot griddle. Too much of a "sticky" or gooey sound means you have too much ink on the plate. Scrape excess ink off the square and continue to even out the ink that remains on the roller. Repeat this until you get the right sound.

Roll over the block with the inked brayer, laying down a thin, even layer of ink. Do this a few times, adding ink to the brayer if necessary, until you have the right amount of ink on the block. If you're not sure how much is enough, make a few test prints on proofing paper. You might need to add a board or a few sheets of scrap paper on top of the proof paper to get the right amount of pressure from the press roller.

STEP 7 ➤ Print.

If your press has grippers, place a sheet of proofing paper under the grippers and lock it in place **F**. Gently lay the paper down in a rolling motion. If your press doesn't have grippers, carefully place one edge of the paper on the top of the inked block and lay it down using the same rolling motion without shifting it or sliding it around. Give it a slight pat with your fingers to make sure it stays put.

Place sheets of paper or board on top to add more pressure if necessary, then slide the roller across the press. Carefully pull up the proof and take a look **G**. Based on the proof, adjust where the block prints on the paper; either move the paper or adjust the furniture until the image prints in the right place. (Refer to the troubleshooting section on page 36 if you're having trouble getting good print quality.) Once you're happy with the proof prints, print the first run on all of your prepared paper.

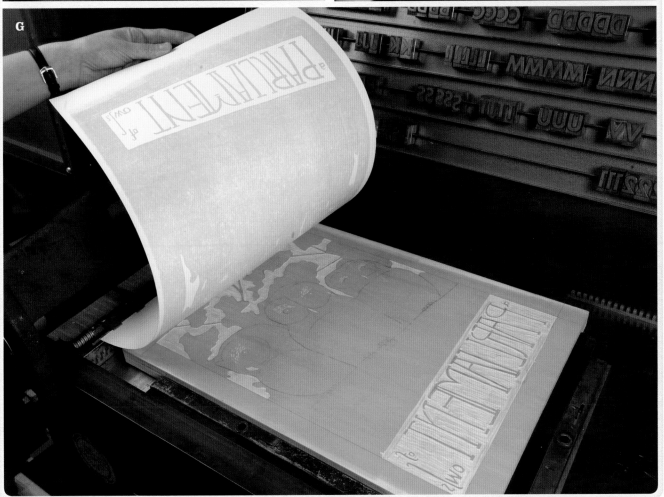

STEP 8 → Reduction cut.

After you've printed the first run, hang the posters up or set them aside on a drying rack and let them dry. Clean the ink plate and the brayer with a rag and some mineral spirits so they'll dry while you work on the block.

To clean excess ink off the block, print onto scrap paper or newsprint until no more ink is picked up. Let the remaining ink on the block dry before cutting again. It's important at this point that you don't move the furniture when removing the block from the press so that you can print the second run in exactly the same place as the first.

If the drawing on the block disappeared during the first print run, use the same tracing paper as before to transfer it to the block again. Cut away everything that you don't want printed on the second run, repeating Step 3. This is a good opportunity to experiment with the cutting tools and create patterns.

STEP 9 → Print the second run.

When you pick out the color you want to use for the second run, keep in mind that letterpress-printing inks are translucent, and any color underneath the print will show through and visually blend with the color printed on top. For instance, blue printed on yellow will look green, and red printed on yellow will look orange. You can also get a nice monochrome effect if you print each run using the same color.

Place the block back on the press bed and lock it up in the exact same place as before. Ink and print the block as you did before on the proof prints so you can see any final changes that need to be made before making the final prints. Print your second run. This run should show up crisp and clear, perfectly registered on the first run **H**.

STEP 10 → Cut and print the third run.

Repeat steps 8 and 9 for the third run. Hang the prints up to dry, and then trim them to the desired size with a paper cutter or craft knife.

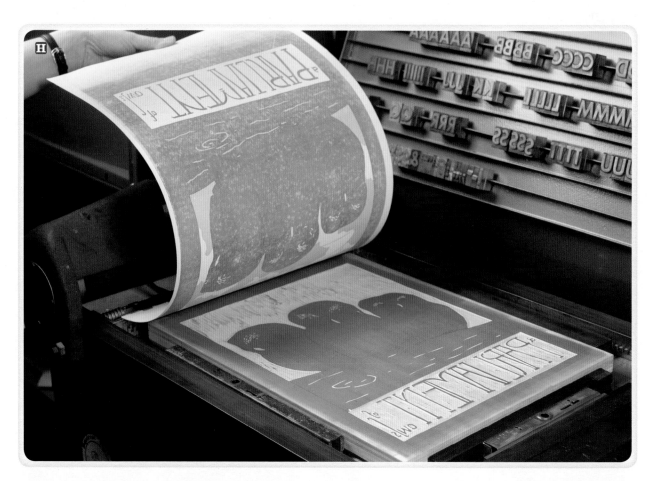

REDUCTION CUT PRINT RUNS

 1st PRINT RUN → **2nd** PRINT RUN → **3rd** PRINT RUN

press proof
FOR SECOND PRINT RUN

press proof
FOR THIRD PRINT RUN

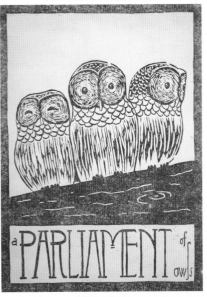

ARTIST TRADING CARDS

Artist trading cards are masterpieces in miniature! About the same size as playing cards, these custom-designed collectibles are incredibly popular among artists of all stripes, including, of course, letterpress printers. The cards can be given away, traded, or sold inexpensively. They're a great way to get your work out into the world and to connect with other artists. This project gives you the chance to create your own cards. It's the perfect opportunity for you to print something you love—motifs or designs that deliver a sense of your personal style. These little works of art can make a big impression!

TOOLS AND MATERIALS ★ BASIC LETTERPRESS PRINTING TOOL KIT (PAGE 17) ★ DRAWING PAPER FOR SKETCHING IMAGES ★ CARDSTOCK, 12 1/2 × 19 INCHES (31.8 × 48.3 CM) ★ LINOLEUM BLOCK MOUNTED ON WOOD, 9 × 12 INCHES (23 × 30.5 CM) ★ RULER ★ TRACING PAPER (OPTIONAL) ★ BONE FOLDER (OPTIONAL) ★ PERMANENT MARKER (OPTIONAL) ★ LINOCUTTING TOOLS ★ BENCH HOOK OR NONSLIP RUG PAD (OPTIONAL) ★ BOOKBINDER'S BOARD OR OTHER DENSE BOARD, CUT TO SAME SIZE AS WOOD BLOCK ★ TWO OR MORE BRAYERS ★ CORNER PUNCH (OPTIONAL)

STEP 1 → Sketch out ideas.

Think about images and designs that capture your imagination or reflect who you are. Sketch out nine different designs, each about the size of a playing card. These sketches should be made in black and white, using pencil or pen. You'll add colors later.

STEP 2 → Prepare the paper.

For this project, you'll need cardstock that's 12 1/2 × 19 inches (23 × 30.5 cm). Cut (or buy) as many pieces of paper as you want to print. Be sure to cut at least 10 percent extra for mistakes or accidents, as well as a stack of scrap for proofs. For the proofs, cut to the same size as the printing paper.

STEP 3 → Transfer the image to the linoleum block.

Draw a grid in the center of the block using a ruler. Start by drawing a 3/4-inch (2-cm) border all the way around the block. Position the block vertically, and draw two lines that are 2 1/2 inches (6.4 cm) apart inside the borders. Then turn the block horizontally, and draw two lines that are 3 1/2 inches (9 cm) apart inside the borders. You should now have a center grid of nine blocks, each 2 1/2 × 3 1/2 inches (6.4 × 9 cm)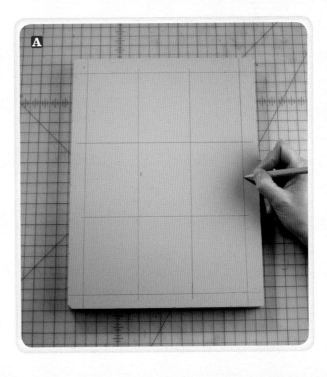

Start the transfer process by tracing your source images onto tracing paper with a soft pencil (2B or softer). Make a nice, dark sketch on the tracing paper. Then turn the tracing paper over onto the linoleum block so

that the graphite is in contact with the linoleum. Hold it firmly in place with one hand while rubbing over the back of the drawing with a bone folder. The pressure from the bone folder will transfer the graphite onto the linoleum and reverse the image at the same time. Check to make sure the entire image has been transferred before lifting the drawing, or you might have a hard time putting it back in the correct position.

Before cutting, I like to mark areas that won't be cut away. These areas seem obvious now, but they can be hard to distinguish once you start cutting! Color in your image using a permanent marker, then, when you move on to the next step, it will be easy to keep things straight—just cut around the black ink. Don't cut away the grid lines, including the ones in the outer border—these will be handy guides later on when you're ready to cut the cards down to size.

STEP 4 ➡ Cut the block.

Use the linocutting tools to cut away areas that you don't want printed. Outline the image with a V tool first, then cut away excess material with one of the larger gouges. Any linoleum left standing will be inked and make a printed mark. Anything you cut away will be the white space in your printed image. With this type of printing, you can only print solid areas—either black or white. However, you can use patterns like dots or lines to create "gray" tones or add interest **B**.

Always cut away from yourself, and always place your fingers behind the cutter. To help hold the block steady and to create some pressure while cutting, use a bench hook or place the block on a nonslip rug pad. If you're having a hard time cutting the block, you can make cutting easier by warming the linoleum under a desk lamp. If you're still having trouble, you may need a new blade.

STEP 5 ➡ Lift the block to type height.

For instructions on how to do this, refer to the Woodcut Poster project on page 130.

STEP 6 ➡ Lock up the form.

For instructions on how to do this, refer to the Woodcut Poster project on page 130 **C**.

STEP 7 ➡ Ink the block.

For instructions on how to do this, refer to the Woodcut Poster project on page 132. If you want to make cards by printing a few colors at the same time, like the one shown here, read on!

When spreading ink on the inking plate, prepare a few colors, using one brayer for each color. For this project, I inked up the block with three colors, but feel free to use as many colors as you like **D**. Ink the block with each brayer, laying down the colors side by side, or crossing over each other. If you cross over as you ink the block, the colors will blend on the block as well as on the brayers **E**.

STEP 8 ➡ Print.

If your press has grippers, place a sheet of proofing paper under the grippers and lock it in place. Gently lay the paper down in a rolling motion. If your press doesn't have grippers, carefully place one edge of the paper on the top of the inked block and lay it down using the same rolling motion without shifting it or sliding it around. Give it a slight pat with your fingers to make sure it stays put.

Place sheets of paper or board on top to add more pressure if necessary, then slide the roller across the press. Carefully pull up the proof and take a look **F**. Based on the proof, adjust where the block prints on the paper; either move the paper or adjust the furniture until the image prints in the right place. (Refer to the troubleshooting section on page 36 if you're having trouble getting good print quality.) Once you're happy with the proof prints, go ahead and print on all of your prepared paper. Hang the sheets up or lay them out on a table to dry overnight before moving on to the next step.

STEP 9 ➡ Trim and round the corners (optional).

Using the printed lines as guides, trim your cards down to size (2 ½ × 3 ½ inches [6.4 × 9 cm]) with a paper cutter or craft knife. If you want your trading cards to have nicely rounded corners, clip each corner with a corner punch that you can get at most craft stores. Some community print shops also have heavy-duty corner rounders that can cut a stack of paper all at once.

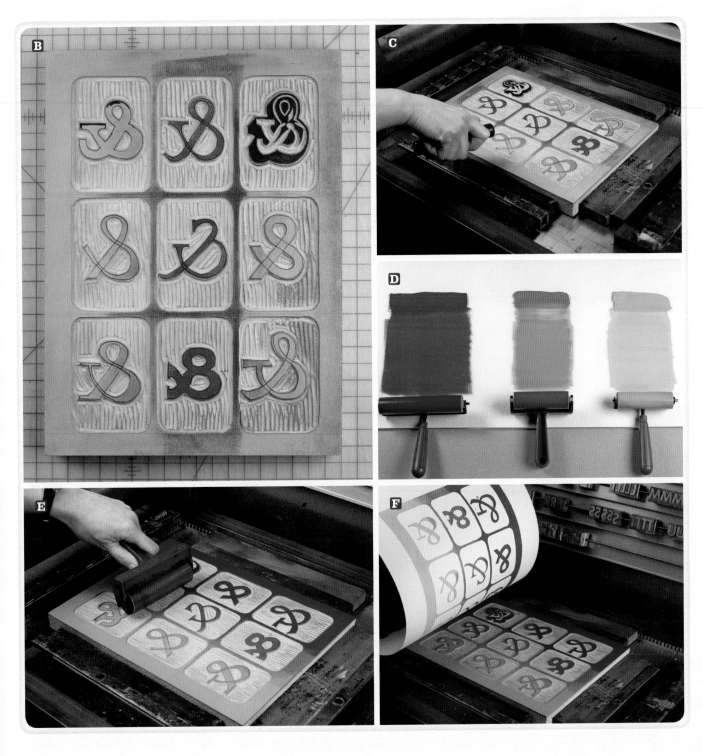

EVENT POSTER
FROM TYPE

One of the best ways to show off your collection of wood type is by making a poster. I love pieces that display a variety of typefaces and styles, echoing the look of nineteenth-century playbills. If you select your type carefully and take time to arrange your text, you can pack a lot of information into a small space. For this project, think of an upcoming event that you'd like to promote. Is your sister's band playing? Are you planning a puppet show in the front yard? Print up a batch of eye-catching posters, and make sure the whole neighborhood knows!

STEP 1 → Prepare the paper.

For this project, you'll need cardstock that's 11 × 17 inches (23 × 43 cm). Cut (or buy) as many pieces of paper as you want to print. Be sure to cut at least 10 percent extra for mistakes or accidents, as well as a stack of scrap for proofs. For the proofs, cut to the same size as the printing paper.

STEP 2 → Set the wood type (for the larger text).

Decide on what you want the poster to say. Write down the information on a scrap piece of 11 × 17-inch (23 × 43-cm) paper. Write everything out at about the size you'd like it to be printed. Pull the letters you need from the type case and put them directly on the press bed. Remember that the type prints backwards, so set the letters on the press bed right side up but reading from right to left (the letters themselves are already backwards). If you choose to use images for your poster, add woodcuts or other printing blocks (such as magnesium or copper blocks) to your design as you arrange the type.

You might not be able to find the exact size or typeface you want for each line, so this is a good time to play around with type. Try setting sections of text in different sizes or typefaces. Move the letters around like a giant puzzle, rearranging them until you find your favorite design. If you're not sure what will work best, don't worry—you can change your layout before printing.

STEP 3 → Set the metal type (for the smaller text).

Pull out the type case and set it on a flat surface where you'll be comfortable setting type. Other handy things to keep nearby when you're setting type include spacing material, tweezers, and a case layout chart (if you haven't yet memorized where all of the letters are stored).

Set your composing stick to a line length that fits your design **A**. Refer to the Setting Metal Type section on page 34 for instructions on how to set the rest of the type and tie up the form.

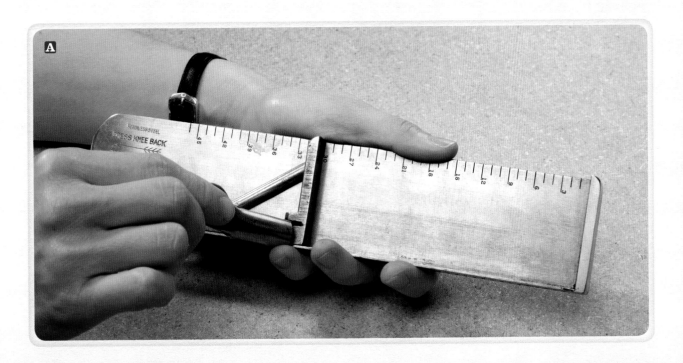

It's best to set lines of type that are all the same point size. If you have a line with two different sizes, such as a line of 12-point type with a 10-point ornament, fill in spaces above or below the smaller type within that line with spacing or leading. Keep in mind that you want all of the lines of type to be set as a solid block that can be locked up tight before printing.

STEP 4 → Prepare the form.

The type should now be arranged on the press bed. Use different sizes of furniture, reglets, and leading to fill in the space around it so that it's snug on the press bed and won't shift during printing. Start by finding the longest line of the poster; this is the line length you'll use for every line of text **B**. Place reglets or furniture above and below this line. Place reglets between the other lines of text, using the reglets as leading. If your layout doesn't fall into exact lines, arrange sections of text into blocks so that you can treat them as separate lines. Use leading to fill in above and/or below your lines of text until they're all the same height **C**.

Fill in the spaces around each block of text using a combination of small furniture, reglets, and leading until it all comes together and forms a solid block. It's kind of like creating your own personal puzzle **D**!

STEP 5 → Lock up the form.

Carefully slide the form to where you want to print it on the press bed. I recommend placing it near the top (head) of the press bed and centering it. Use your line gauge to measure the height of the form, then place furniture above the form, using pieces that are the same height as or slightly shorter than the form itself, filling in all the space between the form and the head dead bar. These pieces of furniture should sit perpendicular to the rails.

Place furniture that's the same length as or slightly longer than the block on the right side of the block, filling in all the space between the block and the rail opposite the operator's side (the side farthest from you). These pieces of furniture should sit parallel to the rails.

Place a piece of furniture that's about 4 picas wide and the same length as or slightly longer than the block on the operator's side of the block (the side closest to you). Place a quoin that's about the same length against it, then use furniture to fill in the rest of the space between the quoin and the operator's side rail. Again, these pieces of furniture should sit parallel to the rail. Make sure that when the quoins expand, they expand toward the form. If you only have small quoins, use two **E**.

If you're using a dead bar, place a piece of furniture that's 4 picas wide and the same height as or slightly shorter than the form itself against the bottom of the form. Place a quoin against it, and then add furniture to the other side of the quoin until you reach the dead bar.

If you're using an adjustable lockup bar, place a piece of furniture that's 4 picas wide and the same height as or slightly shorter than the form itself against the bottom of the form. Place a quoin against this furniture, and then add another, similar piece of furniture to the other side of the quoin. Place your lockup bar at the end and lock it in place **F**.

Once the form is snugly in place, pull up on the trimmed ends of the string that you used to tie up the text blocks. They should pull up easily and leave a bit of space all the way around the blocks. If necessary, add reglets to fill in these spaces.

Place one hand on the form, and use a quoin key to tighten one of the quoins slightly **G**. Do the same for the other quoin, and repeat back and forth until they're both tight. The block should be firmly in place, but be careful

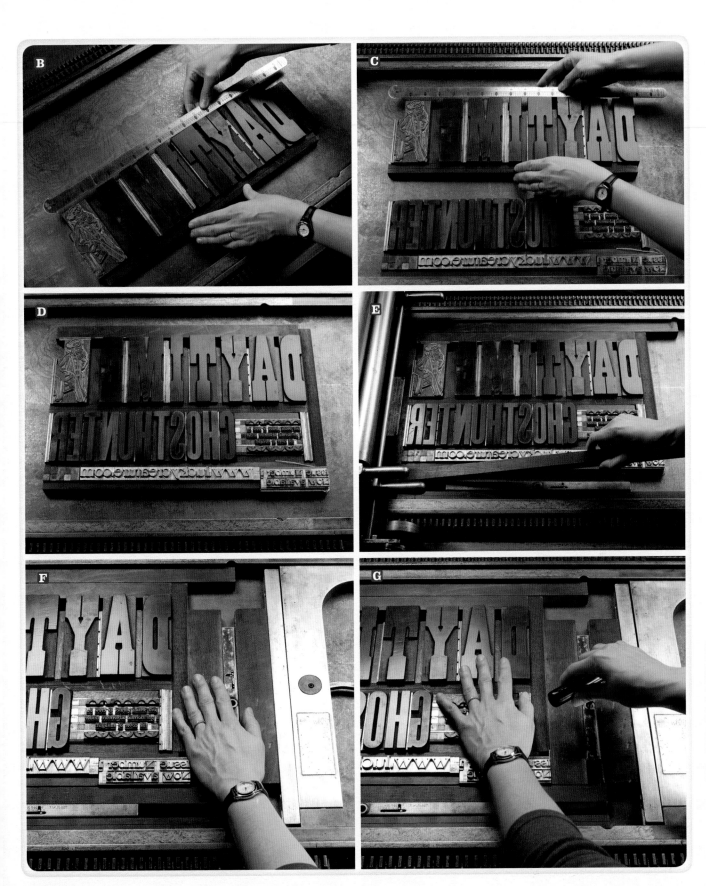

that it doesn't lift slightly while you tighten the quoins. If this happens, then you've tightened the quoins too much. Release the quoins and tighten them again. Push on each letter to make sure that they're snug. If any of them is loose, then there is extra space in the form, and you need to add more furniture, reglets, or leading to fill in that space. Also, check to make sure the pieces of furniture are pressing against the form, not against each other.

STEP 6 → Ink the press.

To get the ink out of the can, use the end of your palette knife and gently scrape off the surface as if you were smoothing the icing on a cake. Never gouge the ink out of the can; the surface of ink slowly dries when it's exposed to air, and you don't want dried bits of ink to sink down into the can. Smear the ink onto an inking table or inking plate and warm it by scooping it up, then smearing it down again. Repeat this step a few times, loosening the ink and making sure that all the ingredients are well mixed. This will get the ink ready for the press.

After preparing two colors of ink this way, turn on the press and disengage the metal rollers by lifting up the ink roller trip lever. Pick up a small amount of ink on the tip of your palette knife and ink the press by adding dots of ink to the rider roller (the small metal roller sitting above the rubber rollers). Dot one side of the roller with one color, and the other side with the other color **H**. Set the metal rollers down, and let them do their work, spreading the ink out smoothly and evenly **I**.

Repeat this process at least three times, adding a small amount of ink each time. When you have the right amount of ink, the rollers should make a slightly tacky sound, like a sizzle on a hot griddle. Too much of a "sticky" or gooey sound means you have too much ink on the plate. Clean the ink off the metal rollers and continue to even out the ink that remains on the rubber rollers. Repeat this until you get the right sound.

Once you have the right amount of ink and see a nice blend of colors, disengage the rollers. Keep the rollers disengaged when you're not actively printing to prevent the colors from blending together too much **J**.

STEP 7 → Print.

First, ink the form. Set your printer on the trip mode **K** and engage the rollers. Roll the carriage over the form and back three times. This adds three fresh layers of ink on the form before you start to print. Return the carriage to the feed board and disengage the rollers **L**.

Place a sheet of proofing paper on the feed board. Walk to the end of the press and look at where the paper will fall—it should be centered over the image area, but don't worry about getting it in the perfect place at this point **M**. Move the paper guide against the far side of the paper and tighten it in place **N**. Step on the gripper pedal to raise the grippers, and tuck the proof paper underneath and against the guide. Release the gripper pedal. The paper should be held in place **O**.

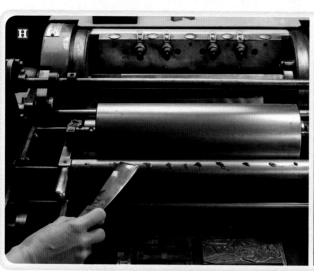
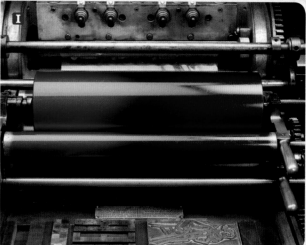

Engage the rollers. With your right hand on the carriage handle and your left hand holding the paper against the cylinder, roll the carriage forward, walking with it down the length of the press **P**. Be sure to take it all the way to the end of the press bed, where you'll hear a little click. This means the press is back in the trip mode, making it possible to return the carriage without printing on the cylinder on the return trip. This is also where the paper is released from the grippers. Pull the print out and return the carriage to the starting position **Q**.

Check the proof for print quality. (Refer to the troubleshooting section on page 36 if you're having trouble getting good print quality.) Also, check the proof for where the print falls on the page. Use your line gauge to get precise measurements for any necessary changes and mark these measurements on the proof **R**. If a lot of adjustments need to be made, move the type on the bed by unlocking and rearranging the furniture around the form. If the paper only needs to move slightly to the left or right, move the paper guide on the feed board until it's in the right place.

Once you've made all of the adjustments and the proof prints look good, wash your hands! You don't want to get smudgy fingerprints on the finished posters. Then pull out your stack of clean paper or cardstock, set it on the feed board, and print away just as you did for the proofs.

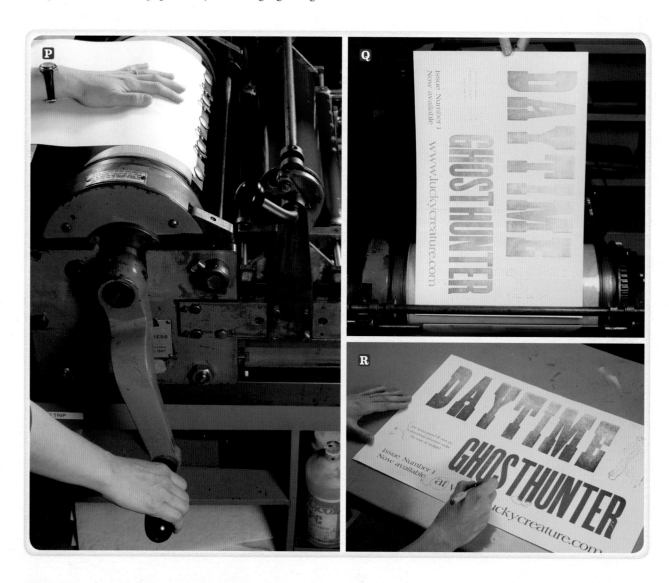

Where does the name of your press/shop come from?

I've always had a love of birds, especially blackbirds in the winter when they inhabit every branch of a leafless tree. The magic of their voices singing until suddenly they stop and the whole flock flies away—that's pure inspiration.

What does letterpress mean to you?

Pure craft. Not in a craft versus art sense, but in the sense of a hands-on process, connected to an impressive history and an inspiring move into the future.

How did you get your start as a printer?

My stepfather, Chuck, ran a print shop when I was growing up, so the smells and sounds were instilled in my senses at an early age. I discovered printmaking in school at Montana State University. I was hooked. I discovered letterpress printing in graduate school at Louisiana State University. I found my first press the fall after I graduated. And Blackbird began.

What was your first press?

A treadle-driven Chandler & Price 8x12.

What do you use these days?

A Chandler & Price 8x12, a Vandercook SP-15, and a couple of proof presses.

What do you love most about letterpress?

The process, the problem solving, and the reward of the perfectly printed final piece.

What is the biggest misconception about letterpress?

That it's quick and cheap.

Who/what inspires you in your craft?

Being outside inspires me, as well as art, both historical and contemporary.

Describe your creative process.

It starts with research, gathering images and inspiration. Then I start drawing. The drawing either gets transferred to wood or linoleum while setting type, or it gets scanned and formatted on the computer, adding type there. And in between, I look around, try to spend time looking at other art, nature, water—those kinds of things. Inspiration is endless and the key for me to motivation.

Who are your favorite letterpress artists?

Wow, there are so many! Amber with Flywheel Press, Rachael Hetzel with Pistachio Press, Amber Favorite with a. favorite design, Marina Luz with Honeylux, Kseniya Thomas with Thomas-Printers, Jessica C. White with Heroes and Criminals Press, Chandler O'Leary with Anagram Press, Hatch Show Print, Yee-Haw Industries— the list could go on and on.

What are your favorite tools or printing methods?

Wood, linoleum, carving tools, and hand-set type.

Do you have a favorite printing trick or tip you can offer?

Make sure your rollers are at the right height, and it will save you from many problems.

Where do you see letterpress in the next 50 years?

I think it will be around, probably morphing with other techniques and materials. It's made it hundreds of years so far—maybe it just can't die!

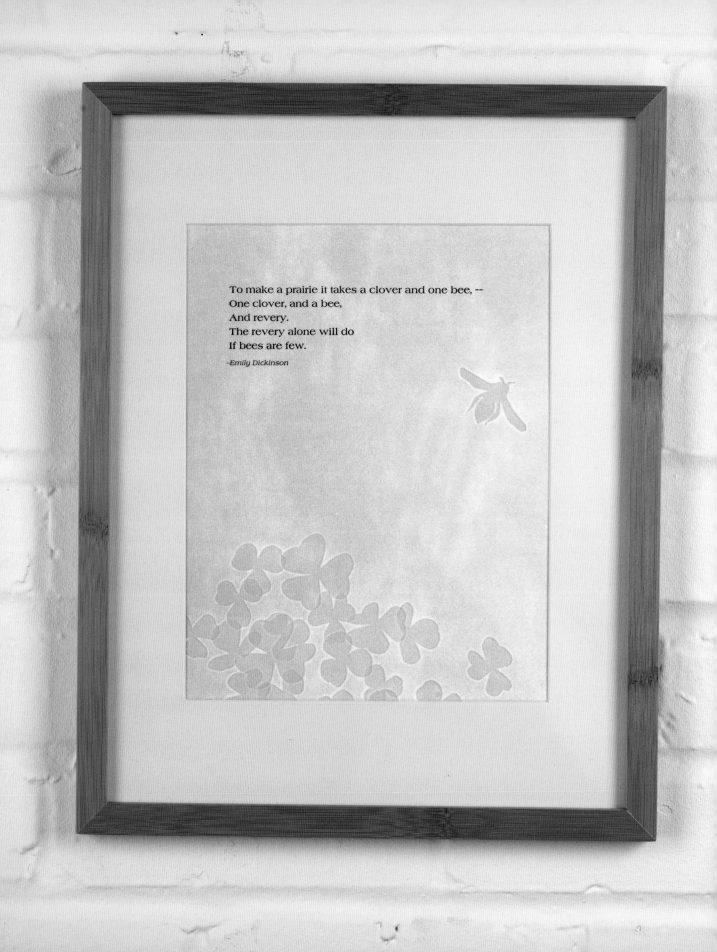

To make a prairie it takes a clover and one bee, --
One clover, and a bee,
And revery.
The revery alone will do
If bees are few.

--Emily Dickinson

PRESSURE-PRINTED BROADSIDES

I'm equally stirred by words and images. A story or poem can easily grab my attention, inspiring a unique design or set of illustrations. Sometimes the creative process works the other way: I'll be smitten with an image and search for the perfect text to complement it. Ideally, the verbal and visual elements in a piece work together to create a whole that's better than the sum of its parts. For this project, you'll print up broadsides that pair text with pressure-printed images. To make a pressure print, you'll first create a low-relief collage on a sheet of paper. When you print the broadsides, you'll place the collage beneath the page you're about to print. As you'll see, the end result is wonderfully impressionistic—hazy and atmospheric.

TOOLS AND MATERIALS ★ BASIC LETTERPRESS PRINTING TOOL KIT (PAGE 17) ★ DRAWING PAPER, 9 × 12 INCHES (23 × 30.5 CM) ★ COMPUTER AND PRINTER (OPTIONAL) ★ TEXT-WEIGHT PAPER, 9 × 12 INCHES (23 × 30.5 CM) ★ BRISTOL BOARD ★ SCISSORS ★ SCRAP PAPER IN A VARIETY OF WEIGHTS ★ GLUE STICK ★ PRECUT SHAPES OR STICKY LETTERS (OPTIONAL) ★ TEXTURED PAPER OR SOFT, FLAT OBJECTS LIKE LACE OR RIBBON (OPTIONAL) ★ LARGE BOOK OR OTHER HEAVY OBJECT TO WEIGHT DOWN MATRIX ★ LINOLEUM BLOCK MOUNTED ON WOOD, 8 × 10 INCHES (20 × 25.4 CM) ★ WOOD TYPE (OPTIONAL) ★ BOOKBINDER'S BOARD OR OTHER DENSE BOARD, CUT TO SAME SIZE AS LINOLEUM BLOCK ★ METAL TYPE ★ TOOL KIT FOR SETTING TYPE (PAGE 32)

STEP 1 → Design your broadside.

Think about what you want to print. Choose words and images that inspire you! Sketch your design on a sheet of 9 × 12-inch (23 × 30.5-cm) drawing paper. Your image should stay within the size of the linoleum block (which is 8 × 10 inches [20 × 25.4 cm]), but the text can be printed outside of that area. You might try digitally printing your text on a separate sheet of paper. Then you can cut out the text and move it around until you find the perfect spot for it in the design.

STEP 2 → Prepare the paper.

For this project, you'll need paper that's 9 × 12 inches (23 × 30.5 cm). Cut as many pieces of paper as you want to print. Be sure to cut at least 10 percent extra for mistakes or accidents, as well as a stack of scrap for proofs. For the proofs, cut to the same size as the printing paper.

STEP 3 → Make a matrix.

In printmaking terms, the matrix is the object that you print from over and over again. It could be a copper plate, a wood block, or a piece of paper. For this project, you'll use a sheet of paper as a matrix.

Start with a sheet of Bristol board as your "base" paper. Using scissors and a craft knife, cut out shapes from your assortment of scrap paper. Glue the shapes to the base paper with the glue stick. You can build up designs or cut away areas—just keep in mind that the thickest part will print darkest, while the thin, cut-away areas will print light (or in some cases, not print at all) . Along with the cut shapes, you can also use precut pieces; sticky letters; textured paper; or soft, flat objects like lace or ribbon.

Once your matrix is finished, clean off any excess glue. Place a piece of scrap paper on top of the matrix along with a couple of books for extra weight. Let it dry for at least 20 minutes.

STEP 4 ➔ Raise the linoleum block to type height.

Before you print the block, you'll need to raise it to type height (0.918 inch [23.3 mm]). You can use a type-height gauge or a piece of wood type as a measuring tool. The best letters to use for this purpose have long straight edges that you can place along the side of the block. Try "H" or "N." Place the type against the block, and look at the difference in height.

Cut down a few pieces of dense board to raise the block up to the same height as the wood type . I use bookbinder's board because of its density and because it comes in a variety of thicknesses. Make sure the board and/or sheets of paper are cut a hair smaller on each side of the wood block so that when you lock it up, the furniture is pressing against the block and not the supports underneath.

STEP 5 ➔ Lock up the form.

For instructions on how to do this, refer to the Event Poster from Type project on page 142 .

STEP 6 ➔ Ink the press.

For instructions on how to do this, refer to the Event Poster from Type project on page 144. Keep in mind that we're only using one color of ink for this project.

STEP 7 ➔ Print the first run.

First, ink the block. Set your printer on the trip mode and engage the rollers. Roll the carriage over the form and back three times. This adds three fresh layers of ink on the form before you start to print. Return the carriage to the starting position .

Place a sheet of proofing paper on the feed board. Walk to the end of the press and look at where the paper will fall— it should be centered over the image area, but don't worry about getting it in the perfect place at this point. Move the paper guide against the far side of the paper and tighten it in place. Step on the gripper pedal to raise the grippers, place your matrix under the proof sheet, and tuck both sheets together underneath the grippers and against the guide . Release the gripper pedal. The papers should be held in place.

With your right hand on the carriage handle and your left hand holding the papers against the cylinder, roll the carriage forward, walking with it down the length of the press. Be sure to take it all the way to the end of the press bed, where you'll hear a little click. This means the press is back in the trip mode, making it possible to return the carriage without printing on the cylinder on the return trip. This is also where the paper is released from the grippers. Pull both sheets out and return the carriage to the starting position.

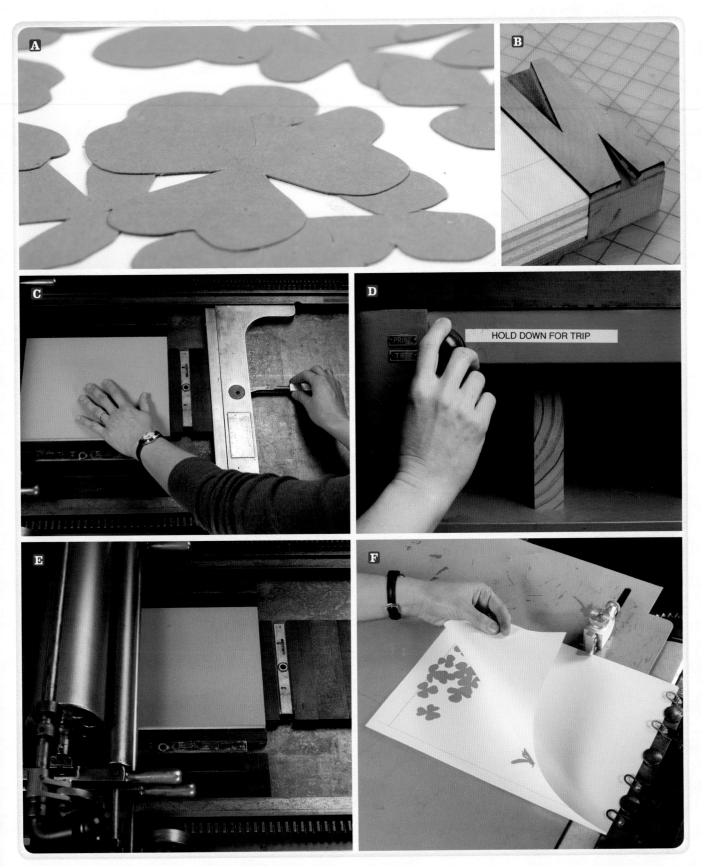

HOLD DOWN FOR TRIP

Check the proof for print quality . (Refer to the trouble-shooting section on page 36 if you're having trouble getting good print quality.) Also, check the proof for where the print falls on the page. Use your line gauge to get precise measurements for any necessary changes and mark these measurements on the proof. If a lot of adjustments need to be made, move the type on the bed by unlocking and rearranging the furniture around the form. If the paper only needs to move slightly to the left or right, move the paper guide on the feed board until it's in the right place.

Once you've made all the adjustments and the proof prints look good, wash your hands! You don't want to get smudgy fingerprints on the finished broadsides. Pull out your stack of paper, set it on the feed board, and print all of the sheets, plus extras for proofing the next run.

STEP 8 ➜ Set the type.

Pull out the type case and set it on a flat surface where you'll be comfortable setting type. Other handy things to keep nearby when you're setting type include spacing material, tweezers, and a case layout chart (if you haven't yet memorized where all of the letters are stored).

Set your composing stick to a line length that fits your design . Refer to the Setting Metal Type section on page 34 for instructions on how to set the rest of the type and tie up the form.

STEP 9 ➜ Place the text block on the press bed.

Once your type is set and tied up, place the galley on the press bed and slide the text block onto the bed. Place your index fingers on the top slug, your thumbs on the bottom slug, and your middle fingers on either side of the block. Squeeze the block tightly, giving it a slight bend while you slide it down onto the press bed. For now, slide the block up against the head dead bar or one of the rails, and place a few pieces of furniture against the sides to keep the type from falling over. Keep the type supported but out of the way.

Place a sheet of the printed paper from the first run on the press bed with the printed side down. Center it along the head dead bar and up toward the carriage about ½ inch (1.3 cm). This is approximately where the paper will fall (it could be more than ½ inch [1.3 cm] or it could be less, depending on the press you're using). Tape the paper to the head dead bar with painter's tape.

Using this paper as a guide, slide the form around on the press bed to the place where you want it to print on the paper. This is just to get the form in the general position—you'll finesse it into exactly the right spot later .

STEP 10 ➜ Lock up the form.

For instructions on how to do this, refer to the Event Poster from Type project on page 142 .

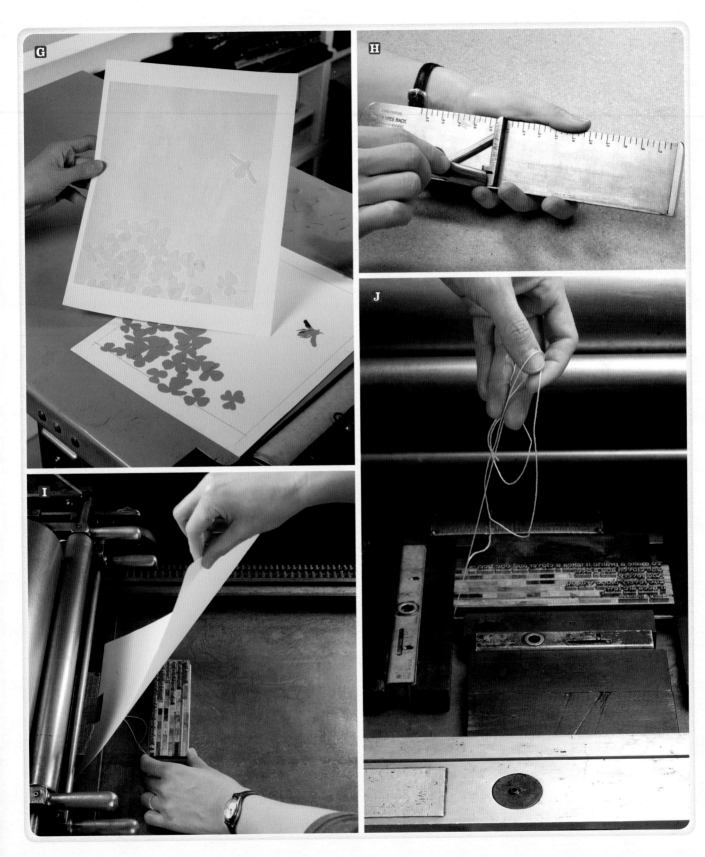

Place one hand on the text block and use a quoin key to tighten each quoin slightly . Place a plane on the form and tap it gently with the side of your quoin key to make sure that each piece of type is resting squarely on its feet. Move the plane around and repeat this step two or three times. Place your hand on the form again and tighten the quoins securely. The form should be firmly in place, but be careful that it doesn't lift slightly while you tighten the quoins. If this happens, then you've tightened it too much. Release the quoins and tighten them again.

Push on each letter to make sure it's snug. If any of them are loose, then there is extra space that needs to be filled. Release the quoins and add a copper or two. Also, check to make sure the pieces of furniture are pressing against the form, not against each other.

STEP 11 → Ink the press.

Ink the press as you did in Step 6, referring to the Event Poster from Type project on page 144 if necessary.

STEP 12 → Print the second run.

Print as you did in Step 7. Be sure to check the proof for where the print falls on the page. Place this proof sheet against one of the printed sheets from the first run. Hold them up to the light or look at them on a light table . This will give you an idea of where the text will print in relation to the image. Use your line gauge to get precise measurements for any necessary changes and mark these measurements on the proof. If a lot of adjustments need to be made, move the type on the bed by unlocking and rearranging the furniture around the form. If the paper only needs to move slightly to the left or right, move the paper guide on the feed board until it's in the right place.

Before you make your final prints, wash your hands again! Set your stack of preprinted sheets on the feed board, and print the text on all of them, including the extras you made for mistakes. You should end up with a good number of broadsides—maybe even a few extras to give away!

Where does the name of your press/shop come from?

The press was founded in 2003 while I was attending graduate school and living in Starkville, Mississippi. The name comes from the song taught to children so they can learn how to spell Mississippi: "M-I-crooked letter-crooked letter-I-crooked letter-crooked letter-I-humpback-humpback-I." It's also a play on words related to the kind of printing the press does and the imperfections inherent to the process.

What was your first press?

My first press is the only letterpress I've owned, a Vandercook Universal I.

What do you love most about letterpress?

I love typography, and I love the way type printed on a letterpress bites into the paper and prints so sharply and beautifully. That was my initial attraction to the medium, and it is still the thing that can bring tears to my eyes when I pull a print from a form of type. There's more to letterpress than type, but it is called a letterpress, so I really think that's what it does best.

What is the biggest misconception about letterpress?

The biggest misconception about letterpress is that it's easy. It looks simple when you see someone printing, but what many people don't realize is that the hardest work comes before turning the cylinder. The typesetting, make-ready, and preparation for printing are very time-consuming and very critical to the quality of the printing.

Who are your favorite letterpress artists?

Walter Hamady's *The Interminable gabberjabbs* were the first works I saw that seriously inspired me to become a letterpress printer and book artist. Julie Chen's work was (and is) a major inspiration, specifically the piece *Ode to a Grand Staircase (For Four Hands)* done in collaboration with Barbara Tetenbaum, another favorite. I could make a very long list of people whose print and/or book work has influenced my own, but I will list just a few more: Robin Price, Steve Miller, Chris Stern, John Ross, Inge Bruggeman, Emily Larned, Artemio Rodriguez, and Kent Ambler.

Do you have a favorite printing trick or tip you can offer?

The best tip I have involves measuring on the press. Many artists are fearful of and dislike measuring. In letterpress, this is unavoidable, but I was taught a simple trick. On a Vandercook proof press, the cylinder sits and travels on a solid rail at each side of the press. The cylinder rim and the cylinder rail are matched fixed points from which to measure. To take measurements at the feed board, measure from the inside edge of the cylinder rim. Match that measurement in the press bed by measuring from the inside edge of the cylinder rail.

Love Poem to America, by Catherine Pierce. 2002. First published in the book **Famous Last Words** [Saturnalia, 2008]. Designed, typeset, and letterpress printed by Ellen Knudson, Crooked Letter Press. Printed from photopolymer plates on French Speckletone Kraft cover. March 2010. This is of 60.

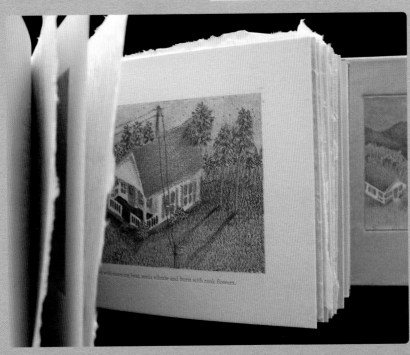

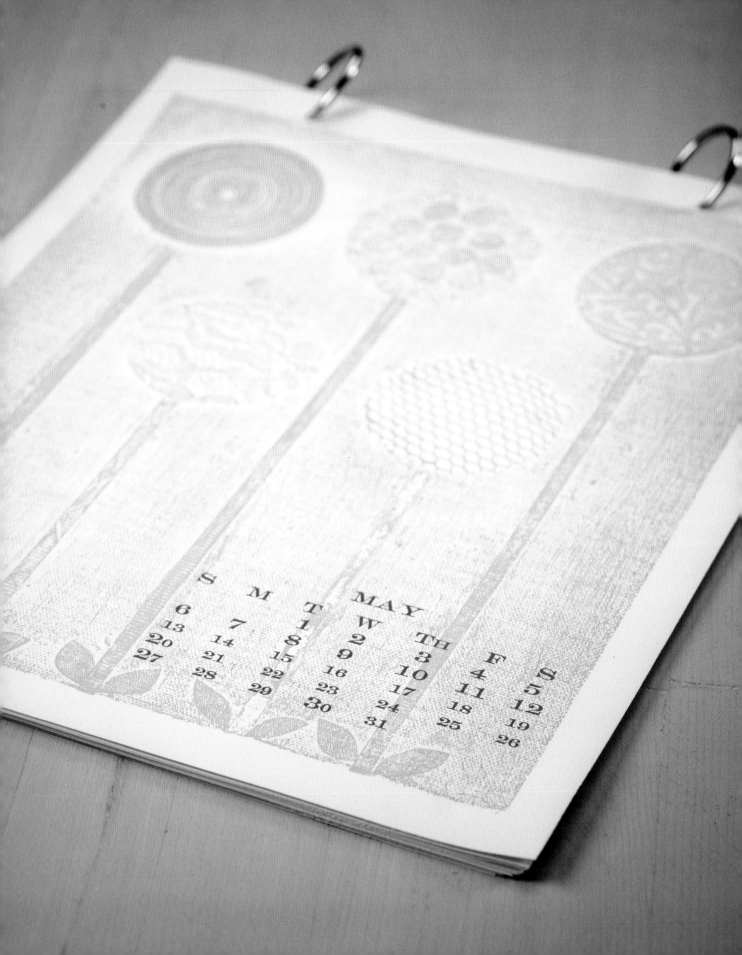

MAY

S	M	T	W	TH	F	S
6	7	1	2	3	4	5
13	14	8	9	10	11	12
20	21	15	16	17	18	19
27	28	22	23	24	25	26
		29	30	31		

CALENDAR WITH COLLAGRAPH

One of the brilliant things about letterpress-printing equipment is that—in addition to printing type—it can be used for all kinds of relief printing. In this project, we'll try a method of relief printing called collagraphy. To make a collagraph, you'll create a textured collage, which will be inked and used as a printing matrix. A flatbed cylinder press is ideal for printing your collagraph. By using a press that exerts pressure through a roll rather than a flat platen, you'll pick up the fine details of the lines and textures in your collage. For this project, you'll make one collagraph for one page of a calendar, but I encourage you to explore the process and make 11 more to round out the year!

TOOLS AND MATERIALS ★ BASIC LETTERPRESS PRINTING TOOL KIT (PAGE 17) ★ DRAWING PAPER FOR SKETCHING DESIGN, 9 × 12 INCHES (23 × 30.5 CM) ★ COMPUTER AND PRINTER (OPTIONAL) ★ SCISSORS ★ MUSLIN ★ PAINTBRUSH AND TRAY ★ HEAVY GEL MEDIUM ★ LINOLEUM BLOCK MOUNTED ON WOOD, 8 × 10 INCHES (20 × 25.4 CM) ★ TEXTURED PAPER OR SOFT, FLAT OBJECTS LIKE LACE, LEAVES, OR RIBBON ★ PRECUT SHAPES OR STICKY LETTERS (OPTIONAL) ★ GLUE (OPTIONAL) ★ WOOD TYPE (OPTIONAL) ★ BOOKBINDER'S BOARD OR OTHER DENSE BOARD, CUT TO SAME SIZE AS LINOLEUM BLOCK ★ TEXT-WEIGHT PAPER, 9 × 12 INCHES (23 × 30.5 CM) ★ METAL TYPE ★ TOOL KIT FOR SETTING TYPE (PAGE 32)

STEP 1 ➔ Plan the design.

Pick a month of the year and sketch some images that capture that period of time for you. Your images don't have to be literal or tied to a narrative. In fact, this is a great process for exploring abstract shapes and textures. Sketch your design on a sheet of 9 × 12-inch (23 × 30.5-cm) drawing paper. Your image should stay within the size of the linoleum block (which is 8 × 10 inches [20 × 25.4 cm]), but the text can be printed outside of that area. You might try digitally printing your text on a separate sheet of paper. Then you can cut out the text and move it around until you find the perfect spot for it in the design. Be sure to designate an area for text that shows the month and dates.

STEP 2 ➔ Prepare the paper.

For this project, you'll need paper that's 9 × 12 inches (23 × 30.5 cm). Cut as many pieces of paper as you want to print. Be sure to cut at least 10 percent extra for mistakes or accidents, as well as a stack of scrap for proofs. For the proofs, cut to the same size as the printing paper.

STEP 3 ➜ Make a matrix.

In printmaking terms, the matrix is the object that you print from over and over again. It could be a copper plate, a wood block, or a sheet of paper. For this project, you'll use a collagraph block as a matrix.

Start by trimming a piece of muslin that's slightly larger than the linoleum block. For an 8 × 10-inch (20 × 25.4-cm) block, trim the muslin to 9 × 11 inches (23 × 30.5 cm). Use the brush to spread a generous amount of gel medium across the surface of the block. Adhere the muslin to the block and press it down firmly, smoothing out any wrinkles **A**. Fold the edges over, using the gel medium as a glue **B**. Trim the excess muslin and let the block dry overnight.

Using your preliminary drawing as a guide, sketch your design onto the muslin surface. Cut shapes from your assorted papers and textured objects using scissors or a craft knife. Based on your sketch, glue the pieces to the block with glue or gel medium. You can build up the designs— just keep in mind that the thickest part will print darker, while the thin areas will print lighter. Try to ignore the way the collage looks, because only its lines and textures will print **C**.

Once you've finished the collage, brush gel medium all over the surface of the collage, coating the whole surface with a thin layer. Keep in mind that your brushstrokes may print, which can add a painterly texture to the finished piece. If you don't want any brushstrokes to show up in the final print, add a little water to the gel medium to thin it out before applying it to the collage. Let it dry overnight.

STEP 4 ➜ Raise the block to type height.

Before you can print the block, you need to raise it to type height (0.918 inch [23.3 mm]). You can use a type-height gauge or a piece of wood type as a measuring tool. The best letters to use for this purpose have long straight edges that you can place along the side of the block. Try "H" or "N." Place the type against the block, and take a look at the difference in height.

Cut down a few pieces of dense board to raise the block to the same height as the wood type **D**. I like to use bookbinder's board because of its density and because it comes in a variety of thicknesses. Make sure the board and/or sheets of paper are cut a hair smaller on each side of the wood block so that when you lock it up, the furniture is pressing against the block and not the supports underneath.

STEP 5 ➜ Lock up the form.

For instructions on how to do this, refer to the Event Poster from Type project on page 142 **E**.

STEP 6 ➜ Ink the press.

For instructions on how to do this, refer to the Event Poster from Type project on page 144.

STEP 7 ➜ Print.

First, ink the block. Set your printer on the trip mode **F** and engage the rollers. With your right hand working the carriage handle, roll the carriage over the form and back three times. This adds three fresh layers of ink on the form before you start to print. Return the carriage to the starting position.

Place a sheet of proofing paper on the feed board. Walk to the end of the press and look at where the paper will fall—it should be centered over the image area, but don't worry about getting it in the perfect place at this point. Move the paper guide against the far side of the paper and tighten it in place. Step on the gripper pedal to raise the grippers and tuck the sheet of paper underneath the grippers and against the guide. Release the gripper pedal, and the paper should be held in place.

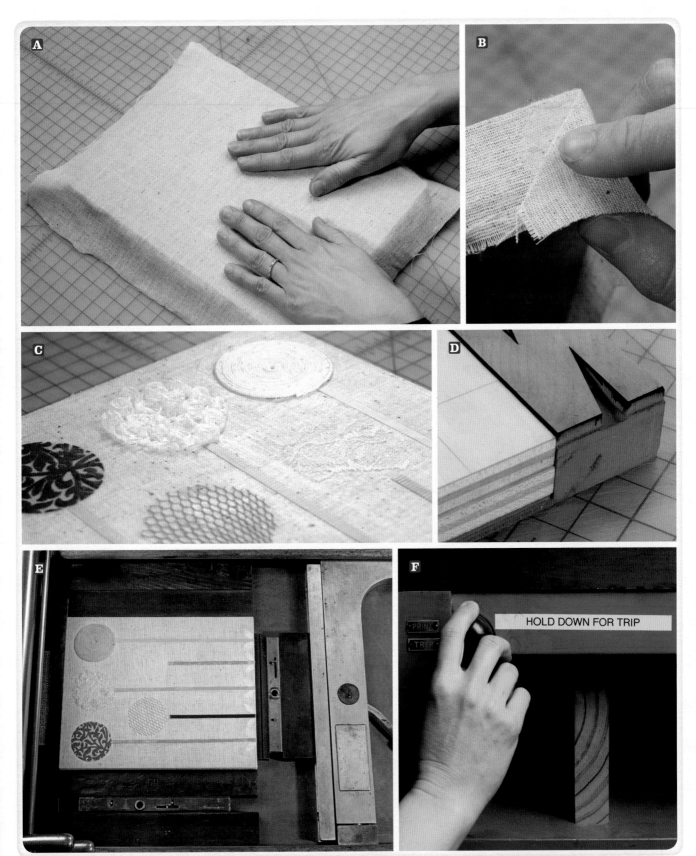

HOLD DOWN FOR TRIP

PRINT

TRIP

With your right hand on the carriage handle and your left hand holding the paper against the cylinder, roll the carriage forward, walking with it down the length of the press **G**. Be sure to take it all the way to the end of the press bed, where you'll hear a little click. This means the press is back in the trip mode, making it possible to return the carriage without printing on the cylinder on the return trip. This is also where the paper is released from the grippers. Pull the proof print out and return the carriage to the starting position.

Check the proof for print quality. (Refer to the troubleshooting section on page 36 if you're having trouble getting good print quality.) Also, check the proof for where the print falls on the page. Use your line gauge to get precise measurements for any necessary changes and mark these measurements on the proof. If a lot of adjustments need to be made, move the block on the bed by unlocking and rearranging the furniture around the form. If the paper only needs to move slightly to the left or right, move the paper guide on the feed board until it's in the right place.

Once you've made all of the adjustments and the proof prints look good, wash your hands! You don't want to get smudgy fingerprints on the finished broadsides. Pull out your stack of paper, set it on the feed board, and print all of the sheets, plus extras for proofing the next run.

STEP 8 → Set the type.
For instructions on how to do this, refer to the Event Poster from Type project on page 141.

STEP 9 → Place the text block on the press bed.
Once your type is set and tied up, place the galley on the press bed and slide the text block onto the bed. Place your index fingers on the top slug, your thumbs on the bottom slug, and your middle fingers on either side of the form. Squeeze the form tightly, giving it a slight bend while you slide it down onto the press bed. For now, slide the text block up against the head dead bar or one of the rails, and place a few pieces of furniture against the sides to keep the type from falling over. Keep the type supported but out of the way.

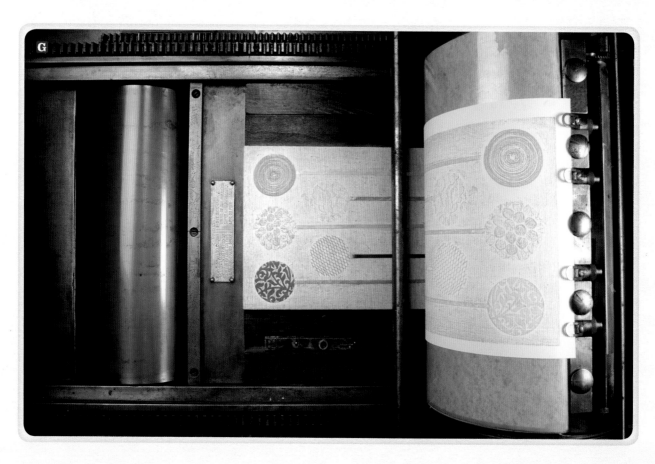

Place a sheet of the printed paper from the first run on the press bed, with the printed side down. Center it along the head dead bar and up toward the carriage about ½ inch (1.3 cm). This is approximately where the paper will fall (it could be more than ½ inch [1.3 cm] or it could be less, depending on the press you're using). Tape the paper to the head dead bar with painter's tape.

Using this paper as a guide, slide the form around on the press bed to the place where you want it to print on the paper. This is just to get the form in the general position—you'll finesse it into exactly the right spot later 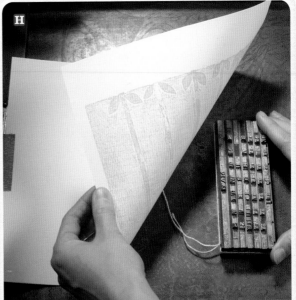.

STEP 10 → Lock up the form.
For instructions on how to do this, refer to the Event Poster from Type project on page 142.

STEP 11 → Ink the press.
For instructions on how to do this, refer to the Event Poster from Type project on page 144.

STEP 12 → Print.
Print as you did in Step 7 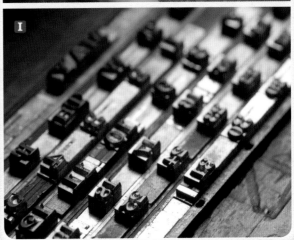. Be sure to check the proof for where the print falls on the page. Place this proof sheet against one of the printed sheets from the first run. Hold them up to the light or look at them on a light table. This will give you an idea of where the text will print in relation to the image. Use your line gauge to get precise measurements for any necessary changes and mark these measurements on the proof. If a lot of adjustments need to be made, move the type on the bed by unlocking and rearranging the furniture around the form. If the paper only needs to move slightly to the left or right, move the paper guide on the feed board until it's in the right place.

Before you make your final prints, wash your hands again! Set your stack of preprinted sheets on the feed board, and print the text on all of them, including the extras you made for mistakes. When you're done printing with this collagraph matrix, you can tear the muslin off the block and reuse it for a new collagraph matrix. Explore a new set of textures for each month of the year!

A LITTLE BOOK
OF CHINESE PROVERBS

CHAPBOOK

I made books long before I learned how to print. After a few years of making blank books, I tried my hand at adding content. I started by drawing, painting, and making collages on the pages and learned later how to use stamps and simple printing methods to add text and imagery. When I first learned how to letterpress print, you could almost see the fireworks—I was thrilled to find a way to combine the books and the prints that I loved so much. In the quick and easy project that follows, I'll show you how to make a printed book from a single sheet of paper. Many different kinds of book structures are suitable for letterpress printing. I hope you'll be inspired to explore the possibilities!

TOOLS AND MATERIALS ★ BASIC LETTERPRESS PRINTING TOOL KIT (PAGE 17) ★ SCRAP PAPER, 11 × 17 INCHES (28 × 43 CM) ★ BONE FOLDER ★ DIGITAL PRINTS OF TEXT OR QUOTATIONS (OPTIONAL) ★ CELLOPHANE TAPE (OPTIONAL) ★ TEXT-WEIGHT PAPER, 11 × 17 INCHES (28 × 43 CM) ★ METAL TYPE ★ TOOL KIT FOR SETTING TYPE (PAGE 32)

STEP 1 ➔ Make a mockup.

Before I start on any printed book project, I always make a mockup of the book idea. Having a physical object to hold in my hands helps me make design choices and is a good reference to have nearby when I'm printing.

Fold a sheet of 11 × 17-inch (28 × 43-cm) scrap paper in half lengthwise, then fold it in half again. Fold the two loose ends over to the center fold **A**. Open the sheet fully, and you'll see that it's been divided into eight equal parts.

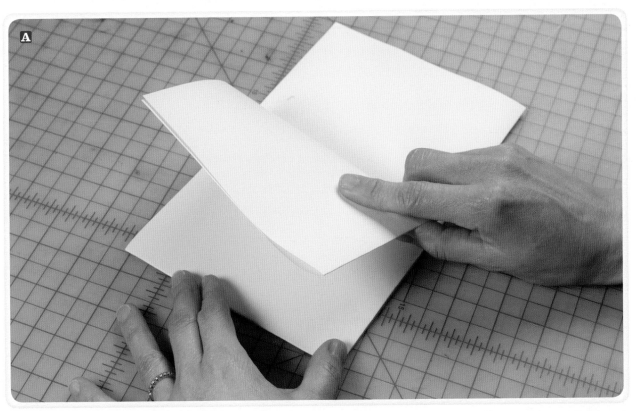

Cut along the center fold. Cut only through the two middle sections, and not all the way out to the edges **B**. Fold the sheet lengthwise, and push the two ends together, "popping" open the center cut **C**. Squeeze the two ends together until they meet **D**, then place the paper down flat on a table. Make one final fold, placing all four pages on one side, and give all four edges a good crease with the bone folder. Now you have a blank book with two covers and two interior pages **E**.

Add text to your mockup. Use a pencil to write in the text, or cut out digital prints of the text and put them in place using little loops of cellophane tape **F**. I prefer this method because it's easy to move the text around from page to page to change the design of the book. Don't forget to add a title on the front cover and a colophon on the back cover.

STEP 2 ➜ Prepare the paper.

For this project, you'll need text-weight paper that's 11 × 17 inches (28 × 43 cm), the same size you used for your mockup book. Cut (or buy) as many pieces of paper as you want to print. Be sure to cut at least 10 percent extra for mistakes or accidents, as well as a stack of scrap for proofs. For the proofs, cut to the same size as the actual prints.

STEP 3 ➜ Set the type.

Pull out the type case and set it on a flat surface where you'll be comfortable setting type. Other handy things to keep nearby when you're setting type include spacing material, tweezers, and a case layout chart (if you haven't yet memorized where all of the letters are stored).

For this project, set your composing stick to a line length that fits your page. I would recommend setting a line length of no more than 60 to 65 letters per line. To simplify the printing process later on, use the same line length for every block of text for this chapbook **G**. Refer to the Setting Metal Type section on page 34 for instructions on how to set the rest of the type and tie up the form.

STEP 4 ➜ Place the text blocks on the press bed.

Once your type is set and tied up, place the galley on the press bed and slide the text block onto the bed. Place your index fingers on the top slug, your thumbs on the bottom slug, and your middle fingers on either side of the form. Squeeze the form tightly, giving it a slight bend while you slide it down onto the press bed. For now, slide the text blocks up against the head dead bar or one of the rails, and place a few pieces of furniture against the sides to keep the type from falling over. Keep the type supported but out of the way.

Open your mockup and place it on the press bed with the text side facing down. Center it along the head dead bar and up toward the carriage about ½ inch (1.3 cm). This is approximately where the paper will fall (it could be more than ½ inch [1.3 cm] or it could be less, depending on the press you're using). Tape the paper to the head dead bar with painter's tape.

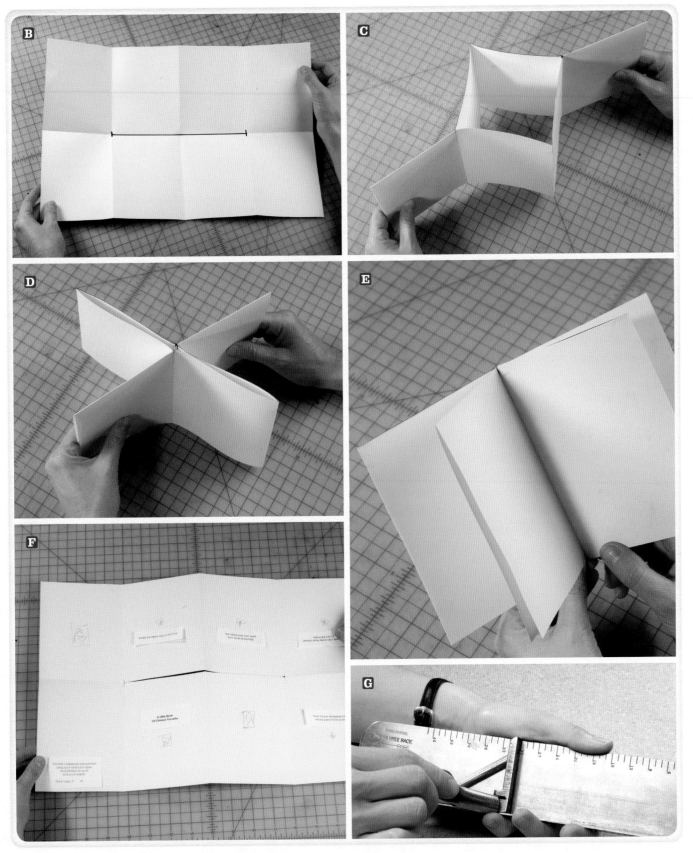

Using the mockup as a guide, slide the text blocks around on the press bed to the correct positions where you want them to print on the paper. This is just to get the forms in their general positions—you'll finesse them into exactly the right spots later on.

STEP 5 ➔ Lock up the form.

Once you have the text blocks in approximately the right place, use your line gauge to measure the space from the head dead bar to the first text block. Place furniture to fill in this space, using pieces that are slightly longer than the height of the forms together. These pieces of furniture should sit perpendicular to the rails.

Place furniture on the right side of the forms, filling in all the space between the upper text blocks and the rail opposite the operator's side (the side farthest from you). You can double up on furniture if you don't have pieces that are long enough to cover the entire length of the forms. These pieces of furniture should sit parallel to the rails.

Repeat the previous step between rows of text blocks and along the bottom of the lower text blocks. Place a piece of furniture that's about 4 picas wide and the same length as or slightly longer than the form itself on the left side of the lower text blocks. Place a quoin that's about the same size against that piece of furniture, then use furniture to fill in the space between the quoin and the operator's side rail. Again, these pieces of furniture should sit parallel to the rails. Make sure that when the quoin expands, it expands toward the form. If you only have small quoins, use two or more.

Now fill in the spaces left on the press bed around each block of text, using a combination of furniture, reglets, and leading until everything fits snugly and forms a solid block on the press bed **H**.

If you're using a dead bar, place a piece of furniture that's 4 picas wide and the same height as or slightly shorter than the form itself against the bottom of the form. Place a quoin against it, and then add furniture to the other side of the quoin until you reach the dead bar.

If you're using an adjustable lockup bar, place a piece of furniture that's 4 picas wide and the same height as or slightly shorter than the form itself against the bottom of the form. Place a quoin against this furniture, and then add another similar piece of furniture to the other side of the quoin. Place your lockup bar at the end and lock it in place.

Once the forms are snugly in place, remove the mockup and pull up on the trimmed end of the strings that you used to tie up the text blocks. They should pull up easily and leave a bit of space all the way around the blocks. If necessary, add reglets to fill in small spaces.

Place one hand on the form, and use a quoin key to tighten each quoin slightly. Place a plane on each form and tap it gently with the side of your quoin key to make sure that each piece of type is resting squarely on its feet. Move the plane around and repeat this two or three times. Place your hand on the text blocks again and tighten each quoin securely. The form should be firmly in place, but be careful that the blocks don't lift slightly while you tighten the quoins. If this happens, then you've tightened the quoins too much. Release them and tighten them again **I**.

STEP 6 ➔ Ink the press.

For instructions on how to do this, refer to the Event Poster from Type project on page 144. Keep in mind that you may only be using one color of ink for this project.

STEP 7 ➔ Print.

For complete instructions on how to do this, refer to the Event Poster from Type project on page 144 **J**. Repeat Steps 3 through 7 to print a second run in another color.

STEP 8 ➔ Finishing.

After you've finished printing, fold and cut each sheet in the same way that you did the mockup. Don't forget to sign and number each chapbook on the back cover.

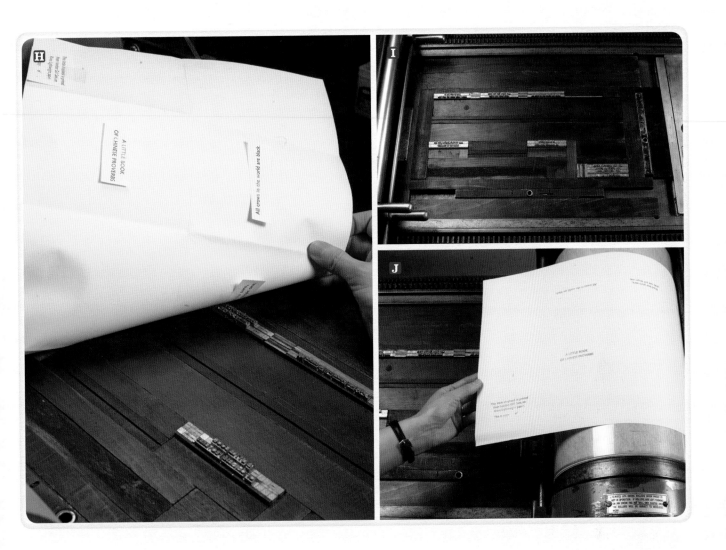

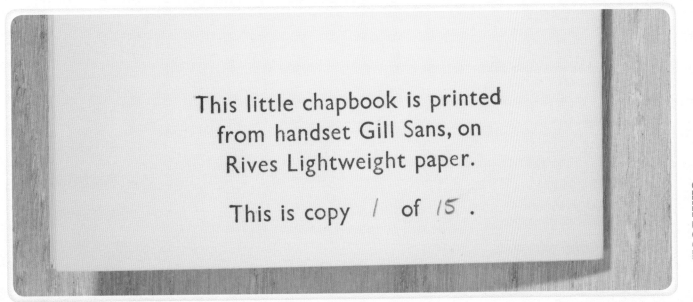

This little chapbook is printed
from handset Gill Sans, on
Rives Lightweight paper.

This is copy 1 of 15 .

GLOSSARY OF TERMS

Bench-hook: A small wooden board with wooden attachments, one on top and one on the bottom. The wooden attachment on the bottom hooks to the edge of the table, securing the board so that pressure can be used against the wooden attachment on top while cutting wood or linoleum blocks.

Bone folder: A tool used to score and crease paper or other materials.

Carriage: On a cylinder press, this is the assembly that includes the impression cylinder and roller assembly. It travels down the press bed as you print.

Chase: A rectangular steel frame used to lock up a form to be printed on a platen press. It is occasionally used for lockup on a cylinder press.

Colophon: A brief description, usually located at the end of a book, about the book itself and how it was made. It often includes the typeface, paper, binding method, edition size, and its number in the edition.

Composing stick: A handheld tool used for setting type. It holds lines of type as they are being set.

Corking: See *ejection rubber*.

Deckled edge: The rough edge on a sheet of paper that's the natural result of hand papermaking using a mold and deckle.

Delivery board: The lower board that sits below the feed board on a platen press.

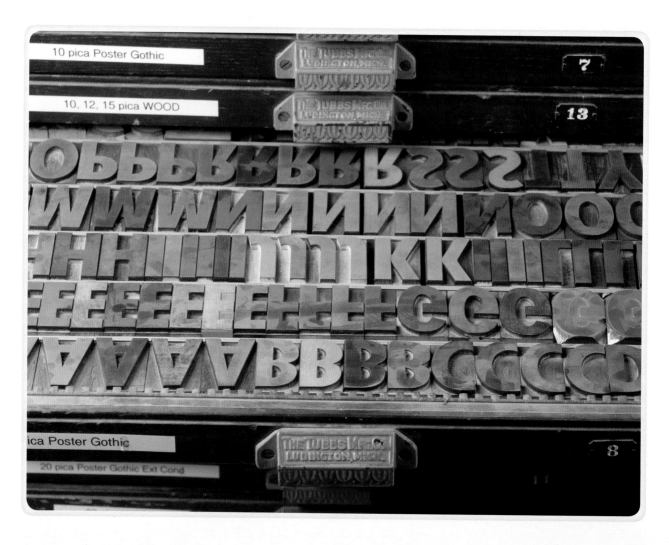

Die-cutting jacket: A thin sheet of steel that protects the platen from damage when die cutting.

Ejection rubber: Rubber strips along the sides of die-cutting or perforating rules that help release the paper from the rule once it is cut.

Em quad: Spacing material that is the same point size on all four sides, forming a perfect square.

Feed board/feed table: The area on a press that holds the stack of paper to be printed.

Font: A complete character set of a single typeface. For example, 12-point Bembo and 14-point Bembo are two fonts of the same typeface.

Form: A block of type (or images) that is ready for printing.

Form string: Strong string for tying up forms. It secures them for transport and keeps them from becoming pied when moved around the shop.

Furniture: Blocks of wood cut to specific lengths and widths used to fill the spaces around a form when locking up.

Galley: A metal tray used for temporary storage of set type.

Gauge pins: Small metal pieces that hold paper in place on the tympan on a platen press.

Gel medium: An acrylic paint modifier that's often used for texture and as a glue in collage arts.

Grippers: A part of the press that holds paper in place while printing. Usually grippers are flat metal discs on a cylinder press and metal bars on a platen press.

Head dead bar: The metal bar on the press bed nearest the carriage on a cylinder press. It prevents the grippers from hitting the form during printing. It can also be called a register bar.

Imposing stone/imposing table: A smooth, flat surface used as a tabletop when locking up a form in a chase. It is traditionally made from marble or steel.

Ink disc: The round disc at the top of a platen press that acts as an ink reservoir. The disc rotates while the press is running to keep the ink evenly distributed.

Inking table/inking plate: A smooth surface used for warming up and mixing ink.

Kerning: Adjusting the spacing between characters in a word or line of text to achieve visual balance.

Leading: Strips of metal used to add space between lines of text.

Line length: The length of a line of set type, usually measured in picas.

Linoleum block: A sheet of linoleum mounted on a block of wood. In this book it is used as a printing matrix.

Lockup: A form that has been tightened into place on a press bed or chase and prepared for printing. Lockup can also refer to the process of tightening the form.

Lockup bar: An adjustable metal bar placed on the press bed of a cylinder press opposite the head dead bar, forming the "fourth wall" when locking up. A lockup bar that's not adjustable is called a dead bar.

Matrix: In letterpress, the matrix is a mold for casting metal type. However, as a printmaking term it refers to the plate that is inked and ready for printing (see *form*).

Packing: Sheets of paper or board in a variety of weights and thicknesses placed under the tympan. Packing is used to prevent excessive wear on metal type and to adjust the impression.

Perforating rule: A strip of steel that cuts through paper with a row of sharp teeth, creating a row of small holes where the paper can easily be torn.

Photopolymer plate: A light-sensitive plastic plate that is mounted to an aluminum or a magnetic base, bringing it up to type-high for letterpress printing. Steel-backed polymer plates are used with magnetic bases, while an adhesive film is placed on the back of plastic plates, so they can be adhered to an aluminum base.

Pica: The standard unit of measure for letterpress printing. Twelve points make up one pica, while six picas are approximately equal to 1 inch (2.5 cm).

Pied: A spilled or mixed jumble of type.

Plane: To tap on a wooden block that's set on a form to make sure that all pieces of type are sitting squarely on their feet. It can also refer to a wooden block used for planing.

Platen: A flat, heavy metal plate on the platen press that presses the paper against the form to make an impression.

Press bed: The part of the press that holds the form while printing.

Printer: A person or company that makes prints. Even if you make letterpress prints, you are a printer (not a presser). A presser removes creases from a garment.

Proof print: A test print, often on scrap paper, made to test the print quality before making the final prints.

Register bar: See *head dead bar.*

Quoin: An expandable tool that tightens the form and furniture in a lockup in preparation for printing.

Quoin key: The tool that activates the expansion system in a quoin.

Registration: The process of printing on a sheet of paper in a specific place, and lining up each sheet so that it falls in the correct position each time. Also the process of printing on one sheet of paper multiple times, and lining up each sheet so that it falls in the correct position in correlation with the previous prints.

Reglet: Thin, wooden spacing material, either 6 points or 12 points thick, used to fill up gaps of space in a lockup.

Relief printing: A type of printmaking that involves applying ink to a raised surface, then using pressure to transfer that ink onto paper.

Slug: A piece of leading that's 6 points thick or more.

Spacing: Small pieces of metal used to separate words or letters in a line of type.

Steel rule die: A tool that's used to cut shapes in paper or board. It is usually a strip of hardened steel embedded in a wooden base. It is sharp along the exposed edge, with ejection rubber along the cutting edges.

Throw-off lever: The mechanism on a cylinder press used to control whether or not the form and the platen meet while the press is running. When the press is in "print" position, an impression is made. When the press is in "trip" position, no impression is made.

Tympan bales: The flat metal bars attached to the top and bottom of the platen that hold the tympan and packing in place.

Tympan paper: A smooth, sturdy, oil-treated paper used as the top sheet of packing. Special papers are made specifically to be used as tympan paper, but it can also be made of similar papers or Mylar. Tympan can also be called a drawsheet.

Type case: A shallow wooden drawer divided into compartments used to organize and store movable type.

Typeface: A style, or design, of the characters in an alphabet.

Type high: The height of type, 0.918 inch (23.3 mm).

UV exposure unit: A tool used to expose photopolymer plates to UV light.

RECOMMENDED READING

Brown, Marty. *A 21st-Century Guide to the Letterpress Business*. Portland, OR: Letterary Press LLC, 2010.

Cleeton, Glen U., Charles W. Pitkin, and Raymond L. Cornwell. *General Printing*. Bloomington, IL: McKnight & McKnight Publishing Company, 1963. Reprinted by Liber Apertus Press, 2006.

Jury, David. *Letterpress: New Applications for Traditional Skills*. Hove, UK: RotoVision, 2006.

Lange, Gerald. *Printing Digital Type on the Hand-Operated Flatbed Cylinder Press*. Marina Del Rey, CA: The Bieler Press, 2009.

MacKellar, Thomas. *The American Printer: A Manual of Typography*. Philadelphia, PA: MacKellar, Smiths & Jordan, 1885. Reprinted by Harold Berliner, 1977.

Maravelas, Paul. *Letterpress Printing: A Manual for Modern Fine Press Printers*. New Castle, DE: Oak Knoll Press, 2006.

Moran, James. *Printing Presses: History & Development from the 15th Century to Modern Times*. Berkeley and Los Angeles, CA: University of California Press, 1973.

Moxon, Paul. *Vandercook Presses: Maintenance, History, and Resources*. Mobile, AL: Fameorshame Press, 2011.

Polk, Ralph W. *Elementary Platen Presswork*. Chas. A. Bennett Co., Inc., 1931. Reprinted by Letterary Press LLC, 2007.

RESOURCES

Letterpress Information and Organizations

Amalgamated Printers' Association:
www.apa-letterpress.com
American Amateur Press Association: www.aapainfo.org
American Printing History Association:
www.printinghistory.org
Briar Press: www.briarpress.org
C.C. Stern Type Foundry: www.ccsterntype.org
College and University Letterpress Printers' Association:
www.collegeletterpress.org
Fine Press Book Association: www.fpba.com
Five Roses Press: www.fiveroses.org
Ladies of Letterpress: www.theladiesofletterpress.com
Letpress Listserv:
https://listserv.unb.ca/cgi-bin/wa?A0=LETPRESS
Letterpress Daily: www.letterpress.dwolske.com
PPLetterpress Yahoo Group:
http://groups.yahoo.com/group/PPLetterpress
VandercookPress.Info (the Vanderblog):
www.vandercookpress.info
We Love Letterpress: www.weloveletterpress.com

Letterpress Tools and Equipment

American Printing Equipment & Supply Co.:
www.americanprintingequipment.com
Boxcar Press: www.boxcarpress.com
Don Black Linecasting: www.donblack.ca
The Excelsior Press: www.excelsiorpress.org/forsale/
fundraising.html#presses
Letterpress Things: www.letterpressthings.com
NA Graphics: www.nagraph.com

Ink

Gans Ink & Supply Co.: www.gansink.com
Graphic Chemical & Ink Co.: www.graphicchemical.com
Ink in Tubes (Dave Robison): www.excelsiorpress.org/
forsale/inkintubes/index.html
Van Son Ink: www.vansonink.com

Photopolymer Plates

The Bieler Press: www.bielerpress.blogspot.com
Boxcar Press: www.boxcarpress.com
Photopolymer Plates: www.photopolymerplates.com

Rollers

Advanced Roller Co.:
www.printing-press-rollers.com/index.html
Ramco Roller Products: www.ramcoroller.com
Tarheel Roller & Brayer Co.: www.tarheelroller.com

Type

The Bixler Press & Letterfoundry: www.mwbixler.com
The Dale Guild Type Foundry: www.thedaleguild.com
M&H Type: www.arionpress.com/mandh/index.htm
Moore Wood Type: www.moorewoodtype.bigcartel.com
Skyline Type Foundry: www.skylinetype.com/home.html
Virgin Wood Type: www.virginwoodtype.com/blog

Dies

A&A Dies: www.graphicdies.com/index.shtml
Dura-Craft Die: www.duracraftdie.com
Owosso Graphic Arts, Inc.: www.owossographic.com

General Printmaking and Art Supplies

Blick: www.dickblick.com
Daniel Smith: www.danielsmith.com
Hollander's: www.hollanders.com
McClain's Printmaking Supplies: www.imcclains.com
Utrecht: www.utrechtart.com

LETTERPRESS

Paper
Arch Paper: www.archpaper.net
Carriage House Paper (handmade):
 www.carriagehousepaper.com
Cave Paper (handmade): www.cavepaper.com
French Paper Co.: www.frenchpaper.com
Hiromi Paper Inc.: http://store.hiromipaper.com
The Japanese Paper Place: www.japanesepaperplace.com
Legion Paper: www.legionpaper.com
Letterpress Paper: www.letterpresspaper.com
Mohawk Fine Papers: www.mohawkpaperstore.com
Neenah Paper: www.neenahpaper.com
Paper Source: www.paper-source.com
Twinrocker Handmade Paper: www.twinrocker.com

Classes/Workshops
Asheville BookWorks: www.ashevillebookworks.com
Atlanta Printmakers Studio:
 www.atlantaprintmakersstudio.org/index.html
Baltimore Print Studios: www.baltimoreprintstudios.com
The Center for Book Arts: www.centerforbookarts.org
Em Space: www.em-space.org
Kalamazoo Book Arts Center: www.kalbookarts.org
Minnesota Center for Book Arts: www.mnbookarts.org
Oregon College of Art and Craft: https://cms.ocac.edu
Penland School of Crafts: www.penland.org
Pyramid Atlantic Art Center:
 www.pyramidatlanticartcenter.org
San Francisco Center for the Book: www.sfcb.org
Small Craft Advisory Press:
 www.smallcraftadvisorypress.art.fsu.edu

MFA Programs
Columbia College Center for Book and Paper Arts:
 www.colum.edu/academics/interarts/
 book-and-paper/index.php
Mills College MFA in Book Art and Creative Writing:
 www.mills.edu/academics/graduate/eng/programs/
 MFA_in_bookart.php
University of Alabama MFA in Book Arts:
 www.bookarts.ua.edu
The University of the Arts Book Arts & Printmaking:
 http://bookprintmfa.uarts.edu
The University of Iowa Center for the Book:
 http://book.grad.uiowa.edu

Museums
Hamilton Wood Type & Printing Museum (Two Rivers,
 WI): www.woodtype.org
The International Printing Museum (Carson, CA):
 www.printmuseum.org
The Museum of Printing (North Andover, MA):
 www.museumofprinting.org
The Museum of Printing History (Houston, TX):
 www.printingmuseum.org
Web Museum of Wood Type and Ornaments
 (online): www.unicorngraphics.com/
 wood%20type%20museum.asp

ABOUT THE AUTHOR

Jessica C. White is originally from Taipei, Taiwan, but spent many of her formative years in central and eastern North Carolina. She first discovered printmaking in high school art class, and went on to college, where she studied metal work, iron casting, and sculpture. She rediscovered printmaking in her late twenties and never looked back. She attended graduate school at the University of Iowa, where she earned an MFA in Printmaking, a Graduate Certificate in Book Studies, and a deep appreciation for the craft of letterpress printing and book art. Today, Jessica works as a studio artist and continues to make prints and artist books under the imprints Heroes & Criminals Press and Little Phoenix Letterpress. She is an adjunct professor of Papermaking and Book Arts at Warren Wilson College and teaches workshops at Asheville BookWorks. She is also the cofounder and codirector of Ladies of Letterpress (http://theladiesofletterpress.com). Along with these credentials, Jessica has also completed half of a pilot's license and half of a sailing certificate. Feel free to contact her about printing, binding, or papermaking, but no requests please for flying or sailing the high seas, at www.jessica-c-white.com.

ACKNOWLEDGMENTS

For Scott, for reminding me every day that I can do it, no matter what I'm doing.

Many thanks to the following teachers, mentors, friends, and fellow travelers who have helped guide me along the way: Tim Barrett, Bette Bates, Judith Berliner, Gloria Bradshaw, Frank Brannon, David Dunlap, Gary Frost, Cody Gieselman, Glenn House Sr., Bud Lang, Sara Langworthy, Julie Leonard, Paul Moxon, Elizabeth Munger, Jessica Peterson, Tracie Pouliot, Larry Raid, Sara Sauers, and Kseniya Thomas.

Thanks to the following for their photography: Tim Barnwell (page 49), Hatch Show Print, A Division of the Country Music Foundation, Inc. (pages 66-7), Jessica Peterson (pages 92-3), Kseniya Thomas (page 119), Curtis Steele (page 127), Kathryn Hunter (page 147), and Ellen Knudson (page 155).

Special thanks to Laurie Corral and Asheville BookWorks for the use of their facilities, cylinder presses, and type collection.

Special thanks are also due to my editors Kathleen McCafferty, for sparking the fire and getting this book off the ground, and Thom O'Hearn, for seeing it through to the end.

INDEX

*Note: Page numbers in **bold** indicate projects.*